MUSEUM

ALSO BY DANNY DANZIGER

1215: The Year of Magna Carta (with John Gillingham)
The Year 1000 (with Robert Lacey)
The Orchestra
Eton Voices
The Cathedral
Lost Hearts
All in a Day's Work
The Happiness Book
Emperor Hadrian: When Rome Ruled the World

DANNY DANZIGER

VIKING

MUSEUM

BEHIND THE SCENES AT
THE METROPOLITAN MUSEUM OF ART

VIKING
Published by the Penguin Group
Penguin Group (USA) Inc., 375 Hudson Street, New York, New York 10014, U.S.A.
Penguin Group (Canada), 90 Eglinton Avenue East, Suite 700, Toronto, Ontario,
Canada M4P 2Y3 (a division of Pearson Penguin Canada Inc.)
Penguin Books Ltd, 80 Strand, London WC2R 0RL, England
Penguin Ireland, 25 St. Stephen's Green, Dublin 2, Ireland
(a division of Penguin Books Ltd)
Penguin Books Australia Ltd, 250 Camberwell Road, Camberwell, Victoria 3124,
Australia (a division of Pearson Australia Group Pty Ltd)
Penguin Books India Pvt Ltd, 11 Community Centre, Panchsheel Park,
New Delhi - 110 017, India
Penguin Group (NZ), 67 Apollo Drive, Rosedale, North Shore 0745, Auckland,
New Zealand (a division of Pearson New Zealand Ltd)
Penguin Books (South Africa) (Pty) Ltd, 24 Sturdee Avenue, Rosebank,
Johannesburg 2196, South Africa

Penguin Books Ltd, Registered Offices: 80 Strand, London WC2R 0RL, England

First published in 2007 by Viking Penguin, a member of Penguin Group (USA) Inc.

1 3 5 7 9 10 8 6 4 2

Copyright © 2007 Danny Danziger
All rights reserved

ISBN 978-0-670-03861-9

Printed in the United States of America
Designed by Nancy Resnick

This book is dedicated, with great love, to my mother,
Gigi Guggenheim Danziger

Preface

In 1866 a group of eminent Americans sat down at a fashionable restaurant in Paris's Bois de Boulogne to celebrate the Fourth of July. John Jay, a prominent lawyer and grandson of the first chief justice, remarked to his compatriots that it was time for the American people to lay the foundations of a "National Institution and Gallery of Art."

The suggestion was enthusiastically received, and over the next few years some of the wealthiest and most ardent art collectors and philanthropists were drawn to this notion. J. Pierpont Morgan, H. O. Havemeyer, the Lehman brothers, Benjamin Altman, many of the Rockefeller family, and Cornelius Vanderbilt all gave their support with money, books, and works of art. The city of New York, for its part, agreed to pay for the building and upkeep of a museum while the trustees retained its contents, an arrangement that still applies.

The project moved ahead swiftly, and the Metropolitan Museum of Art was incorporated four years later, on April 13, 1870. Now, nearly a century and a half later, not only is the Metropolitan Museum one of the greatest museums in the world, but its success is an inspiring story for all Americans, showing what private wealth in public-spirited hands can achieve.

One wonders if the founders of this Museum could ever have imagined that by the twenty-first century the Met would have

become the number one tourist attraction in New York, with more than four million visitors a year.

Reflecting the energy and vibrant lifestyle that is the hallmark of this city, the visitors who arrive here in a never-ending stream are an enthusiastic lot. They walk up the stairs, underneath the promotional banners that once billowed in the wind but are now smaller and tethered to the front of this great neoclassical building; the enormous banners, it was decided, blocked out too much light inside the building. In the formidable reception area known as the Great Hall, you can see dozens of people at any one time waiting to meet friends or family prior to embarking on a tour of the galleries.

On a typical day I made a snapshot inventory of visitors. As well as being from the host city, there were people from Tokyo and Kansas, Barcelona and Michigan, noisy schoolchildren from France, a party of nuns from upstate New York, a sculptor from Omsk, Siberia, eager to see the Rodins, a daughter meeting her mother, a German businessman taking advantage of a lull between meetings to go through the Egyptian wing, and two lovers, who remained unself-consciously entwined as we talked.

It is the Metropolitan's boast that every culture from every part of the world is represented here, from Florence to Thebes to Papua, New Guinea, from the earliest times to the present, and in every medium. Musical Instruments adjoins Arms and Armor, while thirty-five thousand Egyptian objects are displayed on the floor directly above a collection of forty-five thousand costumes. There are nineteen departments or collections, and each could be a major independent museum in itself. There's the American Wing and Modern Art, the arts of Africa, Oceania, and the Americas, Medieval Art, Islamic Art, and Drawings and Prints and Photographs, Ancient Near Eastern

and Asian Art, European Paintings, the Robert Lehman Collection, and on and on it goes.

This is an enormous place, the second-biggest museum in the world, after the Louvre, a building that takes up four city blocks and has more than two million square feet of space. There are treasures everywhere you look: exquisite vases, jewelry, clocks, tapestry, silver and gold, ceramics, baseball cards, Egyptian mummies, sculptures and furniture and paintings. My God, there are paintings, and it is breathtaking to see some of the most famous paintings in the world right here, in front of you, by artists such as Fra Angelico, El Greco, Rembrandt, Vermeer, Constable, van Gogh, Monet. Just name your favorite, and it will be here, a sort of artistic *Thousand and One Nights*.

All these objects are undeniable jewels, but the more I visited the Museum, the more curious I became about the human component of this institution. Of course one can *see* the guards and the attendants who work in the gift shops or operate the elevators, but what about the people one doesn't see during a visit, such as the curators? Where are the collectors who give, lend, or bequeath their possessions? What sorts of people are the benefactors and trustees who give of their time and treasure? What sort of person is the director of this place, particularly *this* long-serving and esteemed director?

That curiosity was the starting point for this book. It could have been any museum I chose to write about, but *this* place had to be the one. Even though resoundingly large, it is not at all intimidating, and it wasn't long before I began to know my way around and really take in and absorb the extraordinary collections around me. Also, I enjoyed the atmosphere and spirit of the place. . . . I just felt comfortable here.

The adventure started just a short time after I called the Museum to declare my interest in writing about it. I went in and met one or two people in administrative positions, each of whom made welcoming noises. But pretty soon it became clear there was only one person who had the authority to countenance such an intrusion, and that was the director of the Museum, Philippe de Montebello. One sunny early spring morning, I went up to his corner office on the fifth floor, which panoramically overlooks Central Park from two banks of windows, facing south and west. "Ah, Mr. Danziger," he said, in his sonorous French accent, "you want to write a history of the Metropolitan?"

"No, no, I want to write a profile of the Museum through the people who work here. . . ."

It was a concept I don't think he ever took in—how could anyone be more interested in people than in *objets*?—despite my interviewing him, intimately, four or five times. But we struck a deal that day. I would be given as much help and cooperation to write the book as I wished, on the whimsical condition that I read Calvin Tomkins's magisterial 1970 biography of the Met, *Merchants and Masterpieces*. Clearly, this is a book the director rates highly! I did read the book—that was no hardship, it is a terrific read, scholarly and gripping. And that was that. I temporarily moved from London, where I live, interrupting progress on a book I was co-writing on Emperor Hadrian, and started right away.

What a wonderful group of people the curators are! I had feared they might be impatient with someone like me who clearly had so

little knowledge of their subjects, but they were incredibly generous in explaining their fields of expertise, neither impatient nor condescending.

No less interesting were many of the important figures who contribute toward making a museum building run successfully: the cleaners, construction workers, firefighters, plumbers, people who had wonderful backstories, as the film studios say.

An army of people are employed to make such a building work; actually, in toto there are more than two thousand full-time employees, plus hundreds of part-time and voluntary workers. There are tour guides and security guards, more than six hundred of them, cooks and waitresses. There are the button guy, as he calls himself, who is responsible for changing the button colors each day (there are sixteen colors in the Metropolitan spectrum); the registrar who sends objects all over the world (no, you don't pop a Rodin or Caravaggio into a Jiffy bag); lovely Hilde Limondjian, who organizes the concerts and lectures; young Remco van Vliet, the Dutch florist who arranges the flowers in the Great Hall every Monday morning—the list goes on and on.

Then there are the trustees, Annette de la Renta, Lulu Wang, James Houghton, and others. It was extraordinary going to their homes or offices to meet them. In some cases, their homes are miniature museums, with dozens of stunning works of art on *their* walls. The view from the library at Henry Kravis's office was unforgettable. I have been in high-up offices before and marveled at the sight of parts of Central Park, but never have I seen a view that overlooks all of the park and beyond, into Maine, I think.

I was struck by the level of commitment from everybody whose life is touched by the Met, whether it's the time and money that the trustees voluntarily give, or the pride and commitment that the

employees feel. Perhaps there are employees nursing cynical and harsh feelings toward their places of employment. I had expected to find some discontent—in some of my previous books about institutions, seething resentment or simmering feuds have made for entertaining reading. But in this place, it is as if Oberon had sprinkled fairy dust over the lot of them, and, you know what?—it doesn't make it any less interesting.

Some of the fifty-two people in this book arrived here somewhat serendipitously. After all, given the Museum's many full-time and part-time employees, I could have interviewed fifty times that number. To tell you the truth, I could have gone on forever with this absorbing task. . . .

All these interviews, conducted as conversation with questions and answers, were taped and recorded, a microphone attached to each interviewee. My wonderful colleague, Glynis Fox, made a transcript, which I then edited—maybe a dozen times or more, taking out my questions, so the resulting interview appears more fluent than normal conversation allows. (I often wish people would at least once in their lives record and transcribe their everyday conversations, to see the repetition, deviation, and sheer confusion of normal human dialogue.) Subsequently, some interviewees made factual corrections in the transcription.

Meeting these people has been the most interesting, stimulating, and rewarding of journeys. The time spent writing the book and living in New York has been the happiest of times. In many ways it has changed my life. It could have been any museum I chose to write about, but it was the Met, which consequently made the writing of this book a labor of love.

Acknowledgments

I would like to thank the following friends and family who were particularly, but typically, supportive during the time spent writing this book.

David Alexander. Nic Barlow. Katie Carpenter. Jackie Chorney. Chris Cleeter. James Danziger. Lucy Schulte Danziger. Jane Elwing. Amanda Evans. Glynis Fox. Karen Geary. Fiona Glynne-Percy. Chris Goutman. Lasse Gunnerud. Peter Hartley. Sarah Hopkins. Robert Jenkins. Charlotte Kennedy. Rupert and Charlotte de Klee. David Kohn. Caroline Lees. Kirsty MacArthur. Tina Mackenzie. Keith Makepeace. Scott Mason. Marcia McCabe. Monica Meling. Helena Moore. Robin Morgan. Ann and Don Parfet. James Presser. Sandra Rossdale. Derick Thomas. Aimée Troyen. James Wilmot-Smith.

I would also like to thank all the people at the Met who were so kind and generous with their time and help.

Finally, Georgina Capel, Michael Carlisle, and Wendy Wolf, without whom this adventure might never have happened. And I'm very glad it did!

Contents

MUSEUM

Juan Aranda

"I'll have the sweetest dreams . . ."

The Met is a clean machine. A battalion of cleaners spring-cleans the place every evening, and a roving team of plumbers, joiners, and electricians patrols constantly during the day. Before coming here, Juan Aranda worked in a factory making cummerbunds and bow ties, but it is clear that that activity was not nearly so important to him as his work here.

I'm from Honduras originally. I was born and raised in a little village right on the beach in the north, where the women worked in the field and the men were mostly fishermen. I emigrated to the United States in 1968 and started work at the Met on August 3, 1970. Coming from a different country and different culture, I found America hard at the beginning, and the language barrier was very difficult to cross. I speak Spanish and a dialect called Garifuna, which is very different from Spanish. But I practiced English every day in the Museum, so my English got a little better.

I am a maintainer in the cleaning department and also assistant to the supervisor. Right now we have three shifts of twenty people. We don't touch the art at all; there are technicians to clean the art. We clean the public areas after the public has left. Sometimes the Museum becomes very messy, especially in the wintertime, when people drag in the snow. The ledges on the balcony above the Main Entrance are

the most difficult places to clean because they are so hard to reach, and sometimes you have to improvise and find more and more extensions to the tubing for the vacuum to get into all the corners.

Some days it's really hard work, but for me, coming from a poor country, I cannot complain about hard work. Actually, I enjoy the work here; the bosses and my coworkers are all very nice and friendly and respectful.

I often take a look at the art. My favorite part of the Met is the American Wing because the galleries are so different from the rest of the Museum. And my favorite painting of all is *Washington Crossing the Delaware* because it looks so real. I visit it every chance I get.

I am proud to be a citizen of this country, and I am now quite Americanized in my way of living, because I am glued to the TV all the time. But I'm proud to be Honduran too. I haven't forgotten my roots.

In fact I intend to retire there. I have a house that sits on a very big piece of land, not far from the beach, with four bedrooms, three rest rooms, a kitchen, and a living room. It's very comfortable, and it's all fenced in, so it's very private. Also, I have avocados, mangos, oranges, papayas, plantains, which are like bananas, growing on my land. Oh, to me that place is like paradise. I invested all my money to buy that property; that's what I worked so hard for. I couldn't have done it if I hadn't moved to America; I probably wouldn't even own a TV.

Everything I have, everything I own, I owe to this country and this Museum. Everything. I came to this country poor but determined to make an honest living, and I have accomplished that.

All the time I tell my coworkers, "Anybody willing to come to Honduras is welcome." My house is so comfortable, it's like a hotel. You are welcome too, Danny.

It won't be long before I'm there. I can't wait. In Honduras I can walk in the street and not worry about somebody coming behind me to rob me, and at my place you don't hear the ambulance sirens, you don't hear police sirens, nothing, it's so quiet. I can hang my hammock in the yard and not worry about somebody coming to mug me, so I'll have the sweetest dreams. And that's why I call it paradise.

John Barelli

"They know we mean business . . ."

Barelli is the sort of man you would want behind you in a crisis. Calm, cool, and collected, he projects authority and integrity.

I was brought up in the Bronx, a big, hectic, close Italian–American family, three sisters and two brothers. It was a hardworking community without any drug or race problems. Everybody worked hard and went to college and got advanced degrees; I have a Ph.D. in criminology from Fordham [University].

My mother was very art-conscious. When I was still living at home, we went to the *Mona Lisa* exhibition. I remember it was a cold day in February, thousands of people were stretched down Fifth Avenue, waiting in line, and eventually we got a glimpse of the *Mona Lisa*. That was my first time in a museum, and it was the Met. I loved the arts ever afterward.

After I graduated from high school, I traveled through Europe with a backpack and hit all the museums, and oh, God, I enjoyed it. The highlight was Florence, where I stayed for two weeks. The greatest thing I saw was *Perseus with the Head of Medusa* in the Loggia dei Lanzi. I was awestruck, it was so huge.

Because I had read the autobiography of Cellini, I had to go see the Annunziata Church up near the Academia. It was empty,

absolutely empty. I was getting pretty good at my Italian at the time, so I said to the sacristan, "*Vorrei vedere la tomba di Benvenuto Cellini* [I'd like to see the grave of Benvenuto Cellini]." He took out a bunch of big skeleton keys and opened this big door, and there, right in the floor of the chapel in the Cloister of the Dead, was Cellini's tombstone. "*Grazie, grazie* [Thank you, thank you]," I say. "When you have finished," he says to me, "lock the door, and put the key back." And he leaves. So I am there all by myself, and on the wall are these beautiful wreaths made out of bronze, and I am thinking, "I can't believe this. The opportunity to take these things is amazing," and I always think that started my interest in preventing crime.

I went to the University of Richmond on a football scholarship and had a very good career; I was defensive tackle and captain of the team in my senior year. I had pro offers, but I knew I was too small. I was only six foot and about 205 pounds.

My passion was law enforcement, and I wanted to join the New York Police Department. But there was a freeze at the time, so I became a cop in the city of Richmond. But as an Italian down South, I found it very hard to move up, so after three years I came back home and got into the private security business and was director of security at the [New York] Botanical Gardens, until I came here.

I started as an assistant manager, working the graveyard shift. My very first night I came in at the main door and saw these two guys playing chess in their pajamas. Well, I stopped that right away, and we raised the caliber of guards. The thing I'm proudest of is that from 1989 to the present we have not hired anyone with less than a college degree, and we tell them, "You could work your way up in the organization with your background." In fact, we've had two guards who became curators, Ken Moore and Kevin Avery.

I'm now the chief security officer at the Museum, and I protect the collections, the staff, and the complex. We run a very big operation; we have over six hundred people assigned to the security department. We have very strict discipline, and if you are not following the rules, you're out. The whole system works on a team concept, because if you're not where you should be at a certain time, then someone else can't be where he should be, and the whole domino effect then occurs, and we become vulnerable.

I have a communications center that is probably the best communications center of any museum, with cameras and alarms, and the people who run them are all computer whizzes. We also have a very good plainclothes detail, who we disperse throughout the Museum, and they do very good work preventing things from happening. Also, there are certain specific areas which are vulnerable, a piece of art that is not under a vitrine, say, where we have to be extra diligent in our observations, and we handpick the best people to be there. We are subtle, but we are strong.

We also use our observational skills and experience to predict where there might be a problem. It's often the obvious. Someone dressed to look like a homeless person could be trouble, *this* person coming in is drunk, *that* person's talking to himself, or we might get kids who are unruly, and we may follow them to make sure nothing happens. We work very hard at taking care of situations before they get out of hand.

The stakes are higher now than they've ever been. Somebody damaging something seems mundane today; now it's people wanting to blow you up, and that's absolutely serious. Our guards at the front door are schooled to pick up on the profile of a terrorist. We look for anything that looks suspicious: people who are nervous, people who are sweating or wearing a lot of coats when it's not cold.

But I have got to tell you, although we deal with the negative side of things in the Museum, anywhere from four to five million people come in every year, so the amount of bad apples, whether employees or visitors, is absolutely tiny.

That's partly because when people come into this Museum, they see my security staff, and they know we mean business; they know if they do anything here, we are going to react, and they're going to be taken care of.

My special officers at the doors can be armed—basically they have police powers. Otherwise we don't carry a weapon unless we need to; our weapons are in a safe. But we will use our guns if we have to. We want criminals to see we have some power; we don't want a person, especially at night, trying to break in and hold us up because they think we are unarmed. If they know we could be armed, they're not going to mess with us. During 9/11 we beefed up, and I armed everybody for a couple of days after.

When we have something big going on here, the NYPD will assist us any time we need them; we have a hotline right into the precinct from our command center. We are also hooked right into Homeland Security, and they send us e-mail alerts. Just the other day they sent us info about a new weapon they had found which looks like a cell phone but is a plastic gun which uses bullets or .22 shells.

We have six hundred guests coming on Monday night for the St. Catherine's Foundation, including George Bush, senior. The borough is going to give us a detail out front, and we have devised a security program to coordinate the dignitaries coming that involves people from the security department, police department, FBI, and Secret Service, and there's surveillance too.

We've had many events like this before. The Millennium General Assembly of the United Nations was in September 2000, and

Clinton invited every single head of state here for a reception. The whole leadership of the world was here, 160-something heads of state. We worked on security with the Secret Service for six months. One of our concerns was someone renting a small plane and crashing it into the Temple [of Dendur] and this was the year before 9/11. It was absolutely mind-boggling to see all the heads of state from every country in the world lined up waiting.

It reminded me of a time in 1981 when Mayor Koch was honoring the Egyptian head of state. Anwar Sadat had the most unruly security group with him. They were actually taking people and throwing them aside; it was unbelievable. That was in August, and in October those same guys killed him.

There has never been a serious break-in at the Met, like the Murph the Surf case, when Jack Murphy went through the roof of the American Museum of Natural History and stole the Star of India ruby, plus some other gems, and made his escape across the park. He went to jail for some time, but he's now down in Florida, where he is a preacher.

We have had a couple of small thefts over the years, usually something that wasn't secured properly; if you put something small and valuable on a pedestal, somebody will try to take it. Mostly they were internal; somebody had the opportunity because he worked here. For instance, a worker stole half a million dollars' worth of early Christian jewelry; he broke open a case and took fibulae, pins, brooches, and Celtic coins. But we caught and arrested him quite soon after, and I got it all back. He was given probation because he had never got into trouble before, and he is a now a doorman on Park Avenue.

Everyone comes to the Met. I've met every single president since Nixon—I met his daughters; both of them are very pretty—Carter, Ford, Reagan, Clinton, Bush senior. I haven't met Bush junior yet, but I've met his wife, Laura, a number of times, and I've met Prince

Charles and Lady Di, which was quite something for a boy from the Bronx like me.

Well, it's been twenty-five years of my life, so you can guess this job is very important to me. It's such a great institution. In the security business there are very few places that are more important than this to secure, and when you tell people you are in charge of security at the Met, they're most impressed. It's a bit of an ego trip, to tell you the truth.

Carrie Rebora Barratt

"Jefferson, in a heartbeat . . ."

She has just come back from training for a triathlon when we meet. She dresses in a bohemian chic fashion, quite unlike most of the curators. She gives little away about herself, but her passion for American art is as clear as a bell.

My field is early American painting. I am responsible for American art before the Civil War, and one of the earliest paintings I look after is from 1729, which is about as far back as the Met goes in American painting. It is a portrait of a Mr. and Mrs. Francis Brinley by John Smibert, who was born in Edinburgh and trained in London. Francis Brinley is a big, fat young man seated with his hands intertwined over his belly, with the town of Boston behind him, while his son and beautiful wife, who looks like a Madonna, are sitting under an orange tree, which bears fruit and blossoms at the same time.

We play a game here where we ask, "If there were a fire and you had to grab something, what would it be?" The paintings I would be heartbroken to lose are a collection of portrait miniatures, of which we have over seven hundred. My emotional attachment is huge. For the most part, what we show in the American Wing and throughout the Museum is very high end. Schoolchildren always want to know

"Who could buy this?" And the answer is, uniformly, the wealthy, the affluent. But with the miniatures there was a middle market because they weren't that expensive.

They were painted from about the 1740s and continued until photographs took over. They are painted with incredible realism in watercolor on a slice of ivory tusk that's flattened and formed into a little oval and then encased in a bracelet or brooch as a keepsake. They are heartbreakingly intimate, sometimes with locks of hair captured in the back of lockets.

Contemporary guides to behavior instructed how to sit for those portraits. The ideal female posture is erect, poised, and composed; showing "a pleasant countenance" is what they would say, although women wore corsets, so they *had* to sit up straight or they wouldn't be able to breathe. Children were often posed with pets, boys with squirrels, and little girls with birds on their fingers. Very few are smiling, and no one is laughing, so no teeth were shown; any kind of exposure of the inside of the mouth was considered offensive, so it was better to keep your mouth closed.

However, if you look at our Thomas Sully portrait of Queen Victoria, which is an immense full-length portrait, you can see her teeth because even at rest, Sully said, her lips never closed, and she had these little teeth that always showed. In his diaries he noted that she was absolutely charming, and very shy, and that she came to the sittings with her dogs and ladies-in-waiting.

He painted her at Buckingham House, as it was then called. You would expect the composition to be very regal and formal, but it is not at all formal. In his picture she is walking up some stairs to the throne, literally ascending to the throne, looking back over her shoulder—it seems as if someone had just called her name. Of course, no one would have yelled out, "Hey, Victoria," and if

someone had had the gall to call out her name, she would never have looked back.

For the most part, painters who worked in America in the early eighteenth century were English and had been trained in London. In a good English portrait studio there was a master who would paint the head and the hands, and then there were drapery painters. Many of those drapery painters went to America, where they would paint the entire picture, which meant that although the clothing is extraordinary, the faces are not very compelling, and the hands are not at all well drawn.

John Singleton Copley, who started painting in the late 1750s, was the first American painter—he was born in Boston—to pull it all together, because he could paint faces too. He just came out of nowhere, like a phoenix. He was incredible. Today he would be a celebrity portraitist.

Copley's paintings are canonically American. He painted every-one of importance at that time, the most tried and true of Ameri-cans, although he painted them so they look British. In Copley's painting of Paul Revere, Revere looks just like the man who is now on the label of Sam Adams beer. He is seated at a worktable, he has his shirtsleeves undone, the buttons are open at the front of his shirt, and he is not wearing a wig. He is very much a man at work.

Probably our best Copley portrait is of Mrs. John Winthrop; she's an elderly lady, sitting at a tea table, holding a sprig of nec-tarines still on the vine. It's beautifully painted, there is reflectivity in the piecrust table at which she sits so you can see the reflection of her hands in the table, and he captures the costume brilliantly. Plus, there is a lot of character in her face, which is what he was known for.

Another of my favorite paintings is of a woman named Mrs. Jerathmael Bowers. The only thing about this painting that is unique to her is the face; the entire rest of the composition is from a print after a portrait of Lady Caroline Russell by Sir Joshua Reynolds, which Copley has copied: the dog, the furniture, the Turkish dress, the plants, the landscape. It is as if Copley just put her head where someone else's should have been. Mrs. Bowers would have entered his studio, and he'd have shown her a whole portfolio of prints from which she could choose a dress or a background or a prop. It was like a party game. You could concoct your own scenario in the painting by looking at Copley's book of prints. . . . "I would like to be painted with *this* dog, and *these* flowers, wearing *that* dress." He knew that his colonial clientele wanted to be painted as English aristocrats, and he gave them that opportunity.

We have eight or nine of Copley's great colonial paintings here, including a dear miniature self-portrait that he painted for his wife. It shows he was very sexy, swarthy, with dark features, dark hair, dark eyebrows, and extremely well dressed. In fact, he cared deeply about clothes, and when he wrote home from a European tour about the paintings he'd seen, he also wrote about the tailors he had been to and details about a red velvet suit he was having made. Of all the miniatures we have here, it would be the self-portrait of Copley I would want for myself; it really is the best. I could slip it in my pocket and be very, very happy.

Gilbert Stuart, who is best known for his portraits of George Washington, was born twenty years after Copley. He went to London to train; he was there for about thirteen years and five years in Dublin. In 1793 he came back to America. The story is that he would have gone to Philadelphia, which was the seat of the government at that

time, but when he got to the dock at Dublin, he found out that there was a circus on board and decided he didn't want to be with all those horses and jugglers and acrobats, so instead he took a boat to New York, where he painted for eighteen months.

Stuart's pictures look deeply into character, down to the soul, some people say. One of the reasons he captured character so well is that he was a great storyteller. He liked to talk, but more important, he got his sitters to tell stories back, and as soon as people started talking to him, that was the moment when he felt he could capture them and start painting.

When he went to see Washington for sittings, he said Washington was like Morpheus. He would not crack; he was like a stone. He tried everything, every topic of discussion, and finally hit upon horses, and that's when Washington became animated, and they were able to talk about horses together.

The first painting he did of Washington is called the Vaughan Portrait; Stuart had got a subscription list of sixteen gentlemen who said if he painted portraits of Washington, they would buy one, and the first name on that list was a man named John Vaughan, a Philadelphia merchant, a very handsome man (his portrait is in the Fine Arts Museum in Houston), who commissioned two portraits of Washington, one for himself and one to send to his father, Samuel (who lived in London). Samuel's version is in the National Gallery in Washington and is called the Vaughan Portrait.

Washington died in 1799, but Stuart continued to paint portraits of Washington for the rest of his own life.

Washington was a difficult subject for an artist. People said his composure on the battlefield was extraordinary, and that comes through in paintings of him. You look at Washington, you see a mon-

ument of a man: general of the Continental army, the first president of the United States. He had no choice but to be a monument. The flip side of that was that he was a man of great passion.

I would not be so eager to meet Washington as much as Thomas Jefferson; oh, it's got to be Jefferson, in a heartbeat. I think he was fabulous. From the paintings you can see that Jefferson was someone who was fully engaged in the process of sitting and talking and understanding what it meant to sit for a portrait. Thomas Jefferson was very tall, thin, handsome, with striking, chiseled features, a very distinctive jaw and aquiline profile.

He was a man of great passion. He had a great degree of knowledge and very wide-ranging interests, including history, wine, and painting. He developed a list, what he called his *Desiderata,* which were things he would like to own, things he would collect for his home in Monticello. And he found most of them, weird things, various implements of Native American manufacture, sculptures and paintings by certain artists.

George Caleb Bingham was a very ambitious painter. Bingham was painting in the St. Louis area for a New York market, people who wanted to think of the West as a rural, underdeveloped idyll; there was already a nostalgia for that way of life. *The Jolly Flatboatmen,* which is in the National Gallery of Art, depicts the joyous life of the riverboatmen on the Missouri, dancing on top of a riverboat. Whether or not there were boatmen who were jolly in real life, jumping on their flatboats as they went down the river, is open to question, but with the men in pink shirts and the beautiful luminous water, it is very agreeable to look at.

The Jolly Flatboatmen is very in your face: happy, happy life on the Missouri. An even better picture than that is *The Fur Traders*

(here at the Met). This picture is very serene, perhaps a little eerie, and rather mysterious. When you look at the picture, you're not quite sure what's going on. You don't know what the relationship is between the man and the boy. They are going to market in a canoe with their furs, and they have an animal on the prow of the canoe, but it's unclear whether it is a pet or a captive or even what animal it is. I think it's a bear, and I recently learned that bear was a delicacy in the river towns along the Missouri, so he's going to be eaten; he's food.

One of the most famous paintings in the collection is *Washington Crossing the Delaware*. It is on so many brochures and membership leaflets in the Museum that it's like a celebrity who is overexposed, you know, like we say Jennifer Aniston should stay off magazine covers for a while because we see too much of her.

It's such an icon that it's hard to understand it as a painting. It crosses patriotism and mythology, and its sheer immensity and power make it very hard to understand in a chronological context. We are trying to figure out how to make the painting more meaningful. We're planning a major renovation of the American Wing, so we have it in mind to install it with two other immense paintings that were done at about the same time (the mid-nineteenth century) and show it not just in the context of Washington and the American Revolution but of patriotic sentiment in America in the pre–Civil War period.

It's just spectacular in the way it captures a historic event on a very large scale, and it is beautifully painted. The artist, Emanuel Leutze, was born in Germany and studied in Düsseldorf, and it is a perfect example of what some people call Düsseldorf training, which is a very minute presentation along with historical accuracy.

Of course Washington was dead when Leutze painted it in 1848, but Leutze got the very uniform Washington wore from the Smithsonian and had a friend model the uniform so he could get it right, and he researched the kinds of boats that would have been used. He makes it look as if he were on the spot; if someone said here was a painter who had seen this event, you would almost believe it.

Nevertheless, Leutze gets the weather wrong. It was winter, but there would never have been icebergs in the Delaware River. Historians say that the boat is going the wrong way, and there were no horses in the boats. There are too many men. Some of the uniforms of the men are from mid-nineteenth-century uniforms, and details of the flag are incorrect; the flag he copied was not in existence at the time Washington crossed the Delaware. He gets Washington pretty well right, although Washington never stood in the boat.

One interesting footnote: when the painting was almost complete, and Leutze was getting ready to ship it to America, it was burned in a studio fire—gone, completely destroyed—and he started it all over again. So this is the second one he painted, which is just mind-boggling.

It was hung first in a New York gallery, and then it went to Washington, D.C., where it immediately caught on. The painting was feted across the nation. This was an era when there were lots of revolutions across Europe, and fifty years after his death Washington had become this mythological, monumental hero bar none. He epitomized the kind of hero that in some ways we are still looking for . . . If only we had a president like Washington now. It's an incredibly nostalgic vision of what America was about at a time when America might not have known what it was about, just as a country never does in the moment.

Leutze went back to Germany and continued to paint phenom-
enal history scenes. But this was the climax of his career, and he
never got past it or did anything greater, which is not to say he fell
into disillusion; he was quite successful, but he just never painted
anything quite so grand again.

Michael Barry

"I have seen the terrible things that human beings can do to one another . . ."

Barry has been in his position less than a month when we meet. It is late in the afternoon, he has a cold, and he has to get home to his wife, but selfishly, we stay talking for hours. Certainly his elaborate ritual of making industrial strength coffee steals some of the time, plus his insistence that I be introduced to each member of the department, all of whom are clearly already fond of their energetic, slightly manic boss.

My father was an American captain who was in the second wave into Normandy in 1944. He discovered Paris, discovered French culture and Europe, and chose to stay in Paris for practically all the rest of his life. That is the reason why I grew up in France and my brother and I speak French with one another and with our spouses. We are about as Francophone and Gallicized as Americans can get.

I was always very interested in the arts, in theater, in history, in Greek and Latin, all these romantic things, but it all felt very explored and familiar, and I was keen to try my claws on something a little more pioneering. And when in my teens I found out that a very good friend of my mother's had married an Afghan prince, I jumped

with joy and said, "I want to go there," and they invited me. And so during my summer vacations I discovered Afghanistan, which sparked my life's vocation.

Kabul in the early 1960s, before any paved roads, before any tourists, was the Tibet of the Islamic world, and it excited both my sense of adventure and my sense of intellectual curiosity. Afghanistan, before the Soviet invasion, still looked like what most of the world had looked like before World War I: markets, petrol lanterns, animal transport, bearded farmers driving bullock teams, glorious nature without telephone wires all over it, without roads or motor vehicles. I was fascinated at the idea of being able to live for the very last time a way of life that had prevailed for hundreds of years and was about to disappear forever, but really one felt not so much an exoticism as a sense of extraordinary normalcy, that this was what until very recently all of us lived, experienced, and took for granted.

I was interested in archaeology and in old artifacts, and I was also very much interested in the artistic expression of Iran and Pakistan on either side of Afghanistan. But Afghanistan continued to attract me because it always offered me the possibility of saddling up and riding off into the desert with my nomad friends and watching the eagles fly through the sky, and I craved this powerful desert experience. The deepest, profoundest experience was one of quite simply getting on a horse and riding for a week to a nomad friend's camp and then riding back for another week to a market town and just living that pace of life.

However, as I was returning nearly every year, I was becoming increasingly aware of the social, political, and economic tensions of a country that was being subjected to the first wave of modernization which it could no longer stave off, nor did it really want to. I was witness to a horrendous famine in 1971 and '72, which corresponded

to a belt of famine around much of the world. It revealed the corruption of the royal officials and the dysfunctions of the society. Very stark differences in revenue and earnings between the wealthy few and the poorer majority were becoming apparent, and things were beginning to crack. Revolutionary ferment was in the air, both Marxist-Leninist and Islamist, and I had to pay more and more attention to these tensions. I could no longer continue to fool myself that I was in Shangri-la.

As the famine got worse, I saw the nomads starving, I saw the peasants starving, and I just couldn't stand it. So I went to Kabul and eventually landed a job as a consultant to USAID to deliver wheat, flour, horses, and camels to all those areas of a country that were inaccessible to traffic but I knew so well.

That resulted in the awakening of my political consciousness, and I began writing about Afghanistan, and I predicted a revolutionary situation. Then I went on with my academic studies.

But a pro-Soviet military coup was carried out in Kabul in 1978 to 1979, and people I knew began disappearing into concentration camps and being tortured to death or being shot, and at that point I came to a terrible decision, which made my newly wedded wife most upset. I felt that it was simply unfair of me to take refuge in twelfth-century archaeology or fifteenth-century painting and turn a deaf ear to the screams of pain I was hearing from this country. Afghans are no more special than any other people on the face of the earth, be they Tibetans, Cambodians, or Rwandans, but I felt a responsibility to that group of people because I spoke their languages, I understood their pain, and if I didn't respond to that, then I was no sort of human being at all.

I sacrificed the world of art and literature and my academic career to serve as a humanitarian officer and to do everything I could: to

deliver food and medicine, to defend human rights, to bear witness, to contribute in any way I could to end the horror which turned Afghanistan into another twentieth-century laboratory of the worst kind that human beings are capable of. As far as I am concerned, I have seen my Auschwitz and my Khmer Rouge. I have seen the terrible things that human beings can do to one another. I have helped recover the bodies of people buried alive with bulldozers. I have taken care of torture victims and watched them twitch in their sleep, because they were reliving in their dreams the torture they had gone through. I simply felt that humanitarianism was a duty from which I could not walk away, or otherwise I would never be able to live with myself. Of course it was an economically disastrous thing to do, and academically it delayed everything, but I just had to.

But a streak in me has always been a little suspicious of pure humanitarian work because the mental trap into which you fall as a humanitarian is that you end up professionally dependent, even mentally dependent, on your own victims; you need victims to take care of in order to justify what you are doing in life. That made me a little uncomfortable, so I decided to keep a part of my mind as an inner citadel. I continued to study academic and literary subjects in order to preserve a sort of psychological independence from this work, and I continued very conscientiously to read Latin and Greek, to study classical Arabic, and to see what I could come up with in terms of research and finish a Ph.D. I used to eat up hours of the night poring over all these tomes. Even when out in the field, I always had something to decipher in my saddlebags.

I am happy now that Afghanistan is on its way to, well, partial reconstruction and recovery. It's an American protectorate now, but after the Soviets and the Taliban this has proved better, at least relatively; there is no serious comparison.

I went back with a vengeance to the academic world. I applied for a job at Princeton University, which I got, and while I was in the middle of my Princeton lectures, the director of the Metropolitan Museum called me, and I was flabbergasted to be offered the job of head of the Islamic Wing. I took a night to think about it, and accepted.

I think the presentation and the understanding of Islamic art have been lopsided. There's a divorce between the people who are looking at the art and the people who understand the texts, the literature, the philosophy, and the mysticism, so they aren't making a connection between the two. As a consequence, Islamic art is treated with something like indignity and downgraded to archaeological curiosities or decorative amusement; *this* archaeological piece or *that* decorative sample is not being integrated into a vision of the civilization as a whole, the way we look at Byzantine art or Mayan art or ancient Egyptian art or any art on the face of the earth. With Islamic art we are left with one of the great orphan art forms of the world.

Part of the blame lies with the Muslims themselves, whose traditional civilization began disintegrating in the eighteenth century, and so the key was lost. Part of the fault lies with the Westerners who didn't feel any real need to engage with the thoughts, the literature, the symbolism, or the religion. So I am trying to the best of my ability to bring together these two strands of the visual and the intellectual and to make this art tell its story from within.

We have been very good over the last century in connoisseurship of art, in assigning the art to this dynasty, to that city, and even sometimes to this particular craftsman or painter. But the mood of Islamic art, the essence of what it is trying to express, I felt had remained in abeyance. With the reorganization of the galleries here at the Met, I aim to give to this art the same dignity that is accorded to the artistic traditions of every other civilization. These artists were wrestling

with the profoundest concepts and yearnings of their own civiliza-
tion and trying to give these the finest possible expression, and the
greatest treasures of the Islamic world between the fifteenth and the
seventeenth centuries we can truly put on the same level, both artis-
tic and spiritual, with the Italian quattrocento and the Dutch seven-
teenth century.

In seventeenth-century Dutch art, to take an example, we accept
that a painting by Vermeer and a painting by Rembrandt are intrin-
sically more meaningful, more significant, more charged with emo-
tion, and ultimately more beautiful than even the finest Delft pot.
We recognize this kind of hierarchy because we know that Rem-
brandt and Vermeer were struggling to express the deepest tenden-
cies in their civilization, and we respond to this, we take it seriously.
No such hierarchy yet exists in our appreciation of Islamic art, so we
put on the same pedestal a kitchen pot and a manuscript illumina-
tion where the artist has sought visually to express the profoundest
allegorical symbols of his civilization.

The galleries here are closed for three years, which is a very short
time, considering we have some twelve thousand pieces to organize
and reorganize, and things are scattered about the Museum, so we
have to scavenge for them. But there is an extraordinary mass of
material, some of it sublime, ranking with the best to be found any-
where in the world. For instance, this Museum possesses one of the
most important books in all of Islamic civilization. It is a manu-
script, copied in the late fifteenth century for a king of Herat, of
one of the single most beautiful mystical poems in the Persian lan-
guage, called the "Parliament of Fowls," in which all the birds sym-
bolize different souls on their way to meet the divine, who is figured
as a great phoenix in the east.

One thing that we're going to get away from is the disastrous

nationalist-minded ethnocentrism that has characterized the twenti-
eth century and seems likely to stay with us in the twenty-first. We
are not going to label *this* art as Spanish-Arab art, or Syrian art, or
Turkish art. We're going to steer clear of that. We will emphasize
the capital cities of princely dynasties, where artists from all hori-
zons congregated and created a distinctively regional school, so that
the viewer will walk through these Islamic galleries with the feeling
"I'm coming to Damascus, I'm coming to Isfahan, I'm coming to
Delhi," as a journey. Or in the other direction: "I am going to Is-
tanbul, I am going to Cairo, and I'm going to Granada." And this
will be an experience that will be almost impossible to replicate
anywhere on earth, because we are bringing together an ideal Is-
lamic world and the best of its art. It will be fabulous.

Robert Bethea, Jr.

"I have this sort of unreal life . . ."

There is no one person more visible in the Great Hall than Bob, who has sat at the Information Desk for nearly three decades. He is a big man, so he towers above most of his colleagues, but he is gentle and unfailingly courteous, and of course his soft, slow Texas accent is immediately calming to frazzled visitors.

My mother was the assistant dean of women at the high school I attended. We traveled in to school together, but she needed to get there about half an hour earlier than I did, so every morning I would stand in the middle of the Great Hall and talk to people as they came in. It was just what I did. And I'm doing it again at the Met. I've been here thirty years, so I've sort of been doing it my whole life, and it's still compelling; it just suits my nature.

I'm at the Information Desk, so I talk to the public as they come in. They could ask directions of a guard or an admissions person, but people seem to feel it's easier to stand and have a bit of a conversation with me, although obviously I can't talk to anybody too long. I can help people find specific works of art or lay out a whole plan for a visit to the Museum. Often someone will be so moved by the experience of being here that he wants to say something to someone afterward. All the time people will stop on their way out the door

and say something like "I just had to tell somebody what a great place this is."

I also see anybody who has had a bad time, because anyone who has a problem is automatically sent to the Information Desk, and we have him fill out a comment form and discuss the problem. Maybe somebody will be angry because the gallery he came to see was closed, or he felt he was treated in an impolite manner by a guard in the checkroom or a salesperson.

A few times a week someone will come up who is incredibly rude, just blatantly offensive, which still kind of surprises me. Sometimes you'll realize that he does this everywhere he goes. He knows exactly what he's going to say; he's playacted the same scenario over and over, whether it's in a museum, a restaurant, or a theater. He likes doing it; it excites him. Moreover, he knows that at a lot of places you get all this special treatment if you're upset and angry. I certainly try to fix the situation, but I'm not one to make huge, magnanimous gestures of apology for someone who doesn't deserve it.

I feel most in tune with a visitor who is a serious visitor to the Museum, you know, someone who is here for a purpose, who is willing to invest his time and his intelligence and his imagination in what he's about to see. For one reason or another, many people who come here are seeing art for the first time, and then you feel like maybe you're in at the beginning of someone's cultural realization or some kind of a new beginning for a person, which is very exciting.

I deal with such a number of people that I can't help but do character studies. The Japanese people are wonderful; the Japanese seem to be the most gracious, the most well mannered, and the most enjoyable to help. The Brits are certainly awfully polite. I like them, and they all say "brilliant" at the end of the conversation, which amuses me. Germans are precise, they really are, and they

certainly are on top of their visit, not that there's anything wrong
with that.

Everyone's sort of embarrassed by his own kind. New Yorkers
hate someone with a strong, obnoxious New York accent making de-
mands, and Southerners hate people seeming dumb and stupid. I'm
from Texas, and of course the people who embarrass me the most are
the ones from the South who just say or do or ask outrageous things.
One time this man came up—I don't think he was a Texan, but he
was from somewhere in the Deep South—and he said to me, " 'Scuse
me, sir, where can my wife shake the dew from her lily?" Things like
that make me cringe.

I love ballet. I go to as much ballet as I can. I have a lot of friends
who love dance as well, and I'm a good partner at the ballet, so I get
a lot of invitations. Ballet is like a painting come to life, only better:
you can hear it, and you can see it. For me, the Balanchine patterns
are amazing, and I leave the ballet feeling centered and inspired.

When 9/11 happened, I was at the Information Desk; we stayed
on a bit longer after the Museum had been evacuated, and then I
went home and watched the clip of the planes going into the build-
ings. But after that, I turned off the TV, and I had this great record-
ing of *Swan Lake*, and I watched *Swan Lake* that night, and it was
wonderful. In fact I could see *Swan Lake* right this minute and love
every minute of it. Dancers are better now than they ever have been,
and the quality of dance just continues to improve so much, and you
think it's got to stop somewhere, but it just grows and grows.

Do you know what Stendhal Syndrome is? I first read about in the
seventies. It is having a big, emotional reaction to works of art. I com-
pletely have Stendhal Syndrome. If I see something that's really beauti-
ful, I will just start weeping, and it's not uncommon for me to be sitting
quietly in a ballet and have tears pouring down my cheeks because it

has moved me so much. And I can do that in front of a painting, and music will do it too, especially certain chord progressions, like from a C to an E flat, which will trigger that reaction in me.

I have this sort of unreal life. I don't read the newspaper, and I don't listen to the news. Some things you can't miss, but I never purposely read or see anything about the war. I just isolate myself from anything that is unpleasant. I have one friend who is very into current events, and he's going to call me if he ever thinks I need to leave New York. That's our agreement. If things get bad and I don't know it, he'll call me, and then I'll leave. I know not everyone can be as irresponsible as I am but I allow myself that luxury. In a way it enables me to deal with these huge crowds of people I meet every day, all day long, and remain calm and cool.

I'm really fortunate. I just seem to have a charmed and lucky life. I really honestly believe that I am supported and nurtured by the spirit of this Museum. This is an ennobling place. You walk into the Great Hall, and you feel bigger and grander just for being there. And then you look at the creations of some of the most talented, spiritual, creative artists who ever lived, and that's a powerful and inspiring force to have behind you.

J. Nicholas Cameron

"Fortunately I am not a spokesman for the Met . . ."

In an office decorated with various colored hard hats, Nick Cameron cuts a figure that is part architect, part construction worker, and, well, a bit hippie.

When I graduated from college, I took a lifeguard job in Darien, Connecticut. Living on the beach is great; there would be tons of people around in the summer, but from October to May it seemed like it was all mine. I had a very small garage apartment, but I bought a huge picture window, so I had a magnificent view, and every night I would watch these great sunsets. There is an awful lot of wildlife when people aren't there. Canada geese would come in the winter and walk up and down the beach, and I fed them corn, so they'd come flocking in to see me, and also, every dog in town that gets loose winds up in a place like that, so I took care of a lot of dogs too.

While I lived on the beach, I decided to further my career options, and I worked on an MBA at night. But when I got it, I had trouble putting myself in the right mind-set for a corporate job, so I started looking for unusual jobs in the newspaper. When I saw an

assistant building manager's position at the Metropolitan in the *New York Times,* I applied for it and was lucky enough to get it.

The Buildings Department then was kind of an old-fashioned department. It didn't have any modern business practices or systems in place, and it was mostly staffed with people who had an old-timey feeling about them. No one was actually a degreed mechanical engineer or really understood mechanical systems. There were people who called themselves engineers, but that was more like somebody operating a train calling himself an engineer. So when I was promoted to be assistant manager for Operations, I set about trying to restaff the department, and I was able to hire good engineering staff and get some key people on board.

Well, now my job entails building buildings or building major renovations to buildings. For example, the project on the launchpad right now is the renovation of the southeastern building, which we call Wing K. We are going to pretty much gut that building and put in this fabulous Roman Gallery installation on the first floor, and the second story is going to become a Roman peristyle, about as tall as the Grand Vaulted Gallery, somewhere in the sixty-foot range, with a very clear barreled skylight over the top. It's going to be just breathtaking.

But the progress of Wing K depends on the outcome of a pending lawsuit. I don't think it really threatens the project, but it's got to be worked through before we can get there. A certain group of neighbors across the street have become increasingly irritated over the years by the level of activity here. The thing that seems to bother them a great deal is our cooling towers. We have a very large amount of climate controls in this building, something in excess of eight thousand tons of chilled water production capacity for our air-conditioning

systems. You have to aspirate the heat someplace, so we aspirate it through cooling towers, and consequently you get these rising clouds of water vapor coming off, which we have euphemistically been referring to as plumes when we argue about them, because *plume* sounds better. Anyway, the neighbors hate the vapor because it obscures their view of the park; they also hate all the noise and commotion on the plaza, especially in the summer, when there is just a huge number of people on our plaza all the time, because it's one of the best spots in New York to stroll, and our front steps are great to sit on too, and they just can't abide it when we have big parties at night.

Our construction activities have pissed them off too. We were taking demolition debris out in steel containers, and when our garbage truck would back up to pick them up at six o'clock in the morning, there would be a lot of clashing and clanging. A few times I'd get calls from some of the neighbors, conversations which ranged from cordial, people thinking a properly placed word or two could better the situation, to enraged individuals telling me how important they were and how dare I disturb their sleep. We've managed to start a little later, so we now aren't making much noise before eight o'clock.

There are probably people who could sympathize with our neighbors more than I can and be objective about all this. My feeling is that this Museum has been here a lot longer than they have. Also, it's one of the great cultural institutions in the United States, not to mention one of the great assets of New York City, so it deserves not to be harassed by a few people who have only their own interests at heart. Fortunately I am not a spokesman for the Met, and it's not my job to be careful about what I say. I am just a guy who is in charge of building the next project.

This building has to operate at a higher level of technical capability than most buildings. For instance, we aspire to keep environmental

conditions of approximately 70 degrees in 50 percent relative humidity for the collections, which is difficult, because New York's outdoor environment is such that you can have humidity in the summer as high as 100 percent and as low as 20 percent in the winter. Works of art, like anything organic, tend to absorb moisture and swell and dry out and shrink over time, and there is movement when that happens. Wood will crack, and with a painting, if the canvas expands faster than the paint, the paint is going to crack too. So the best thing you can do for a work of art is just keep the humidity and the environment steady.

Fortunately, as institutional buildings go, this building is in very good shape. There has been a gradual understanding of the implications of trying to hold relative humidity, and every building we build is better than the last one in terms of its ability to contend with that.

We have twenty contiguous buildings in this complex, so there are twenty roofs. The roofs are ugly. I can't deny that: This place must look horrendous from the air. But there is also a strange kind of industrial beauty in them too. You can actually walk from one end of the building to the other on the roofs, which was something I used to do a great deal. I would actually take people on roof tours. But we had a very tragic accident about three years ago, when a man who was servicing the water treatment systems stepped off a parapet and fell to his death. That caused a whole series of safety systems to be installed on the roof, ropes and rails and such, and you actually have to wear a harness and hook yourself up to cables to walk around now, so it's really no fun anymore.

I definitely think of this building as something more than just bricks and mortar. I love arriving here in the morning, I walk from the Eighty-sixth and Lex subway down Fifth Avenue, and that last couple of blocks, when you can see the raking view of the front of

the Met, always fill me with wonder. You know, the United States is so modern there just aren't that many monumental-looking buildings, but somehow, the Metropolitan seems to rise above the here and now and represents something significant and substantial. And it seems like the heritage of mankind is embedded inside it.

Thomas P. Campbell

"A kind of Arnold Schwarzenegger . . ."

One of a number of English curators who work at the Met, he is always dressed in tweed and brogues, at least whenever I run into him in the Museum. If you needed someone to play an amiable earl in one of P. G. Wodehouse's short stories, Tom would be your man.

So often I find that when I talk to people about what I do, as soon as I mention the word *tapestry* I can see their eyes glazing over, and they immediately think of the needlework that their spinster aunt used to do after Sunday lunch. People nowadays think of tapestries as being these faded, dull backdrops, but when tapestries were made, they were as richly colored as oil paintings or stained glass. They've just faded with the passage of time.

One of the advantages of tapestries was that they were partly practical. They could be rolled up and carted from one castle to another, and in the time it took to hang them up, you could transform a cold, dank interior into a richly colored setting. In an age when any pictorial image was very rare, tapestries were woven pictures. They could serve as useful propaganda, where the patrons of the day could portray the mythological heroes they wanted to be associated

with, or even their own exploits, and of course they were enormously expensive, which would show off their wealth.

The European tapestry industry really got going with large-scale production from the late fourteenth century, but the really big industry through the fifteenth century was in the southern Netherlands, in towns like Arras and later Tournai, and by the first half of the next century it was estimated that about one-third of the population of Brussels was involved in one way or another in the tapestry industry.

Tapestry was the most important form of figurative art of the courts at this time. King Charles I of England was famous as a collector of paintings, but in fact he spent as much money on tapestries, and he actually set up a factory in London, at Mortlake, where dozens of weavers were working. And in spending enormous sums of money on tapestry, he was following the precedent of his great-grandfather by marriage Cosimo de'Medici and his Tudor forebears, following the convention that tapestry was the art form of kings. Henry VIII would pay Holbein three or four pounds for a painting, but he was dropping a thousand pounds for a set of woven gold tapestries, as did so many of the great magnates, enormous sums of money at that time.

There are still fantastic sets of tapestries to see, like *The Hunts of Maximillian*, for example, at the Louvre, which was made in about 1530 for the Holy Roman Emperor Charles V. At the time it was made it was the largest, most ambitious attempt that had ever been undertaken to represent the real world, with life-size portraits and accurate representation of landscapes. Each of the twelve pieces is about ten yards wide by five yards high and depicts the emperor and members of his court hunting in recognizable landscapes around Brussels. In one tableau, Charles's brother Ferdinand is on horseback

about to spear this enormous shaggy boar which is rushing at him, while all his hunting dogs, who look like pretty serious killer beasts, are slavering around him. It's very dramatic and exciting visual stuff and shows Ferdinand as a kind of Arnold Schwarzenegger of his day.

This was the period in which artists and weavers had really started to reproduce the real world in a very convincing way. You feel you could almost walk into some of these scenes.

Whereas with oil paint you can gradually mix the colors together to create a sense of volume and form, with tapestry you can't blend the colors, so any transition of color had to be created by the weavers painstakingly creating little triangles of interlocking color. It required huge skill to interweave colors to create a convincing image, and it was very slow work. For a big tapestry, you would have five or six weavers sitting side by side along a bench, with craftsmen uniquely specializing in landscapes or faces or animals, and they could weave about half a square meter each month. So it was enormously time-consuming; it could take years to make one tapestry.

In the medieval era, tapestry was like manuscript illumination or stained glass. The designs were highly patterned and often very complex in terms of narrative and iconography, but very two-dimensional. However, in the early sixteenth century, that flat-pattern style gave way to a much more pictorial, illusionistic style, partly under the influence of great artists like Bernard van Orley. And the seventeenth century saw the emergence of more grandiose designs. Artists like Rubens and Van Dyck designed tapestries, so the designs became much more theatrical, and there was great play on dark and light, chiaroscuro, and lots of trompe l'oeil. It's all great stuff.

In the early eighteenth century, people started going for much lighter style, and artists like François Boucher produced the most

fabulous, decorative, romantic, sexy designs, which were hung in all the great French houses and châteaux. We've got a lovely set at the Museum called *Fêtes Galantes*, which depict beautiful young men and women in pastoral settings, flirting or just hanging around in rich costumes under a lovely silvery sky. It's exquisite, and the colors and mood are charming.

Tapestry finally got edged out in the mid-eighteenth century by the then all-consuming obsession with oil paintings. It increasingly became an established part of an aristocratic young man's education that he go off on the grand tour to Venice, Rome, and Naples and come back home laden down with paintings and sculptures. Gradually the demand for tapestry subsided.

Then, in the late eighteenth century, what was already a weakened industry was dealt a deathblow in France when the French Revolution destroyed the clientele on which all of the great French workshops had depended. Lots of terrible things happened. Many of the great tapestries, which had been woven with silver and gold thread, got burned to melt out the silver and gold. Even great pieces that had survived from 1400 suddenly got cut up and thrown out. The famous Angers Apocalypse tapestries were used to wrap orange trees at the Angers orangerie in the château.

In the mid- to late nineteenth century there was a revival of interest in tapestry as an art form, with William Morris actually setting up a workshop in the outskirts of London in the 1880s. Contemporaneously fifty years later rich American industrial barons, like the Morgans and the Vanderbilts, were building huge houses and palaces in America and bringing over vast quantities of tapestries to decorate them. But the sad thing is that these historically interesting objects were used as everyday furnishings and exposed to sunlight and far too much humidity fluctuation, and by the time of the Wall Street

crash, when many of these collections got broken up and essentially dumped into American museums, many of them had become very faded, which is why the color and life and splendor of what was once great tapestry are quite hard to see in those tired and sad-looking things.

Although we don't have any galleries which are specific to textiles alone, tapestry is part of a very broad range of textiles that the Museum collects. We have an enormous collection. In total the Met has 37,000 textiles, which range from huge tapestries and carpets to tiny fragments of lace. The Islamic department has one of the most important collection of Islamic rugs and woven silks in the world, while AAOA (Arts of Africa, Oceania, and the Americas) has fantastic Oceanic textiles, which include all sorts of weird things, with feathers and bits and pieces stuck in them, while the American Wing collects American textiles, including quilts and all that stuff.

I'm responsible for European textiles between 1500 and 1900, which number about 17,000 objects. While every curator at the Met can say, "We have the best in our department," I can't say that about tapestries. I don't have as many buying opportunities as my colleagues, simply because of the limitations of what survives. Also, many of the best surviving pieces are still in royal collections, great houses, and cathedrals, from which they are very unlikely to be moved.

Before I arrived here, my department had not been aggressively purchasing tapestries, because the priorities of the former head of the department lay very much elsewhere. I'm not saying this as a criticism. The pattern of collecting at the Museum very much reflects the interests of the individual department heads, and Olga Raggio was a world-renowned sculpture expert and spent enormous energy and effort in building up the sculpture collection of the department over a long period of time.

But finally, we have begun to buy tapestries. About four years ago I bought a hugely expensive tapestry which comes from the collection of the Spanish queen Isabella the Catholic. It's an incredible piece, just perfect. The condition of the piece makes it look as if it were made yesterday, the colors are so strong and fresh. It shows a winged figure of Fame holding a globe with a cross on the top of it, reflecting Isabella's very strong Catholic devotion, standing on the bodies of the Three Fates, surrounded by famous figures from myth and history. It's from a set of allegorical *Triumphs*, a popular medieval theme.

While I want to buy great objects when it is possible, at the same time my goal is to draw people's attention to the importance of this medium through publication and exhibition. I do have the potential to organize exhibitions on a level that other museums simply don't have. I mean, no one but the Met could have pulled off the exhibition of Renaissance tapestry we had here a few years ago, where there were forty-five tapestries on show. The politics involved, the financing involved, the leverage, and the expertise involved: No one else has that. We bribed and cajoled and twisted the arms of institutions around the world—well, we didn't bribe, of course— but politically it was very complicated negotiating the loan of these objects, which came from the British royal collection, the Louvre, the Hermitage, the Vatican and were all just absolute masterpieces.

The tapestries that we brought together here for the exhibition were probably the most magnificent collection of tapestries amassed together since some of the great conferences of the sixteenth century, like the Field of the Cloth of Gold, when Henry VIII and Francis I met and deliberately tried to outshine each other with the greatest riches their respective countries could boast. That show, I

think, is as close as anyone of our generation will get to walking through the great palaces of the sixteenth century. And it took New York by storm.

Tapestry is such a great art form, but it's an aspect of art history that has been largely overlooked by art historians. If you pick up any standard history of European art, it's all about painters, sculptors, and architects, which is terribly frustrating, because every year great sets of tapestry are fading and falling apart for lack of attention.

Lorraine Chevallier

"Martini for table fifty-one . . ."

*Hidden acts of generosity define her working and personal style.
One morning, on her way to work, Lorraine accidentally dropped
her engagement ring along with a handful of change into the cup
of a performer singing "Under the Boardwalk" on the subway
platform. The* New York Post *ran her story and photo, and the
singer read the account in a discarded paper. He called her at work
and returned the ring, and the happy ending made a great local
television spot.*

I have a lunch job in the Trustees Dining Room, and I also work at
the Café des Artistes at dinner, so between them I see a lot of
movers and shakers of the world.

I think I'm a really good waitress. Certainly I try to be as good as I
can. I truly want my customers to enjoy their stay and come again.
My philosophy in life is that everybody needs to be loved. That's the
bottom line, and I try to bring that to the table. Not everybody wants
to interact; all they want is food. Some people have horrendous aller-
gies, where they can't eat nuts and butter and cream and sugar, so I'm
very careful to listen to their laundry list of can't haves, but most of all
I try to do what I can to make their meal more pleasant and to make
them feel like somebody cares about them, even for that brief period

of time. I guess it's just a Christian thing, where you're supposed to do unto others as you'd have them do unto you. In turn I would hope that God looks kindly upon me and my life.

A lot of people's behavior is governed by needing to feel important, and as a result they need to kick us around a little bit to show they're top dog, and when we kowtow and acknowledge that they're alpha, and we're not going to give them a problem, then they calm down. I don't know what it is, maybe they've had trouble at work, or maybe they've had several martinis too many, but I try to remain open and be kind and understanding.

I'm a pretty good judge of people. When I wait on a couple who are on their first date, I look at them and think, "*You* should be together," or "You *shouldn't* be together," just from the way they treat me and the busboy, because I find if people are nice to us servants, chances are they are kind, giving persons all around. The funny thing is, I can never tell what sort of tip someone will leave. You'll think, "I've barely spent any time with this person," and then he leaves a huge tip, and the people you bend over backwards for, it's very average.

People often ask me how I became a waitress. Well, I always considered myself a singer. I was talented very early on, and so I went to college in the city and majored in opera. But I did not like the course at all, so I didn't complete it. My parents had supported me while I was in college, but once I was out, I was on my own, and it was kind of: What am I going to do now? I had a friend who was a flautist, and she worked as a waitress, and so I started doing it too, and I've been doing it ever since, which is twenty-five years now. I'm forty-seven, and people ask me, "What do you really want to be when you grow up?" And that's kind of where it is at. If you'd told me all those years ago that this is what I'd be doing, I'd probably have slit my wrists.

Physically this is a very difficult job. I'm up at 6:30, and I never get home before midnight; sometimes it's more like two in the morning. I was pregnant until nine months both times at work. I carried trays and lifted heavy things, although on the plus side it probably kept me leaner than I would have been at home, eating bars of chocolates and reclining on a chaise longue.

I try to divide up the day to make it seem less long. *This* is my train time—I have an hour-and-forty-five-minute commute—*this* is my subway and bus time; *now* I'm here at the Museum putting on this uniform, and then I change and go across the park to the café, and put on another costume, and am with another group of people. I often feel like an actress going onstage.

There's a big element of "The show must go on." For instance, my father has been in and out of hospital for weeks now; he has a terrible heart. Yesterday I called him, and he was very badly off. "They can't do anything for me," he said. "In thirty years they have made no advances with this kind of heart condition." He's a doctor, so he knows these things, and he's extremely frustrated. "I can't eat, I can't sleep, my life is terrible, I'd really rather die." I just said, "I love you, Daddy," and he started crying on the phone. So I'm taking this heavy heart to work, and I've got to say something like "Hello, what would you like to eat today?" which seems so mundane and incidental. You know, life is more than your lunch. But I have to take myself out of my problems and address the immediate needs of my customers. They're paying good money, and they deserve to have a nice meal without my crying on their shoulders.

Of course the best part of my job is that I don't take the job home with me. I leave the place, and that's it. Nobody calls me at home and says, "Pick up the martini for table fifty-one . . ." And it affords us the money to have a nice house in New Jersey.

On the weekends I knit and needlepoint and garden, and I bake with my husband, who's a really good cook, so we're always in the kitchen together. Really, the home life is fantastic when we're all together on the weekends. My husband's a really lovely person, and he's fun to be around. If I had to be on a desert island with one person, it would be my husband. I mean, at the end of the night I'm so happy to go home to him and our son, John Gregory, and daughter, Nicole.

John's an opera singer. He's got a phenomenally gorgeous, dramatic tenor voice, but he's on a slow track at the moment and his income is very fluctuating, although we are hoping to get him into the arena where I can quit this. Because I would love being just a mother and wife. That would be the greatest gift to me, to get to stay at home and really watch over everybody.

Keith Christiansen

"If you are not having a good time, please leave . . ."

Keith is a tall, athletic-looking man, with the firmest handshake you would ever want to avoid.

Every curator has a dream object: a work of art that he or she feels will transform the Museum's collection and the visitors' experience. But also one that speaks with a particular voice to the curator. I've been privileged to propose for acquisition a number of outstanding works of art over the years that I've been here, but probably the one with which I identify the most is Duccio's *Madonna and Child,* which we acquired in 2005. What makes it special is not the price that was paid for it, which was widely reported in the press—as though the measure of quality was the dollar. Nor even the excitement of beating out an institution like the Louvre in Paris, which was as anxious as we were to add it to their collections. No. There was something much more personal.

Duccio was from Siena, in Tuscany, and I've always had a special response to Sienese painting—ever since in 1968 I first visited the city as an undergraduate on a Eurail Pass summer trip. So one event has embedded itself in my curatorial memory with particular force. It took place during one of those long summers in New York.

Nicholas Hall of Christie's, with whom I have been friends for many years, phoned me up and said, "I would like you to have lunch with me; there is something I'd like to show you." During the meal he slipped me a transparency, and I looked at it.

It was a painting that had not been seen by any of the major Duccio specialists for fifty years; it had been in the hands of the Stoclet family and out of circulation. "Fantastic, how about the price?" I asked. He told me. "OK," I said, "I will deal with that later," and then we finished our lunch.

I wondered what to do next. This was probably the most important early Italian picture that could ever come on the market. Do I send an e-mail to the director or call him in Quebec, which is where he likes to vacation in August? But I thought, "No, I will wait until he returns." Besides, the price was very, very high, way beyond the Met's means, I would have thought.

So I waited for the director to come back from his vacation. And then I went into his office and said, "I am duty bound to show you this," and then I showed him the transparency. I casually said to him, "You know, Philippe, you deserve this picture. Tom Hoving had his Juan de Pareja, Rorimer had his Rembrandt; I don't see why you shouldn't have this toward the end of your career."

My director fortunately is a person who loves old master paintings, who grew up with old master paintings and worked as a curator in this department and does not need to be told much. He was completely riveted by it. He asked me the price while he kept looking at it, and then he said, "I don't see how we can get it. . . ." But that I imagine was also when the wheels began to turn in his head, because when I left, I thought there was a real possibility.

Sure enough, a couple of weeks later the director, conservator Dorothy Mahon, and I took the day flight to London, which is where

it was. We got into our hotels late that night, and the next morning we were looking at the Duccio in a second-floor office at Christie's in St. James's.

It was a beautiful sunny day. The light was streaming through the windows and Philippe sat down on the couch and we looked at the picture for an hour and a half; he was completely caught up in it, as were we all, and I could tell that this picture was not going to slip away easily.

One surprise was the subtlety of the color, which wasn't indicated by the transparency. And we were all amazed that despite its very small size, you could stand back fifteen feet, and the image carried. One of the outstanding features of this picture is that it's completely intact and retains all this beautiful modeling which is very unusual. The drapery of the Virgin is astonishingly three-dimensional in the way it falls over the arm; it's like a Roman sculpture. It is a very humanly conceived picture. The child reaches up to his mother and with his right hand has gathered up her veil and is pushing it up so he can get a clear view of her face. At one very beautiful point his foot touches her wrist.

In fact the emotional content is what is so special to this picture. When Duccio started painting in the 1280s, the norm was still a very Byzantinizing style: very heraldic, with very schematic, formulaic figures. But in this picture you feel very much in the presence of two figures that are responding to each other in a very human fashion, although a gold background immediately transforms them into beings from a higher realm.

The director made an offer for it on the spot. Two other institutions had been offered the painting: the Getty and the Louvre. The Louvre, we knew, was working on trying to get the money together.

After about two hours at Christie's we all walked down to the National Gallery, where they have a rare and very beautiful Duccio

triptych. The director wanted to assure himself that the two works were equivalent. We stood in front of the triptych, which is simply marvelous—a touchstone of Duccio's work—and we all felt that "ours" was every bit as fine and in certain respects more intimate and direct.

We took the plane back together at lunchtime, and when we landed, the director went his way, I went mine, the conservator went hers. This matter was now completely out of the curatorial realm; this was up to the director.

I thought there would be a huge time lag, but this was simply something he did not want to risk losing, and it took just two days for the trustees to say yes, and within two days it was basically ours.

The art historian Ernst Gombrich used to say, "There is no bad way of looking at a work of art; there are different ways." I have friends who look at works of art exclusively with a historical perspective and have almost no aesthetic response to them. Some are just the opposite; they respond to a painting completely aesthetically. For those people, it is irrelevant who the artist was, why it was painted, its history, and so forth, because they feel it is a work of supreme quality. My guess is that most visitors fall somewhere in between. And when they come to the Metropolitan or any of the great museums of the world, they not unnaturally assume that if a picture is on the wall, it's ipso facto important, and in order to come to grips with it, they want to know just the minimum. This we try to provide with labels but it's a sorry task.

But what's the minimum with a picture like the Duccio? You can indicate on a label that when it was painted—perhaps around 1295— it marked a turning point in the history of European painting. Which

it did. You can mention the name of Giotto—Duccio's younger contemporary in Florence. But in the end, the viewer has somehow to find a way to connect personally with the work he or she is confronted with; a common language has to be struck. All we—we curators, I mean—can do is to try to provide the very greatest work we can to ensure that those who do connect have the sort of enriching experience a place like the Metropolitan is supposed to provide.

We live now in an intensely secular world and one that is more visual than literate. Contrast this with the nineteenth century: any educated person knew not only the biblical stories but classical mythology, and looking at a picture, he was in a better position to read the image, understand what the figures were doing, and connect with the artist's ideas. A visitor to a museum now comes without the shared cultural values that these works of art assume as a condition to entering them.

I taught for a semester at Smith College and enjoyed it immensely. The students were very bright and inquisitive. But one day when we were looking at Michelangelo's *Last Judgment,* a student raised her hand and said, "You know, I am having an awfully hard time relating to these massive figures, which look as if they have spent too long at the gym." That caught me up short, because I had never thought of anyone looking at works of art and finding it had nothing to do with his or her life. But when you have a world where people now come to religious paintings via Mel Gibson's movie and receive images from television and handheld games, this makes the images which emerged in the past seem distant and even irrelevant.

It seems to me that museums run the risk of becoming merely an extension of tourism: places for people to go, often simply to say they have been there, ticked it off the list. Just look at the crowds outside the Uffizi in Florence. The Metropolitan is the number one tourist

attraction in New York, and it is always busy. But I am quite certain that on any given day you'll find any number of people who would rather be someplace else and, quite frankly, they probably shouldn't have bothered to come.

I am all for museums being open to everybody; everybody should come at least once to see if he or she connects. But there should be a condition, and that is that you should be willing to make the effort to meet the works of art on their terms—not those we bring with us from our very different culture.

George Cuesta

"There was a showdown between the priests of Baal and Elijah . . ."

His longish black hair, silver earring, and easy good humor indicate a colorful personality. It is a pleasure to meet someone with such honesty, sensitivity, and joie de vivre. This was the last interview I did for the book, and for all sorts of reasons, I felt melancholic when we parted.

Oh, I didn't choose plumbing; it chose me. Well, what happened was, I was out of high school and didn't know what I wanted to do for a living. My cousin worked for a small plumbing shop, and they happened to get a whole lot of extra work that was more than they could handle, so they were looking for extra hands. They hired me on a temporary basis, and I just took to it and caught on really quickly.

The shop was down on Fifty-seventh Street, between Fifth and Sixth avenues. Actually, Steinway & Sons used to build their pianos right on the same floor as our workshop, and they did everything by hand, which was real fascinating to watch.

I've been at the Met going on fourteen years now. I love the place, but to be quite honest with you, I don't really agree with what happens to paintings in museums. When the artist was alive, his art

was worth nothing, and now he's dead and his art's worth millions. That's crazy. Who puts a price on these things?

The building is in pretty good condition considering the amount of use it gets. There have to be at least thirty bathrooms in this place, and in each of those bathrooms you have six or seven toilets, four or five urinals, four or five sinks, plus you have the locker room for the employees, with showers and things like that.

We're quite a small team to look after all that number of fixtures. Apart from myself, we have Frank, the maintainer; Rawle, who's a helper; Eddie, the supervisor; and then they recently created a one-to-nine shift, which Mike works.

The guys are great, don't get me wrong, but I don't really hang out with them after work because my way of life is different. A lot of them like to drink and smoke, and I don't do those things anymore.

I did at one point. Oh, yeah! I used to drink a lot. I was hooked on marijuana; actually I was a cocaine addict. One time, after a night of really heavy partying, I thought I was having a heart attack. Oh, I felt for sure I was going to die. I said right there, "God, if you get me out of this, I'll never do it again." And I made it through the night, although it took a day for the high to come down, and after that night I never did cocaine again.

Well, the next day I went into a church, and the preacher preached the message. I remember he spoke about the wilderness experience, which was just the perfect description of what I had been going through. And then he made what's called an altar call, which is for those who want to accept Christ into their lives. I went up, and I accepted Christ into my life, and it was the best decision I ever made.

I started reading the Bible. I love the Bible, particularly the stories where God uses regular men to do extraordinary things. Like Moses, for example. Moses was a murderer, and he had a speech

impediment, and yet God used him to deliver the nation of Israel from the Egyptians.

Then you have Elijah, who stood up against King Ahab, who was the king of Israel at the time. He had married an ungodly woman, and they worshiped gods like Baal. There was a showdown between the priests of Baal and Elijah to show whose god was the true one. The priests of Baal put stuff on an altar and called to their god to send fire to burn it. Nothing happened. They cut themselves and did all kinds of freaky things, and still nothing happened. Elijah soaked down the altar to make it even more difficult for anything to happen. But all he did was speak one word to God, and God consumed the whole thing with fire. Things like that happen when you trust and obey.

I believe that when you accept Christ as your Lord and Savior, a part of you becomes awakened, and that part is in direct communication with God, and he then guides your life and helps you stay on the straight and narrow. It doesn't eliminate trials and tribulations or difficult situations that arise. No one's exempt from that because we live in a sinful world. But once you live the way he expects you to live, you get a helping hand.

Oh, I never want to be the person I was before. I'm married now. I have two children. One is nine, and the other is going to be twelve next month. You know, I look at my life, with my family, and compare it with the life I had with my parents, and it's like 100 percent different. My father was an ex-marine; he was a very rough dude, and his disciplinary ways made me afraid of him because he was so brutal. It was not intentional, but when he started hitting, he used to go overboard.

I'm the opposite type from my father. My daughters love me. I mean, I come home from work, and they run to the door, still, and that's beautiful. You know, I'm not perfect, but I can show my kids that I love them; I have no trouble expressing that.

I still live in the Bronx, where I was raised. I've been involved in a church plan there, which means I started a new church, which was a very difficult thing to do. The church is called New Life in the Bronx, it's on Williamsbridge Road, between Allerton Avenue and Mace. We rented a storefront and converted it ourselves, and we went out into the community and started talking to the people to let them know we were here. But it's moving along very nicely. As a matter of fact, if things keep on going the way they have been, we're going to need a bigger building.

We do community service too, and all that sort of thing. We have a full-time minister, Pastor Robert Cole, and we also run a children's ministry. These kids live in a really rough neighborhood, so it's good to get them off the street. We teach them Bible stuff and also how to read, because a lot of these kids are not learning what they need to get into the next grade, and it's a beautiful thing to see these young people reading fluently who couldn't read two years ago.

People have taken advantage of the things we offer, and when they come on Sunday, they get to hear what the church is all about, and some of them have even converted. Why don't you come along, Danny? Who knows what could happen?

I have to add a very sad postscript. Just days after writing up the interview, I heard that George had died in his sleep. He leaves behind two daughters, Jacqueline and Natalie, and his wife, Denise. I shall cherish the memory of his amusement and pleasure that he was going to appear in this book.

Malcolm Daniel

"I've got the department beeper . . ."

There is enormous depth and beauty in the daguerreotypes of old, a clarity and honesty that are often missing in these digitally driven days. Malcolm is enthusiastic and tireless in promoting these wonderful images.

My interest in photography came about at graduate school. Photography seemed like virgin territory then. There were all these major figures who'd done incredible work about whom virtually nothing was written. Princeton has the archive of Minor White, and I had the chance to work with his notes and diaries and proof prints, which was very exciting. Minor White represents a more spiritual aspect of photography; he found a kind of symbolic and spiritual content in the forms of nature and sequenced his photographs of waves and rocks to form a kind of emotional rather than literary narrative.

My dissertation was on a nineteenth-century French photographer named Baldus. He went to Paris to study painting but then turned to photography and became one of the great photographers in the 1850s, which was, to use a trite term, a golden age. It's the moment when paper photography became fully mature as a medium.

My favorite photograph in our collection from the 1850s is

a beautiful Baldus, made in 1855, of the entrance to the port of Boulogne. Two curving jetties go out to the sea, and there's a ship anchored in the entrance, rocking in the water, so it comes out as a slight blur. A scruffy shoreline is on one side, and a beach with Victorian bathing carts on the other. You see ships very faintly dotting the horizon, and you can almost feel the humid seaside air, which is the effect one finds in Impressionist painting a decade later. Our print is about the best anywhere. It has a velvety matte surface on the salted paper print and a wonderful rosy color and tactile quality.

The medium was still handcrafted then, and a lot of attention was lavished on each print, and there was a lot of experimentation. Each photographer had his or her own recipes and tricks; it was more cuisine than science. If you read the journals or letters of the day, people are writing: "I find on a warm day two drops of such and such, and a dash of so-and-so makes my prints have a softer tone." By the 1860s that's been lost. You could go to a photographic supply store and buy industrialized photographic paper, rather than have to take a piece of fine writing paper, mix your own chemicals, and coat the paper. Everything started to look more alike, and the pictures no longer had the same incredible richness and beauty.

Our collection of nineteenth-century French work is fairly strong, because we believe that it was one of the great moments in the whole history of photography. Nadar, for example, was the great portraitist in France in the 1850s, and in his portrait of Eugène Pelletan, the charismatic left-wing politician, you can just feel this kind of pent-up fire in his gaze. It's a terrific picture. We've also got English pictures from that time, notably a beautiful pair of cloudscapes by Roger Fenton, where the horizon is very low in the picture, and the land is almost completely dark, so there's this wonderful sea of sky and rolling waves of clouds.

In 1928 Alfred Stieglitz gave twenty-two of his own pictures to the Met, and that opened the door for photography to be collected here. In fact Stieglitz proudly wrote to a friend saying, "The Metropolitan Museum of Art has opened its sacred halls to Photography, [and] my photographs have performed the miracle," and they are still among our great treasures.

Five years later he gave another four hundred works from his collection, including three great master prints of Edward Steichen's picture of the Flatiron Building down on Madison Square, which was, and still is, a great work of architecture, but at that time, also, a great symbol of modern architecture: tall and distinctively shaped, like the prow of a ship cutting into a new modern age. I'd say those pictures are among our crown jewels. Also included in that gift of four hundred is work by Paul Strand, who went out into the streets of New York with a right-angle viewfinder on his camera, so that it looked as though he was shooting one way but was really shooting another. That let him photograph people in a very direct, powerful way. It was the beginning of modern documentary photography.

What has happened over the years is that the more great works we collect, the higher our standards become, and things that would have excited me fifteen years ago don't excite me now, although when I see great things, it's a great high. It's a little like being a connoisseur of great wine: the better the wine you've tasted, the higher your standards become and the less satisfied you are with all the other stuff. But our standards *have* risen, and as a result the collection is even better.

Periodically we sit down as a department and talk among ourselves about what we would do if the Museum were burning down or there was a leak. We really do think about such matters, and have plans to save the most important masterworks.

For example, we have a beautiful Gustave Le Gray photograph of *The Great Wave*, and recently another print of *The Great Wave* sold for a record amount. So it's valuable, but the truth is there are numerous examples of that. So we try to think about what would be a terrible loss to the Museum, or the artist, or posterity. *The Flatiron* and the Steichen prints of Rodin's *Balzac*, which to our eyes are the very best things that Steichen ever made, are prints which exist no place else, and they're unique and central to this Museum's history. So they're something we would save right away.

We actually have emergency plans which are kept by the curatorial department, the conservators, and security department, and teams have been set up. There's never a case where everybody in the department is off on vacation; at any given time somebody is responsible.

We've had drills where we've actually moved the work, which is important because when the flames are engulfing the room, you don't want to be deciding things, like, "Hmm, shall I take the Steichens or the Strands?" And second, you must know where everything is.

At the moment I've got the department beeper. If I go out to dinner carrying the beeper, people will look at me like "Oh, please, you're a *curator*. What could the emergency be?" People understand why a fireman or a doctor would have a beeper, but what's the emergency going to be with us? But it's when you're off to dinner in the evening, when you're not on site, *that's* when it matters most.

People always think that curators are very highbrow and intellectual. I wish I could tell you I go home and have dinner and then read nineteenth-century French novels or the latest art journal in the evenings, but the truth is I go home, cook some dinner, and then sit and watch stupid TV for an hour with my partner and fall asleep.

Michel David-Weill

"With a harem you like all the ladies equally . . ."

A butler serves coffee and Perrier in his enormous Fifth Avenue apartment. Room after room contains astonishing works of art, which he proudly shows me. He speaks in a charming but almost impenetrable French accent and smokes cigars throughout our conversation.

I'm French. I was in France during the war, which was not particularly practical. In 1939 I was six, and my grandmother used to play cards with the lady who owned a hotel nearby, which was then occupied by the Gestapo. She saw our name on a list of people to be arrested and called us. We left the next day. My mother had prepared false identities, which she had obtained through somebody who was in league with the Resistance, and all of a sudden I was re-named Vatel and had been born in Amiens a year earlier.

We moved into a big castle in the Lot, which was contrary to common sense, because this place could be seen from five miles out! But no one assumed we were who we were, so we were very lucky.

Things got tough during that period. When German troops were moving from the south to Normandy, they were shot at by the Resistance and reacted extremely violently. A village nearby was burned down in retaliation, and six hundred men were deported from Figeac,

the nearest town, which had maybe four or five thousand people. I also remember hearing that a German messenger was killed by the Resistance, and papers were found on him that proved our village was going to be burned next. However, the truth is, to me this was all an adventure. I don't remember being scared, although I have to say that my sister, who lived exactly the same experience, was a little frightened.

I come from a banking family. My family originally came from eastern France, but they emigrated to the United States around the middle of the nineteenth century, first to New Orleans, and then they moved to San Francisco just after the gold rush, when they established the bank called Lazard, with which I was associated until very recently.

We are a collecting family, particularly my grandfather, who was one of the great collectors of his time. He loved French paintings and French silver and then seventeenth- and eighteenth-century furniture, and his house was full of Impressionist art. My father's apartment was quite modern; the railings were done by Giacometti, for example, and there were paintings by Masson, things like that.

So I am greatly privileged coming from all of this, but art is normal to me. It's my normal surrounding, something which is an intrinsic part of my daily life. And I was always very interested in art. In fact one of my joys was that for my ninth birthday I asked to receive tuition in art history, which was one of my best presents ever.

I moved to New York in September '46. It seemed a different universe after the very gray atmosphere of postwar France, where life was pretty difficult. Oh, I thought it was so gay, so active, the number of cars, the colors, the abundance. My family had an apartment in Hampshire House, which is on Central Park South, and as there were not enough rooms for all of us, I was put in the dining room, which overlooked Broadway. All the lights burning at night left an extraordinary impression.

Eventually, I was on the Board of the Guggenheim, but it bought a major minimalist collection from an Italian gentleman, and I disliked everything. It was really hideous. So I said, "Look, I prefer not staying on your Board. Try to find a replacement for me." I had the same experience in the Pompidou where I was on the Acquisition Committee. A curator walked me into a room and said, "Isn't *that* beautiful?" And I looked around and didn't see anything.

Art suffers from a sort of overadmiration. People don't have confidence in their own likes and dislikes, and in particular they give too much reverence to what's in museums. I strongly believe that when you don't like something, there is sometimes a very good reason for not liking it.

I have very fierce likes and dislikes. For example, I hate Palladio; I think his architecture is horrid. I love Romanesque churches; there is a particular church in Poitiers I adore, which is one of the earliest Romanesque churches in France. Cistercian abbeys are absolutely fantastic, and for a while I thought the only good paintings were murals.

There was a period in my youth when I very much liked American paintings of the nineteenth century, but very frankly, now most of it I consider second-rate, including those at the Met, and that goes for Russian paintings and things from their Egyptian collection. Sometimes Philippe de Montebello, with whom I was at the Lycée Français in New York, forewarns me before an Acquisition Committee meeting: "Please don't be too hard on this. It is a present from somebody. Maybe you will not find it very great, but it's OK, we like it."

When I was asked to join the Board of the Met, I was told it's customary for our trustees to concentrate on a particular field, so I chose Medieval Art. The reasons were that, one, I didn't collect in that field, so I wouldn't have the feeling of "Oh, God, I would love

that," although lo and behold, I now sometimes buy the religious Middle Ages because I have gotten to like it so much. And, two, one of the great differences between the United States and Europe is the lack of relationship to the past; Americans have no history, which is one of the reasons many of them like only Modern Art, and consequently the Middle Ages, which is basically the Christian heritage of the West, is then absent. So I think it's very important to bring Medieval Art to the attention of the American public.

Unlike French museums, the Met is very good at honoring its trustees. One of the things which it has done is to call the curator of Medieval Art the Michel David-Weill Curator of Medieval Art. That's very flattering; I appreciate that. I try to teach the French museums how to do the same, but they don't know how. It starts with walking into the museum. I have a very nice card from the Met, saying who I am. When I show this card to the guard at the entrance, he welcomes me, "Nice to see you," he says. My French card is not as nice. Actually it's rather ugly. When I enter the Louvre or Versailles and show this card, they look at it very suspiciously for five or ten minutes.

I think it's very important to have art in the world. I am somebody who is not terribly impressed by people. The only thing which is really exceptional about humans is art; apart from that, we are animals. Art is very intriguing and mysterious; sometimes it's a reconstruction of reality, which is more real than reality. Maybe it has nothing to do with artists; it's like a sort of current which goes through them and creates something which makes them comprehend reality better.

I have a lot of art, but I try not to have favorites. It's not that I like everything equally. There are days when I think, "*This* is fantastic." But to me the art I have is like having a harem, and with a harem you

like all the ladies equally. At least you don't reveal publicly which is your preferred one; otherwise you are a bad harem keeper.

My grandfather liked to buy things for the Museum just as much as for himself; he really made no distinction. I am amazed at that. It's wonderful to go to a museum and see something you like, but when you buy something, maybe for millions, which perhaps you have made a sacrifice for, it is an homage to the thing you are buying. Of course the main advantage of having it for myself is that I can see it better and more often. You can go to a museum many times and become very familiar with things, but nevertheless, you see what you own much better.

Just as much as art, I love the sea, and I love to see the sea. I think it's very restful for the eyes to have an open view, because living in the city surrounded by buildings, we have a myopic view. I don't even like mountains because they spoil the openness. I have a place on Long Island, and I have a house by the sea in the south of France. I like houses. I have seven houses—far too many, I know—but that way I can move from time to time, gazing afar.

Alice Cooney Frelinghuysen

"The dragonflies have gossamer wings . . ."

Talking to Alice, called Nonnie by everyone who knows her, is like listening to a wonderful teacher telling you things you very much want to hear. I had virtually no knowledge of Tiffany's work outside his lamps, and of course she is right: the dragonflies are exquisite.

My field is American ceramics, American glass, late-nineteenth-century furniture, and I'm particularly interested in the work of Louis Comfort Tiffany.

Tiffany was born in 1848. His father, Charles, had started a business in stationery and luxury goods in Connecticut, but by the time Louis was born, he had founded Tiffany (originally called Tiffany & Young) at 271 Broadway in New York, which sold stationery and "fancy goods," much of it imported. In 1842 the firm began selling gold jewelry imported from Europe, and by the mid–1840s it sold genuine fine jewelry and began manufacturing its own jewelry as well as high-end porcelain, silver, and glass. It was among the first to sell diamonds and other gemstone jewelry in America.

Louis Tiffany studied art while he was in a military boarding school in Perth Amboy, New Jersey, where he worked under an

American painter called George Inness, a Hudson River painter. He frequently traveled abroad on trips that were financed by his father, usually accompanied by another artist, who was also often paid for by his father, as a sort of paid companion.

On these travels Louis made sketches of the architecture and landscapes, working in pastel, oil, watercolor, and pencil. We have a wonderful Orientalist scene called *Snake Charmer at Tangier, Africa,* based on a trip he made there in 1870. It's a very dark picture, mysterious and evocative, a little theatrical. A figure with dark, curly hair is in a courtyard, standing on an oriental rug; all you really see of this man is a glint of gold in his ear, which counterpoints with the eye of the snake. There is a building, which is not defined, but you can make out great columns and carving and detail, the kind that Tiffany would later incorporate into his own architectural work.

Tiffany's studio was located on Seventy-second and Madison Avenue. It was in a great large building that his father had built for the family, the top few floors of which he had given his artist son for a studio, which was described by contemporaries as "Arabian Nights in New York." And it really was exotic, very amorphic in its contours, with colorful mosaics and exotic plants, swirling carpets, and fantastic Islamic-like mask lamps hung from different heights in the ceiling, and a unique fireplace in the middle of this cavernous room, a concrete-covered four-sided fireplace, which looked like the bottom of a great big tree.

Tiffany started out as a painter, but in the late 1870s he went into decorative work for the first time. He became a stained glass artist and at the same time one of the first interior decorators of his time, making and designing furniture. He utilized imported Indian woodwork and carved parts that were incorporated into the furniture he made

and started making rather avant-garde stained glass windows which would be part of the interior.

Within just three years of his taking up interior decoration, he was decorating the homes of the rich and famous, including President Chester Arthur's White House. Louisine Havemeyer instructed him to do her entire house, but some people would ask for just a room, or a window, or even a stair landing. He also worked for public buildings, colleges, galleries, banks, and churches and gave things he had made to museums. In fact in 1925 he supervised the installation of the *Autumn Landscape* window at the Met, that great big window you see as you walk into the American Wing Courtyard. He even determined the time of the unveiling, so that the sun would stream through at the right moment.

This was the first time electricity was being introduced into private residences. J. P. Morgan, who had invested in Edison's light-bulb, was one of the first to have electric light in his house in 1882. Tiffany was fascinated by light and was one of the first to deal with how to present electric light. The lamps have certainly overshadowed much of the other work that he did, but they are just one part, this man was so multifaceted. In a way Tiffany was an extraordinary Renaissance man, moving into all kinds of decorative work: he did pottery, blown glass vases, metalwork, enamel, textiles, carpets, furniture, stained glass windows, lighting fixtures, little glass shades, all of which we have in our collection; we have an entire gallery devoted to his work.

In this Museum we have his paintings and drawings; we have glass vases, wonderful mosaics, furniture from the Havemeyer house, metalwork desk sets, pottery, enamels, lamps, and jewelry. If I were to single out a couple of my favorites, I would have to mention a remarkable vase, called the Peacock vase. Louis Tiffany started blown glass in

1893, and it was given to us in 1896, so he was still in his experimental period, but it is exquisitely executed. There's a kind of bulbous base, with a slender stand that opens up in a fanlike shape, which conjures up an image of a peacock's plumage, where each little individual strand of feather is delineated in the glass itself; it has all shades of green with a subtle iridescence to them and a tiny peacock eye in blue. Another remarkable piece is a hair ornament. It's an incredibly delicate combination of silver and platinum, with enamel work of two dandelion puffs, one of which is partially blown away, and resting on these are two dragonflies. The dragonflies have gossamer wings; their backs are made up of brilliant blue and black opals, with pink opals for their faces. It is truly an amazing piece.

Louis never made a lot of money. His firm lost money virtually every year, but he didn't care; he was motivated purely by creativity. Besides, every year his father would bail him out by writing a check for whatever the shortfall was.

Tiffany left very few letters; he was scrupulous at trying to control how he was thought of. We know he married twice; both of his wives died young, and he had six surviving children, three by each wife. He was a man of dramatic appearance; he would wear these immaculate white suits, and he was tall and stood very straight and walked in a stately way. He had a well-cut beard, which turned a wonderful silver toward the end of his life. He lived a long time, until 1933. He probably lived too long because by then his work was well out of favor. His style had not changed appreciably, particularly with regards to things like his windows and lamps, and in the machine age there had been a change in aesthetic: things were much more streamlined, clean lines, new materials, color was going out the window, and Tiffany's work didn't really fit into that whole genre.

I also look after late-nineteenth-century furniture. Probably our

finest piece, which was from a commission for William H. Vanderbilt, is a fantastic rosewood library table made by the Herter Brothers, Gustave and Christian, the preeminent cabinetmakers and decorators from 1848 through the early 1880s, who had emigrated from Stuttgart. The top is inlaid with the constellations, and each side has half of the globe in mother-of-pearl, brass, and wood.

Glass, for which I'm also responsible, was actually America's first industry. In fact it was part of the Jamestown experiment. Glass is very fuel-intensive. You need to burn a lot of wood in the furnace to bring it to the temperatures it needs to be continuously running at, and as the forests were getting scarcer in England, and America was a fuel-rich area, the English felt this was a great opportunity for them. In 1608 they sent over highly skilled glassmakers, but that failed almost immediately, due to famine and sickness. Later in the seventeenth century Americans began to make glass for themselves, but there were no successful colonial glass factories until major factories were built in the mid-eighteenth century. They started off with very utilitarian things like bottles and windowpanes, and then Caspar Wistar established his glass house in southern New Jersey, near Philadelphia, in 1739, which survived until the Revolution. America's real heyday came in the second half of the nineteenth century, when great craftsmen developed more ornamental things, with colorful textures and decoration applied to the surface, and at that point, American glass was competitive with the finest in the world.

England dominated the market for those who could afford finer ceramics. The American ceramics industry was very utilitarian, low-fired red earthenwares and high-fired stonewares. American manufacturing of finer porcelain and ceramics made and marketed here didn't begin until the mid-1820s. I love those early attempts where you can see them trying so hard and ambitiously to make the most

complicated pieces. I particularly love the exuberance of the porcelains that were made at the time of the nation's centennial in 1876, where they just went crazy, making large vases in homage to baseball, for instance, with baseball players around the side, and crowned on the top by a big baseball, or the great vases made for the centennial with bison handles and scenes from American history, like the Boston Tea Party, which reeked of that great pride in America's history and future.

George R. Goldner

"They have thick black hair to protect them from the cold and weigh about 120 pounds . . ."

You can imagine George as a schoolboy, the cheekiest, most irreverent and likable child in the class. Grown to man's estate, he dresses more informally than any of the other curators and has an ease and self-confidence that are immediately endearing. You have to warm to someone who harbors an equal passion for the painter and sculptor Donatello from fifteenth-century Renaissance Florence and Roy Campanella of the Brooklyn Dodgers.

My mother came from a low-level Hungarian noble family, which had the distinction of being among the only Orthodox Jews knighted by the emperor Franz Josef, so she was rather well educated, and in the way that nice Middle European girls were then, she spoke several languages, went to museums, played the piano, all those sorts of things.

My father, on the other hand, came from a very poor background in what is now Slovakia, but if the truth be told, he was more genuinely intellectual than my mother. He read good books; he was someone who would take two weeks to read *War and Peace* just because he felt he should read it.

Both my parents' lives had been tremendously disrupted and affected by the Nazis, particularly my father's family, a great proportion of which had been killed at Auschwitz. I was the first member of my family to be born in America, a year after my parents fled from Hitler. Growing up, I wouldn't say there was no laughter in our household, but it was muted; there was a sense of foreboding about life, an element of nervousness and fearfulness, which under the circumstances was understandable but at the time seemed constricting.

I went to an Orthodox Jewish school until I was eighteen. The school still exists, and I've no idea what its curriculum is like now, but in my time there were as many courses in Bible, Talmud, and Hebrew language as there were in English. I was in school all day and practically all night, so when I went to Columbia as an undergraduate, I thought it was rather easy compared to being in a Hebrew school. Also, the teachers tended to be Jewish immigrants from Central and Eastern Europe, and they were very old-fashioned. I mean, they actually believed that one's brain wouldn't be destroyed by memorizing a fact, something that is no longer in vogue, I gather, which is why people under twenty-five don't know any facts anymore.

I was not an extraordinary child. I collected baseball cards, and I loved playing it, even though I wasn't any good. But most of all, I loved watching it, and I still do watch baseball very actively. I was a Brooklyn Dodgers fan when I was a boy; they were the underdogs, but they were also the characters, and I liked both of those features. Roy Campanella, who was the catcher, was my hero. He was kind of the backbone of the team, a very dependable, good-natured guy and also a very good player; he's in the Hall of Fame now. Probably the worst thing that's ever happened to me was when the Dodgers moved to Los Angeles. I still regard that as one of the bleakest

moments of my life, and for years I refused to watch them play, I was so pissed off with them.

I became interested in art history somewhat accidentally. I started college as a math major, but quite early on I realized I wasn't going to be a terrific mathematician. It wasn't like I flunked it, but I started getting Bs, and I thought, you can't be a B-level mathematician, there's no point to that, so I switched to economics. But I found that so catastrophically boring I couldn't take it anymore.

Around that time my roommate at Columbia, who was Italian, invited me to stay in his family's house for the summer; his family had a country house between Siena and San Gimignano. And I just loved it. I loved Florence; I loved the art, the food, the wine, the landscape, the whole nine yards. I liked the things that were pretty obvious, Giotto, Masaccio, fourteenth- and fifteenth-century paintings and sculpture, and still, today, if you ask me who my favorite artist is, it's Donatello. There's a wonderful scene in San Lorenzo of the Resurrection of Christ; it's a bronze relief which shows Christ as a tired old man coming out of the grave, and it's a deeply personal and evocative interpretation of such a tried-and-true subject, which I've always found very inspiring. Sadly, we have nothing by Donatello at the Met; there's almost nothing by him in America.

After that summer I thought, "I'll have to find a profession that allows me to work in art," so I switched to art history and taught for nine years.

And then I went out to L.A. I knew some people at the Getty Museum, which had just come into this huge bequest, and one of them offered me a job there, and I thought, "Well, I can always go back to teaching"; when you're young, you think you can jump around. So I took the job. And while I was there, I persuaded the museum to collect drawings, and they said, "OK, you can buy a few drawings." They

liked what I bought, so they then said, "OK, we'll make you curator of drawings," and very soon after that they said, "Why don't you buy the paintings also?" and I did that too.

I was there for eighteen years, and I detested L.A. from the beginning until the day I packed my bags. I'm not tolerant of stupidity, and Los Angeles is so far over the line it's hard to imagine. The only people I ever spoke to were people who had emigrated from the East Coast or Europe. But then fortunately Philippe offered me a very good job at the Met, and it coincided with the fact that I was marrying someone who lived in New York, and I've now been back here for ten years.

The drawings collection is probably around fifteen to twenty thousand drawings, and the print collection is somewhere in the neighborhood of a million and a half items; I say items because this includes printed and illustrated books, images on cigar wrappers, and baseball cards. The universal conception of the print collection was due to its first two curators, William Ivins and Hyatt Mayor; the baseball card collection and the cigar wrappers were later gifts that fit into their idea. I think curatorial work can lend itself to great intelligence and sensitivity, and many other virtues, but rarely, if ever, will you hear me refer to a curator as a genius in his outlook. But I think Ivins came as close as you can because he had a brilliant, universalist conception of this department, which is that it should collect examples of all kinds of illustrated, printed matter which have very little aesthetic merit but which document a side of printed imagery in the Western world. And so it ranges from the great impressions of Dürer, Schongauer, Goya, down to pedestrian imagery like cigar wrappers and designs for carriages and things like that.

The baseball cards were a particularly fortunate thing because anyone can go out and buy a famous Picasso for a lot of money.

There's nothing brilliant in that—except maybe you're brilliant in that you've made a lot of money in order to be able to do it. I've done stuff like that at the Getty, as we had all the money in the world. But I think it is very impressive to have a different and interesting and personal view of collecting. So sure, I don't think baseball cards are as important in the history of imagery as, say, Dürer—I'm very old-fashioned, even reactionary; I think there is a hierarchy of values in art—but I think baseball cards are important because they tell us part of the story. Also, I think a collection has to respond to the nature, the objectives, and the mandate of an institution, and this is a universalist museum, so they have a place here. They would have no place in the Frick, say, which is more precisely based on excellent work and not much else.

The most valuable and famous baseball card of all time, which we have here at the Met, depicts a man called Honus Wagner, who played for Pittsburgh at the end of the nineteenth and first fifteen years of the twentieth century. He was always regarded as the greatest shortstop in baseball, not just for the Pittsburgh Pirates but ever. While he was still playing, a tobacco company put out a baseball card of him together with a pack of cigarettes. Well, he was very much against smoking, and this had been unauthorized, so he legally prevented them from continuing to do this, and all the cards were confiscated—only ten or twelve exist today. The last time one was sold at an auction it made something like six hundred thousand dollars, so it's a very valuable card, and it's funny to think it's worth more than the vast majority of the prints and drawings here.

A curator should collect what the museum needs, but anyone who claims he isn't affected by his own biases and preferences is lying. Therefore, who's head of a department is tremendously important. I have a fairly obvious taste in prints. I like Rembrandt and

Dürer and Goya and so on. In drawings too, I like fifteenth-century drawings very much, and I'm one of those people who not only study Raphael but actually like him. The later one goes in history, the thinner my interest becomes, and I have a lot of trouble with Modern Art. It's just not my thing. It's not that we don't buy it, or I don't support it, but I don't personally respond to it very much; for me it lacks a literary context, which I miss. That's just personal. I like Raphael more than I like Picasso. I just do. If you want me to sit down and prove he's the better artist, I can't do it, but on any day I'd rather look at Raphael, buy him, collect him, or exhibit him. Maybe my successor will feel the opposite way.

Once in a while I'll wander out into the gallery without my badge on just to see where people stop and look or where they don't stop and look. They tend to be very attracted by things which have color in them, and by names they recognize. I don't talk to visitors in the galleries because I'm not conducting a poll. If you're in a job like mine, people will tell you what they think they *ought* to say, and it's usually incredibly boring for that reason. If you show them a print by Rembrandt and a print by an unknown artist, they will always tell you the Rembrandt is better because they feel they should tell you the Rembrandt is better. Children give you a much more honest response to art. You show them a van Gogh, and they ask, "Why is it so yellow?"

I think it is the job of a museum to instruct people on what they should look at, rather than simply say, "OK, most people want to see van Gogh, so let's plaster the building with van Goghs." If you go back to the nineteenth-century, when museums were first founded, they were founded with an explicit obligation to instruct and elevate people. They weren't founded in order to get more people in the building just because you had given them what they wanted. I mean, it's not the entertainment industry; it's an educational establishment.

We curators know more about art, about buying it, showing it, writing about it, and preserving it, than anyone else. And just as when I go to the doctor, I don't tell him what he should prescribe, I really don't want someone from the general public coming in and saying, "Well, actually, I'd be happier if you'd put up another van Gogh drawing and took down the Schaufelein drawing." It's not because I don't think they have a right to an opinion—I think everybody *should* develop an opinion; I think it's important to develop opinions even if you don't know a lot—but when it comes to decisions, they should be made by people who actually know what they're doing. Also, we should challenge people to look at new things, things they aren't used to looking at. I think one of the great failures of museums today is that we sell what people will buy, rather than try to teach people to want to buy something else.

For example, if you go out of my office the back way, you will be in the Ancient Near East galleries, where there are fantastic Assyrian reliefs. There are very few institutions in the world that have these, and they're fantastically high-quality, important, beautiful, and historically interesting. But you see very few people in there, and I think a museum's job should be to try to push people into seeing things like that, to say, "Hey, look, you don't know anything about the Ancient Near East or Assyrian reliefs, but you ought to look at them," not just say, "Want to see another van Gogh? And you can buy a calendar. . . ."

There are a few drawings hanging at the moment that are personal favorites of mine which I'd love people to see. There's a pen-and-ink drawing by a German Renaissance artist called Hans Schaufelein from the 1520s which shows a soldier of fortune with a pike, and it's incredibly expressive, powerful, and dramatic. There's another drawing I like very much by Joachim Wtewael, who was a Netherlandish artist at the end of the sixteenth century, which

shows Adam and Eve with the animals, and the way the animals and the light are distributed has a kind of a kaleidoscopic quality which I find very engaging and likable.

But if there were a fire in the Museum, I would take Michelangelo's *Libyan Sibyl* and run out of the building. Even though the Sibyl is of course a woman, it's a study, drawn in red chalk, of a rather muscular nude male model in the pose of the Sibyl, because in the Renaissance people didn't make nude studies of women. It was eventually shown on the Sistine ceiling. It is obviously of tremendous historical interest, but it's also an incredibly beautiful and powerful image, one of the great studies of the human form anywhere, and you could make a case that it's one of the very best things in the Met, let alone in this collection. Actually I think it's the most important drawing in America.

My wife restores old master paintings, and when I go home and we have dinner together, we talk about what we've done that day. But we don't just talk about art. I'm a dog fanatic; we have two big dogs, whom I love dearly, and as anyone who knows me will tell you, I talk about them incessantly. They're a breed called Tibetan mastiff, which are big woolly dogs from the Himalayan Mountains, used to protect livestock in villages in Tibet. They have very thick black hair to protect them from the cold and weigh about 120 pounds, and they cost a fortune to feed.

Many people are intimidated by a place like the Met. What's intimidating is the combination of social, financial, and intellectual superstructures we've built around art. Art suffers from the fact that it's used by people for many agendas. Social agendas, for instance. If you're tied to a big museum, on one of the committees, for example, then it's axiomatic you must be rich, important, socially prominent, attend scary parties with ladies in ball gowns and limousines, and if

that's not you, you're left out of it. Art has become too tied to money and power. You can compare the collecting of art today with the collecting of relics in the Middle Ages. It's a way of expiating sins, a way of rising in society, and instead of having a chapel named after you, you have a wing of a museum named after you.

I think most museums have become utterly paralyzed by the kind of people who become trustees and the kind of people who become directors. Rather than have collectors who think the museum should be about art, boards have become increasingly full of businessmen. When you look at them, you wonder, how much do any of these people know about art? And it's damn little.

Museums today are all about getting people in through the door. And therefore the museums then have to buy and exhibit lots of what the public want. It's a strange treadmill, like a bunch of hamsters running in a circle. No one is enriched, so you wonder, What's the point of it all?

We do have wonderful shows, but you ask yourself, "Why don't most other institutions ever do an interesting show?" And the answer is, "There's no one to do it." No one can afford to hire new curators. You can see it in the declining place of curators in most museums. It's a desperately declining profession, to the point where I'm glad that I'm sixty, rather than thirty. Philippe is the last great museum director in this country, and this is one of the last places where curators actually matter. And we do matter. We matter a lot.

Maxwell K. Hearn

"A small corner of nature, ten inches square . . ."

Mike (as he is known to friends) is originally from Salt Lake City, and he tells me that the street where he grew up offers the best panoramic view of the surrounding Wasatch Mountains. I head to Salt Lake the very day after we meet, and I go to 740 Sunrise Avenue and find he is right. I wonder whether his passion for the towering monumental landscapes of China's tenth-century Song dynasty has its roots in twentieth-century Utah.

I still remember . . . I was thirteen, and we were walking out of the Art Institute of Chicago at closing time. I was directly alongside *La Grande Jatte,* Seurat's great pointillist painting of a summer afternoon along the Seine, when they switched the lights off so I literally saw the painting in a different light, and all of those color dots became gray tones. I was astonished to learn that art looks different in a different light; I had always assumed there was something immutable about it.

Years later I took a seminar at Yale on Southern Song painting, Chinese painting of the twelfth and thirteenth centuries, which was all about Zen and misty landscapes. They were all monochromatic. In China color was not seen as a necessary component of artistic description; it was felt that ink tones could capture all the colors you

needed. Somehow Seurat must have figured that too, and before I knew it, I was hooked.

The Song was a long dynasty, from 960 to 1279. It was a period in which China was militarily weak but culturally very rich. The Tang dynasty, before it, had been vast. It reached far into Central Asia, but it was weakened by barbarian invasions and eventually fractured into regional states until 960, when a general reunited the country and proclaimed himself the first Song emperor. During this time non-Chinese peoples were expanding their empires, and when the Jin occupied northern China, the Song dynasty was divided into Northern and Southern Song, and the remnants of the court retreated to the south.

During the Southern Song period the towering monumental landscape panoramas of the early Song were transformed into more intimately scaled images, where just one corner of a landscape was represented. Ultimately, the focus narrowed to just a small corner of nature, ten inches square, and scholars might add a poem right on the painting, which announced that the painting wasn't just a representation of a space; it was a mental construct. Landscapes were transformed into "Mountains of the Mind."

Paintings were graphically transformed from visual records of the physical world of granitic rocks, pine trees, and temples into evocations of nature's spiritual essence. The world was visualized through veiling layers of mist until the landscape disappeared into nothingness. White paper could evoke water, mist, or sky, and you couldn't discriminate one from the other, and the idea of representing the real world became less and less important until you were on the verge of abstract art. It seemed like a world that could simultaneously embrace and wash over you; there was definitely a quality of magic to it. And there was something philosophically appealing in

this contemplation of the void, which tied in with Buddhist meditation practices.

Silk was an important medium for painting during the Song period and one of China's most distinctive formats, the horizontal handscroll, was undoubtedly derived from the weaving of silk in long, narrow bolts or rolls. The beauty of the handscroll format is that it enables you to move through a landscape by unrolling a section at a time, so you can actually imagine yourself on a journey. It is a very participatory kind of art.

In 1279 Khubilai Khan completed the conquest of China that his grandfather Genghis had begun seventy years earlier and he proclaimed a new dynastic title, Yuan, which means "beginning." Chinese scholar-officials, displaced by the Mongol conquerors, withdrew from public service to pursue their own personal and artistic cultivation. For these literati artists, the emphasis of painting shifted from representation to self-expressive brushwork. Painting lines became calligraphic and artists began using the verb *to write* to describe the act of painting. So a rock might be drawn with separated bristles of the brush, which they called *feibai*, which means "flying white" because it really looks like the brushstrokes are flying across the paper. In *feibai* the brush appears to move very quickly, turning and twisting, until the bristles separate and open up and you get white paper showing through the ink. When the brush tip is centered above the paper it is called a centered-tip brush, which creates smooth, even, regular lines. So soon you are no longer looking at pine trees and rocks, you are looking at the marks which convey them. It's how you might look at the signature of Abraham Lincoln or George Washington to see the individual.

I am attracted to the paintings that were done when China was under foreign occupation. You get this intense response to an outside

threat to the culture. The brushwork itself carries an extra electricity, and there is an emotional charge to the paintings. I'm particularly thinking of two paintings we have here, Zhao Mengfu's *Twin Pines, Level Distance* and *Watching Geese* by Qian Xuan, which were done shortly after the Mongols had conquered the Song and occupied China.

Artists saw themselves as the representatives of their culture during these epochs when society was in turmoil, and they began making both political and cultural statements in their art. Permanence in the face of political change became a real issue, and they developed this metaphorical language in which the landscape became a private language for resistance and survival. So a pine tree (*song* in Chinese) became an emblem of survival because it remains green in the winter; bamboo (*zhu*), which bends in the wind of adversity, was another favorite symbol; also, the plum (*mei*), which blooms in the spring when snow is still on the ground, represented survival and renewal. Those three symbols were called the three friends of winter, and they became an emblem for the spirit of resistance, endurance, and survival.

That tradition continued. When the Ming dynasty ended in 1644, a group of artists who saw themselves as loyalists to the fallen Ming dynasty turned to art to express themselves, very much like the fourteenth-century artists of the Yuan. They created landscape paintings which were imbued with a sense of loss. We have a very powerful hanging scroll by an artist called Dai Benxiao, who painted a depiction of a stone bridge, with ancient pine trees growing around it, which represented a way of going from this world to paradise but over which only a chosen few can cross.

For me, what is very exciting about Chinese painting is that you have an artist who adds his own story to his paintings, inscribing it

with personal views or a poem, and you also have owners who add inscriptions or comments or a seal to the painting or its mounting, as contemporary owners continue to do, so they become a part of that work of art, part of its story. And you can follow reactions to a painting from now right back to when it was made, maybe a thousand years earlier, so you have a sense of connectiveness through time. In this way a work of art in China evolves. You have a sense of transmission and history in the provenance, and I don't think there is any other culture where that happens.

Morrison H. Heckscher

"I've never been to Indianapolis . . ."

I find the first interview of any book a testing moment, but this time I could not have chosen a more encouraging figure for this honor. Courteous, passionate, informed, he is a delight. His love for American art and architecture is infectious.

He was the ideal grandfather. He taught his grandchildren all the things one should know; he taught us about buildings and geology, the Latin names for trees, and the names of the stars. He was such an interesting man, an amateur painter, a cabinetmaker, all in all, a very civilized human being, and I was very fortunate to have had him in my life.

I grew up outside Philadelphia, and my grandfather used to take me into town. Back in the late 1940s, before redevelopment, Philadelphia was an eighteenth-century city with Victorian overlay; it could have been an English or a European city.

So thanks to him, I saw the great row of High Victorian banks by Frank Furness, who was the greatest American architect in the post–Civil War years, just before they were all torn down, and they overwhelmed me with their beauty. In fact good architecture captured my imagination from the very beginning, and Frank Furness

was the architect who captivated me more than any other, although most of his work has now been demolished.

To my mind, every American who goes to high school should know about architecture. I think architecture should be the most democratic and accessible of all the arts; after all, everybody sees it every day. But it's a big problem in this country. We are tearing down our architectural heritage, and there is nothing left of Frank Furness of Philadelphia; there is virtually nothing left of H. H. Richardson, Louis Sullivan, the great architect of commercial buildings in Chicago—his work has also been torn down—and Frank Lloyd Wright is disappearing. There is a much greater awareness of preservation now than there was; in New York City, for example, there is now a Landmarks Commission, which came into being after the demolition of Penn Station in the mid-1960s, which was the greatest public building in New York, but it took that to mobilize people.

Architecture is a hard thing to have in museums because you can't collect it in the normal sense. There aren't auctions or dealers to whom you can go and say you want to buy rooms, and most collectors won't go near architecture because of the logistical problems. But we have a history and tradition of it here. The Metropolitan Museum, more than any other museum in the world, has in its collections and displays the architectural context in which works of art are displayed. It's one of the unique features and special glories of the American Wing. You can walk into the rooms where Americans lived in the seventeenth, eighteenth, and nineteenth centuries, right up to Frank Lloyd Wright in the twentieth century, all in one building.

The seventeenth-century room comes from Essex County, Massachusetts. This was made by people from the west of England who

came over and brought as much of their culture as possible with them to make it seem like home, making only the changes necessitated by the new climate and conditions. The eighteenth-century room again reflects English taste. London was the cultural center for affluent Americans, who went to school and studied law there, and when they came back, they aspired to produce a little London in America. The best things we have in this room are the works of highly skilled and ambitious young men who trained in the London guild system as apprentices and saw opportunities to be their own bosses in America.

When I started here, the American Wing was a charming, funky, little appendix off the northwest corner of the Museum, a three-story building made of yellow brick, with barred windows on three sides, and a great marble bank facade, facing an interior court that no one could see. By the 1960s it was ripe for expansion, bringing it into the era of the bicentennial, and now the old American Wing is just a small portion in the middle of the American Wing.

We wanted to continue chronologically with the historical interiors when we expanded, so I was on the lookout for major figures to represent twentieth-century American architecture. A great opportunity presented itself in 1972. There was a Frank Lloyd Wright house in Wayzata, Minnesota, right outside Minneapolis, called the Francis Little House, which was actually going to be demolished, and I arranged for the museum to acquire the entire house.

The first trip, I flew out there with a representative of the administration. We were met by the owners, an older couple, and as we were driving on one of these indistinguishable interstates, I was sitting in the backseat, and I thought, "I've got to say something to keep the conversation going"—I was young and enthusiastic then.

"Gosh, this is exciting, I've never been to Indianapolis before," I tried, and it suddenly got very icy in the car. But we got over that, and when we arrived at the house, well, it was one of those spaces where you go in, and your throat goes dry, and you can only croak, "Oh, my God."

It was absolutely magical. Most Wright interiors are free-flowing and anchored by a large center chimney, which would be very hard to re-create in the Met. But the Little house offered the great advantage of having a free-standing pavilion for a living room, which had incredible light and space, and a wonderful high ceiling, and all its original furniture intact. As a bonus, when we arrived, the sun was pouring in on both sides, which reflected in the snow, and the whole roof seemed to be floating above windows all the way around.

Thomas Hoving, the director at that time, came out with me on the next trip and sealed the deal with the family that day. We headed back that night on a late flight, me with a brown paper shopping bag from the local supermarket, filled with architectural drawings I had found in a corner of one of the rooms, the original drawings for this house by Frank Lloyd Wright himself. It was pretty thrilling to have something like that, in many ways the most exciting acquisition one could ever have.

We then had the task of having the building dismantled, which was painful, but we knew it was better than to stand back and say, "Isn't it terrible that it's been demolished?"

We are actually in the midst of replanning our Wing again. It feels like a quasi-independent operation at the moment; we're a quarter of a mile from the other end of the building, and we find that many people don't find their way here. I actually enjoy working with the

architects to try to get the right design. I like floor plans, I like look-
ing at architectural drawings; I want everything to be displayed in a
way that will make people say, "Wow!"

Washington Crossing the Delaware was installed in this building in
1980. It is not, I think, anybody's favorite work of art here; it's a
huge-scale, bombastic history painting which is not characteristic of
American art. It's more interesting historically than aesthetically
pleasing. But we realize that it is probably the thing most people, and
certainly schoolchildren, think of first when they think of American
art. It is an icon, so it is very central in our plans for reinstalling the
picture galleries. Because of its scale, it's one of the few pictures that
need purpose-built locations; it needs to be approached from a great
distance and yet still be something that draws people in.

Actually, we have an even bigger painting than that, *Palace and Gar-
dens of Versailles*, by an American painter named John Vanderlyn, which
is something like fifty feet in diameter and originally more than
twelve feet high, and one of the few surviving nineteenth-century
panoramic visions.

I happen to be married to a young lady who's a physician. I re-
spect the fact that she's dealing with life-and-death matters daily.
But I tell you this: we here are dealing with matters of life and death
too. I think a tremendous obligation has fallen upon a handful of
great institutions—the British Museum, the V & A, the National
Gallery, the Met, the Museum of Fine Arts in Boston, the Philadel-
phia Museum of Art—with guardianship of so much of the best
stuff of the world. We've gathered, and continue to gather, all the
best things together, and we have an incredible duty and obligation
to preserve everything for future generations.

Continuity is terribly important in a museum like this. I've

been here a long time, and so the most important thing I can do is have people younger than I am learning about, caring for, and understanding the collections, curators who are passionate and deep in their knowledge, so that they in turn can pass on the torch one day.

Harold Holzer

" 'I like a man who orders cheese' . . ."

*Always engaged, always witty, helplessly irreverent. As director of
communication he has a close relationship with the director, where
he is the Sancho Panza to Montebello's Don Quixote. And yet
in his own right he is a distinguished writer and scholar, winning
many awards for his work on President Lincoln.*

I wouldn't call mine an art-loving background; my father was a
businessman and my mother a homemaker, and we grew up in
the New York suburbs. But in 1959 my mother decided that the
Guggenheim's opening was important enough to pack us all up and
have a big trip to New York City. I remember the mobiles, the
Kandinskys, and the Mirós, and I loved them, and after the Guggen-
heim trip, every Saturday I would go into New York with a friend
to look at museums.

I got sick when I was nineteen. I had a melanoma on my back,
which spread to the lymph nodes, so there was a series of surgeries and
terrible scars; it was a mess. I went back to college, but I was very un-
happy and depressed. As soon as I missed a semester, I was reclassified
from student deferment to draft status. I didn't really know how sick I
was until I had my military medical and looked at the doctor's report,
and it said, "Prognosis guarded." That really hit me.

I then took a job at the *Manhattan Tribune* in the Chrysler Building, which I thought was the most fascinating, exciting, bustling, busy place, with hard-boiled editors smoking and drinking. It was meant to be a West Side and Harlem paper, so our slogan was, "Black and white and read all over," like the joke. But it really wasn't read in Harlem, and I'm sure it wasn't read on the West Side either, so I have no idea who was reading it. But I stayed with it for four years and had fun. And I wasn't depressed anymore. I became completely nonintrospective for the rest of my life, and I never think about how I feel now—I don't have time.

One day I went to a building on Sixty-eighth Street to write about this woman who was running for Congress. And so I encountered Bella Abzug for the first time and was absolutely spellbound; it was like I fell in love on the spot. Bella was a three-term congresswoman, a leader of the women's and antiwar movements, a large woman with a great foghorn voice. She was an original, a revolutionary, and if it weren't for Bella, women's full participation in society would have been delayed by God knows how many years. The next job I took was to be her press secretary when she ran for the Senate.

After that, I worked for Mayor Beame as a special events coordinator, creating events where he would walk around neighborhoods and talk to people. But he was so small that when he walked into a crowd of people, you couldn't see him. He wasn't like Mayor Lindsay, at six feet four, towering over people, striding through Harlem in shirtsleeves to calm the race riots. This was a disaster from beginning to end. I knew that, but it was fun, and the mayor was a nice person.

When Bella decided she would run for mayor, I had a choice to make. Should I stay with Mayor Beame, who was running for

reelection but had gone through a terrible fiscal crisis and would surely lose? Or should I work for Bella, who I just enjoyed being with but who would also probably lose? I finally went to the mayor's press secretary and said, "I have to work for Bella." "If you have to," he said, "but we would be very disappointed." And even before I got back to my office, my phones had been turned off, which I found fascinating, my first experience of the brutality of government. I just packed up and left.

After that I took my first regular grown-up job, the communications person for New York public television. Those were the glory days of *Great Performances*, *Live from Lincoln Center* and *American Playhouse*. And I was no longer aiming toward an election day, when it was make or break, live or die, succeed or fail, job or no job. So that was transformative. Everything became acclimatized to openings and seasons and debuts, which is very much like my world here.

Then the next great epiphany. Out of the blue, I got a call from a headhunter, a woman with a soft radio announcer voice, who said, "We are on an executive search for head of communications at the Metropolitan Museum. Is there anyone you could recommend?" And I said, "Me." I had just read an article about the Kennedy Center, where they had written a letter to Bette Davis and asked, "Who can you recommend to receive the Kennedy Center honors?" And she had written back and said, "Me." I don't compare myself to Bette Davis, but you know, it was in my head.

The first thing I did was visit the museum, as I hadn't been there in years. I had a ball.

I don't think when presidents vet vice presidents, they go through as many interviews as I went though. Finally, things were looking good, and I just had lunch with the director left to do. We were

walking to a French restaurant called Le Refuge, on Eighty-second Street, which evidently was one of his favorite restaurants, when he stopped short, and I stepped on the back of his heel. That was pretty awkward. Then at lunch he asked me what I thought of the artist Ribera, and I didn't really know who Ribera was. "Diego Ribera?" I asked. Just a stab in the dark. "No," he said, "Ribera, Jusepe de Ribera." And I began to feel that this honeymoon period, which had lasted about one hour, had just ended in a terrible divorce, based on incompatibility and ignorance. But we were ready to order dessert, and I asked for cheese, and he said, "I like a man who orders cheese. . . ." So I thought I might be back in his good graces, and the next day I got the job.

With all due respect to my predecessors, at the time I got there, everyone would just be waiting for journalists to call up and ask, "Isn't *that* exhibition about to commence?" and waiting for the reviews. We went out and promoted ourselves more, although it was a slow process because the Museum was not used to that idea. It couldn't be vulgar or excessive, no showmanship at all. So there was a process of working with the director and president to find a level of comfort in which they accepted being more aggressive. We went after television, we doubled our advertising, and then every museum started to do what we were doing, so the competition was elevated by another notch. I'm still looking over my shoulder all the time at other museums. I probably needn't, but I do. I'm competitive, I measure success in terms of inches of space in the papers. I still get out of bed at six in the morning to tear open the paper when there's an exhibition to be reviewed. That's the biggest thrill I get, although the night before is murder. Murder! I fret and worry about each story and how it's going to come out. I worry about the placement, I worry about the pictures, the tone. Gee, I hope they don't repeat

that thing I said en passant, that I now wished I hadn't said. But it gets my adrenaline going, which is good at my age.

I love walking through the galleries looking at people looking at art, whether they're acting silly, posing in front of a sculpture, or taking a picture of a painting that's not going to come out right. Just to see their eyes aglow. You couldn't represent a more fabulous institution. The Museum's for the obvious things, education and illumination, but it's also about a part of life that's to do with creativity and not about strife and conflict. I think it's a way to leave the hurly-burly of the present and to be absolutely transported by visions of beauty or reverence on a scale we don't experience anymore today, tragically, and to see how all that passion can be focused on something beautiful and extraordinary.

I can't believe I've worked here more than a dozen years, so much of my life has passed. I'm grateful to have had the opportunity, and I think I've more than lived up to it.

I'm also grateful because I have this other life, with my writing and lecturing on the Civil War and Lincoln. And Philippe is not only tolerant of it, I think he's sort of proud of it. He is a person who encourages scholarship, and although the scholarship is not coming from the curatorial side or evolving into something that is beneficial to the Museum, I like to think the fact that I am a person who has different parts and areas helps in the long run. I don't want to say that it adds prestige, but I hope they think I'm not just a PR person. It means a lot to me because it's the one moment where I am representing me, not someone or something else. So it is important, if only from an ego-assuring point of view, and I have a small but nice following of people who care about what I write, and I love the public speaking and the conferences and showing off a little bit.

The thing that interests me is that Lincoln wasn't handled, or created, like today, by professional political handlers or image makers. His image was completely evolutionary. It's fascinating to watch his evolution: Lincoln the great rail-splitter, the frontiersman, the self-made man, this exemplar of American opportunity. And then being transformed by his own decision to grow a beard, which helped turn him into the avuncular Father Abraham, the statesman, who was strong and wise enough to lead the North through the most difficult crisis ever. And, finally, the slow transformation of his image into that of an emancipator.

Without question, though, it's his words you should look at. Lincoln is the most astonishing American writer. Great writers like Whitman, Tolstoy, and Harriet Beecher Stowe have all remarked on his writing, the adroitness and the brilliance of his communication, not just the Gettysburg Address and the things that people are familiar with but letters; he was the most brilliant stylist and craftsman.

Certainly, everyone should read the Second Inaugural Address: "We deserve the punishment we are receiving in this war because of the sin of slavery," he said. A most astonishing thought for the time. And then he ends with the famous peroration: "With malice toward none, with charity for all, with firmness on the right, let us strive on to finish the work we are in, to bind up the nation's wounds. . . ." Fire and brimstone and forgiveness in one extraordinary speech.

My great fear is of burning out. The amount of time I have been spending at work is a killer. I get here at seven in the morning most days and do an evening related to the Museum most evenings. I spend nearly all of my weekends writing. Four years into the job I had a heart scare and a double bypass operation, which were pretty earth-shattering for me, and I was out of it for about six weeks. The

Museum was wonderful—visits, admonitions not to worry, kid gloves—and I milked it for all it was worth, let me tell you. I took off a lot of weight, and I went from 210 to 152 pounds. And now I have more energy than I ever did, because I discovered all these new worlds: eating healthy foods, exercising, things that I had never dreamed existed before. So I can go on forever now, if they don't get sick of me first.

James R. Houghton

"I'm a WASP from upstate New York . . ."

*Despite coming from a privileged dynasty, he yearns to be a man
of the people. But even if you don't know his background, there's
an aristocratic mien that he cannot conceal.*

It may seem strange that I am the Chairman of the Board. People
always assume I live in New York and go to Corning for the
weekends. But I don't. I live in Corning; Corning is my home. So
we compress all my meetings; we have one day a month when I'm
pretty solid Met, starting at 7:00 a.m. and going right through.

I grew up in Corning and went to public school, as did my
children—we didn't have to interview for kindergarten in a New
York prep school—and then in my teens I went off to St. Paul's, as did
my children later. We always believed we were nothing special, and
that we were going to walk down Market Street the same way as
everybody else. We live in a place where Saturday morning I will run
into the head of the union in the supermarket, where he can give me
his complaints about the company.

Corning is a tiny little town of fifteen thousand people, and it's
got one thing there, and that's the glass company. I am fond of saying
that our company is the largest international company with head-
quarters in the smallest town in the United States. My family started

the company, my father was the chairman, and I'm the fifth-generation Houghton who's been in the Corning Glass Works, now Corning Incorporated, so it goes way back.

Corning has had this extraordinary history. Most companies can't say they have made any inventions that have really changed the lives of mankind; Corning can claim at least three. Edison came to us in 1879 and asked us to blow his first lightbulb. We invented the cathode-ray bulb, first for radar in the Second World War and then for television, and we invented optical fiber, which is now the way land-based communication works around the world.

We don't bring people in at the top, even with family. You earn your way up. I joined as a shift foreman at a factory in Danville, Kentucky, making incandescent lightbulbs. I loved it; it was the best job I ever had. The greatest thing about being a shift foreman is that at the end of eight hours you go home, and there is nothing more to do: no papers to take home and read, no phone calls to make, you're done.

Next, I was in the financial area for a little while, and then I moved to Europe and ran our business there for four or five years. That was very stimulating. I then moved back to the States and ran our consumer products division, which was fun, and most of my career afterward was heading our international operations, not only in Europe but around the world.

I have been to most countries in the world, but my favorite country is India. Most people who live in the shelter of places like the United States think, "Oh, that's a dirty place with a lot of poor people," and of course, when you first go there, you must get used to the fact that you are going to have the hands out asking for money. But I just love it. The people are wonderful, plus, it's a beautiful country.

The Corning Glass Museum was started in 1951, when I was fifteen, and that was really the brainchild of my cousin Arthur, who was a brilliant guy. He became head of the Metropolitan Museum and was on the Board for years. The Corning Museum has the most comprehensive collection of glass in existence. There are other great glass collections in the world. The Victoria and Albert has a wonderful collection, the Met has a large and important glass collection too, but for concentration on one subject—glass—we've got the best there is anywhere in the world. It's unfortunate that Corning is such a long way away in upstate New York as it's kind of hard to get to. As a result, we get in a year the amount of visitors the Met gets in one week! This has always been frustrating to me, because we really have a world-class museum.

About ten years ago somebody suggested I might take over from Punch Sulzberger as the next chairman. I violently disagreed. "This is crazy," I said. "I am a WASP from upstate New York. I don't even live here. It just doesn't make any sense." But they kept coming back, and they finally persuaded me. So here I am. I became chairman in 1998.

When I took over, we had this complicated organizational setup with the president and the director as coequals, both reporting to the chairman. That caused all sorts of problems, because they were constantly fighting and sniping at each other, and the chairman would always have to settle things and make the final decision. When Bill Leurs retired as the president, we decided that Philippe, the director, would become the CEO and run the place, and the new president would work for him. That made my life a lot simpler because Philippe really runs the place now. This is just fine with me. He is brilliant and steers the ship with great dexterity.

Actually, Philippe and I went to Harvard together. We knew each other a little bit then, but not well. Philippe was interested in art, and I was interested in parties, so we didn't meet that frequently. But he and I have always got along well, and I think I understand him.

Once a year I make him write down on a piece of paper whom he would suggest take his place if he got hit by a truck. He didn't like to do that at the beginning, but he has sort of gotten used to it now. I keep the list in a sealed envelope in my desk. And the list changes. New people emerge, some become too old, etc.

The Met is an extraordinary institution, and I am absolutely awed every time I go there. And it's an amazing value. For twenty dollars you can spend the whole day at the Met; you can't go to a baseball game now for less than about forty dollars. I was at the Metropolitan Opera the other night for the *Ring*, and the seat I had was three hundred dollars. So twenty dollars is amazing; for that amount of money you can see the whole sweep of history.

Laurence B. Kanter

"You start by making twenty years of contacts . . ."

The Lehman Collection is apart from the rest of the Museum, and in some ways Larry gives the impression of being a loner too. But he is also humorous and engaging, and formidably interesting when he talks about some of the Renaissance and Old Master paintings as we toured the galleries.

The Robert Lehman Collection houses the private collection of the Lehmans Philip and Robert, father and son, who were New York investment bankers. They assembled it from 1904, when they bought a house on West Fifty-fourth Street, until Robert Lehman's death in 1969, when he left the vast bulk of it to the Met.

It was a typical early-twentieth-century New York limestone row house, albeit on a very regal street—the Rockefellers lived down the block—with very grand spaces inside. It was essentially one room wide, but three or four rooms deep, and six stories tall, illuminated by grand windows facing front and back, and a stained glass skylight at the top of a spiral staircase that wound up the center column of rooms, bringing illumination down. Because the Lehman house is all vertical, it would have been a very impractical house for a public museum and

a nightmare having the public tramping upstairs and downstairs; liability insurance alone would have been prohibitive.

Following Robert Lehman's instructions, we try to keep it looking like a private collection; he wanted it to remain intact and separate from the rest of the holdings of the Museum and, to the extent possible, exhibited in a way that reflected the atmosphere of Mr. Lehman's home.

The collection is almost encyclopedic; we have excellent collections of glass, ceramics, drawings, bronzes, virtually everything. But our greatest strength is the Italian Renaissance, in paintings, drawings, and works of decorative arts, and we also have a distinguished collection of nineteenth- and twentieth-century French paintings and drawings, the highlight of which are Renoir, Balthus, Bonnard, Matisse, Gauguin, Cézanne, van Gogh, all the usual greatest hits names. Jean-Auguste-Dominique Ingres is not a household name, but he is one of the finest painters in the world, and we have his portrait of the Princesse de Broglie, which is such a rich image. There is also an extensive collection of Old Masters, including our Goya, which is a great and famous painting, and a Rembrandt.

We have Rembrandt's portrait of Gerard de Lairesse. Lairesse was a theoretician and a painter, but he contracted syphilis, which in the end blinded him so he could no longer paint. This is an uncompromising portrait because here is a dying man. He is suffering from the well-advanced stages of syphilis. You can see he is ravaged by the disease, with pockmarks over his face, and his nose is badly eaten away. It's rather interesting that Robert Lehman would have bought this painting because while it was socially desirable to own a Rembrandt, a Rembrandt portrait of a syphilitic man is not something most gentlemen at that time would have wanted in their sitting rooms. So I

have always thought that Robert Lehman bought it with a sort of spitting in the eye of his social peers: "I own a Rembrandt, and look which Rembrandt it is," which rather encapsulates Lehman's complicated personality.

I would guess Robert Lehman could be a very difficult man, but beneath the gruff exterior you can see there was a sensitivity and sensibility which put together this most refined collection. Actually, the most astonishing thing is that he put the collection together himself; he was an investment banker, not an art historian, but he collected with a precision of taste and unerring sense of quality that very few collectors have come up to, except perhaps J. P. Morgan or Norton Simon.

His flaws had to do with price; he and his father liked to buy bargains. Also, if I'm finding fault, his taste for French art is not as refined as his taste for early art, and amid the truly great objects are some really forgettable objects, many of them just stylish at the moment when he was buying and of no real lasting value as works of art. But that having been said, he bought some of the most astonishing objects, and he bought an amazingly small number of forgeries at a time when every active collector was accumulating forgeries at an incredible rate.

When I started going to the Cleveland Museum of Art as a child, I never felt like a privileged guest. The museum was very wealthy and well endowed, and it didn't care if anyone ever came into it or not. No museum survives that way today. Museums today don't do anything without having half an eye seriously glued to the bottom line. What works on the bottom line is entertainment, and so we compete with movie theaters and sports complexes for our audiences. Therefore museums become palaces of entertainment, because, frankly, entertainment will pay the bills.

That is fine as far as I am concerned. I will do whatever it takes to keep the machinery going, to make sure the next generation has a chance to enjoy what I have enjoyed. It's very rewarding to see a lot of people looking at things. But I do resent seeing thousands of people crammed together to look at someone because he's on some bestseller type list of artists. The Metropolitan recently did a large and very handsome exhibition of Leonardo da Vinci's drawings, which was attended by hordes of people anxious to see even the tiniest scribbles of this legendary genius. But it was a completely undiscriminating audience; they didn't care what was shown as long as Leonardo was the name on the banner. Leonardo deserves to be in the top ten, but an even greater artist is Raphael. He is a truly sublime artist, but a Raphael show would attract half the visitors that Leonardo could. If we did a show of Velázquez, the people who know would come, but the great masses would not, and Velázquez may have been the greatest painter who was ever born. Fra Angelico should be in the top ten, but I know he is not. We can show Titian, Giotto, and Duccio to the public, but unless we can mix them with van Gogh, the public won't come in large numbers.

When we do attendance projections for exhibitions, if there's a van Gogh in the title, you start with six hundred thousand as your head count, and you can move up from there. If you have Duccio in your title, you start with two hundred thousand. Is Duccio one-third the artist of van Gogh? Frankly, I think he is three times the artist van Gogh is, as much as I admire van Gogh.

We've just had an exhibition of Fra Angelico. It took three years to put it all together, and that is actually a year less than I would have liked to have spent on it. We like to dedicate four years to a major project, enough time to do the refined research you need, not just the generic research that led to that project in the first place, and it

allows you to compose a catalog that's a meaningful contribution and enough lead time to negotiate the trickiest of loans. But in three years we had to accelerate all that, so the loan negotiations were going on at the same time as the research and the writing, which made it a bit hairy for a few moments.

Generally, when you're starting out on a project like this, the best policy is to start with the people you know best, to whom you can explain most comfortably what your project is. Then once you've got a certain critical mass, you can use that to leverage other involvement. So you start by making twenty years of contacts; you can't do these shows fresh out of graduate school, no matter how clever you are, because there's a lot of networking involved.

Altogether about 130 paintings were in the show. The Met contributed 9 works to the exhibition, so most of them were loans, and the 121 that were loaned came from around 50 different places. So many people were very generous, although I could tell you the-ones-that-got-away stories all day long.

Some institutions cannot lend by terms of the benefactors' gifts; there was a painting in Switzerland I very badly wanted, and that museum simply could not lend it. Some institutions own pictures that are just too fragile to travel. Frankfurt had a painting I coveted, but it's on a very thin panel, and the curators told me they couldn't in good conscience send it across the Atlantic. Munich has four of the greatest paintings by Fra Angelico that it was simply unwilling to have absent from its galleries for the length of time this exhibition would run, but it felt bad about being unrepresented in the show, given how closely it's identified with Angelico, so it asked if I would take consolation prizes, and it had Angelicos in storage that had never been seen by anyone. I was only too happy to have them.

Angelico's pictures are made on wood panels, and wood panels are

more fragile and more susceptible to environmental change than canvas. When they're small, it's possible to protect them in ways that make them safe for travel, but when they get up to nearly a meter in size, you're straining the limits of technology for how much you can protect them in transit, so we hesitate before we ask for anything over ninety centimeters.

The final problem setting up this show was that because these paintings are so highly esteemed by their collections and the collectors who own them, it's often a real song and dance to persuade anyone to let them go. But I would say the Met has a cachet that few museums can compete with: not only are we big and prominent, but also we're in New York, and a lot of people want their things seen in New York. It's exposure on the big stage.

I began this project believing Angelico was a truly great artist, but once the pictures arrived here, I realized I had appreciated only a tenth of the subtlety of the man's genius, I had only grasped the shadow of the true profundity of his mind and intelligence. And it suddenly dawned on me that he was far more exceptional than I had ever imagined. These paintings represent the great moments in time when humans are contacting other humans on a level that you don't encounter very frequently, and these experiences are like epiphanies.

The exhibition lasts till Sunday, just two more days. It will be heartbreaking, truly heartbreaking, to pack this exhibition away. I don't want the paintings to leave. But packing starts Monday, ten o'clock, when museums from all over the world will send their couriers here to retrieve their treasures. It's going to be a very difficult week.

We've had 250,000 visitors to this show, which is an incredible number for an Old Masters' show. I am glad that people have been enthusiastic and interested, but it's been a toll; I have had to give two

tours a day for the last ten weeks, and I've been worn out every day. Sometimes I wished the public would go away, because I couldn't bear giving any more of these tours. This morning I had 350 people on a public tour, and you can't talk to 350 people meaningfully; in fact the galleries aren't big enough to hold more than 100 comfortably. So it's been tiring.

Any curator who does an exhibition in which he has been very personally involved gets very depressed at the end, and this one was very, very personal, so I'm very, very depressed. But it'll pass quickly. You see those piles on my desk? Those are all projects that I turned my back on while the exhibition was going on, so at least I'll be distracted from my unhappiness.

Although the exhibition has been a dazzling success, it's made me never want to do another exhibition again. I find it very distasteful that one becomes identified with this success. There's a veneer of personality hype that goes with it that I had absolutely no way of expecting. Your stock suddenly rises, and people are staring at me now because they know my name, and frankly, I find that pathetic. I mean I'm no different from me five months ago.

I don't know what my next show will be. I know the expectations are already high, but I want to do something serious, whatever its reception will be.

Harold Koda

"Men don't wear pearls . . ."

Like the Lehman Collection, the Costume Institute is another world unto itself, squirreled away in the basement of the Museum. When we meet, over tea in the Trustees Dining Room, we talk about Harold's Hawaiian background and various career moves before his return to the Met. After about an hour I realize, with a shock, that the tables around us have been colonized by trustees straining to listen to his stories.

Mrs. Vreeland was what the French call *belle laide*, striking-looking, but not pretty, by any standard of beauty. By the time I met her in the mid-seventies, she had defined her look to the one she kept until she died, which was hair dyed jet black, pulled tightly back from her forehead in a kind of samurai way, and falling down into a pageboy cut. Then a sort of kabuki makeup, with powder and a slash of red lipstick, and on high occasions she would put rouge on her forehead as well. Truman Capote described her as "a toucan tossed screeching out of the jungle" because she also had this very prominent nose. She dressed very simply, a black cashmere sweater, and a red cashmere sweater around her waist, black trousers, and red Roger Vivier python boots, and at night she would dress in haute couture.

Before Mrs. Vreeland, fashion and costume were regarded as

historical artifacts. If you went to any costume museum, it was all very fusty. She, on the other hand, attempted to capture the excitement of fashion. Her methodology was to focus on personalities; her premise was that history is made by individuals. Also, she always concentrated on the aristocratic: she was incredibly elitist.

And her exhibitions were absolutely transportative extravaganzas. The V & A would lend 150 pieces for a show—no one does that anymore, you are lucky to get three things on loan—and there would be another 200 extraordinary treasures, loaned from all over the world, and half a million people would come to see it.

She put on a show on Diaghilev; she saw him as important in introducing a form of modernism through his collaborations with Stravinsky and Picasso. I worked on that one, although theater costume doesn't really thrill me, but her way of presenting it was wonderful and a real learning experience.

I was asked to make a crown for Le Dieu Bleu, the blue god, who was Vishnu. I studied gouaches and photographs of Nijinsky dressed in the costume and made a headdress based on that. She sent me down to Kenneth Jay Lane, who has become rich making costume jewelry and is most famous for doing Jackie's fake pearls, and I picked all these cabochon rubies, emeralds, and pearls at Kenny's atelier, and started making the crown.

I was thrilled with the result. Mrs. Vreeland came in and looked at it. "Hmm," she said, "that's not right, men don't wear pearls."

"But, Mrs. Vreeland," I exclaimed, "the Bakst drawings show pearls, and if you examine the photographs of Nijinsky, there are definitely pearls."

Again: "Men don't wear pearls."

"But Mrs. Vreeland, he is an Oriental prince, a maharajah, and they wear pearls and diamonds."

"Men don't wear pearls," she said again, and walked away.

I was incensed. But I painted it all out gold that very night, and when she saw it the following morning, she was pleased. "*Now* he is the god of thunder and lightning," she said. "Now he is a warrior." And she was right. Mrs. Vreeland wasn't about historic fact; she was about capturing the essence of an idea.

You either loved her or dismissed her, because she could seem incredibly trivial. Academics hated her shows. But her exhibitions got you engaged; you suddenly cared about whatever she was putting on because she was able to make it exciting just by the sheer extravagance of her installations.

I did another project for her. Her premise was that women were the centers of power in the eighteenth century, ladies like the Marquise de Pompadour, Marie Antoinette, and Madame de Sévigny. She called me in and said, "I need a wig." I knew what she meant. In the 1770s, there was a fashion for these huge hairdos, and when there was a naval battle, women of the court would insert models of warships into the waves of their hair. So I studied paintings and prints from the period, and then in my loft I began to make the hairdo. It was huge, and with the warship in it, it was about two and a half feet high. I wrapped it up, took a Checker cab to the Museum, and unveiled it to Mrs. Vreeland in her office. She took one look at it and went, "Hmm, let's see it on the mannequin." I knew she was disappointed, although I didn't understand why, because I thought I had replicated it accurately. I plopped my hairdo on the bald mannequin, and as soon as I stepped back, I understood exactly what she felt. It was historically correct but it wasn't big enough. What Mrs. Vreeland wanted was the surprise of a roomful of people as the woman entered with a ship in her hair, a hairdo so large she had to open the sedan chair roof as she traveled, a hairdo that

brushed the chandeliers when she arrived. "You know," she said, "sometimes the caricature is the truth."

So I went back home, and this time I made a hairdo that was the maximum dimension accomodated by the height of the ceiling of our galleries. When it was finished, I brought it in—it was incredibly heavy, even though it was papier-mâché—and then she purred— she would always purr when she was pleased—"Mmm, *now* she can go to the guillotine."

Our twentieth-century collection has no equal in the world. We have every major designer and many of the iconic pieces of the works of those designers. For example, we have Chanel's little black dress, and no other institution has that.

In 1926 Coco Chanel did a collection that had a series of black dresses, beautifully done but very pared down and unornamented, which was very much in line with modern aesthetics. It was a significant collection. American *Vogue* called it "the Ford from Paris," and it was seen as the style that everyone was going to wear and embrace.

The '26 dress, *the* little black dress, has crêpe de chine elements, but it is primarily black wool jersey. This was audacious because earlier if you didn't dress rich, you didn't look rich, and you couldn't play poor. Chanel was the first designer to do reverse chic. Chanel introduced the idea that you could wear what the maid wears, a simple jersey dress. Still, her cultivated ladies would not really want to look like their maids, so her dress had the finest of details. The pleated jersey was finished with a really finely done binding of silk satin and a satin waist and hip yoke that are not seen, as they are obscured by the jersey. The woman wearing this dress was really wearing silk satin but looks to be wearing wool jersey. She was dressing down at extraordinary expense.

When Poiret first saw the Chanel collection, he called it "poverty

de luxe." He meant it dismissively. Poiret, despite the fact that he was really the first modern twentieth-century designer, still had the fin de siècle idea of women. Mrs. Vreeland had this funny line: "Poiret models entered the room like Percheron horses," meaning they looked like the zaftig figureheads on a boat.

My two favorite designers in the twentieth-century collection are Vionnet and Balenciaga. With Vionnet, clothing was transfigured into art. She did something very simple, which I will explain in words, although you have to see it, really, to understand.

Fabric has a straight and a cross grain, a warp and a weft; it's a grid. When you pull the fabric one way, on the cross grain, the tensions of those threads establish how far it can stretch. If you pull it the other way, on the lengthwise grain, it stretches a little bit more because the threads are longer. However, if you turn it on end, the grid becomes diamond-shaped and incredibly elastic, the fabric almost stretches by half; it's what you call true bias. Once you put cloth on the bias, you end up with these triangular pieces, and front seams merge into back, and the dress becomes very much a cubistic expression. Vionnet played with this in her designs.

We have dozens of her pieces, but my favorite is the honeycomb dress, which is a black organza with honeycomb shapes graduated toward the waist. It's sort of counterintuitive because as the pieces get smaller, they actually pull up more fabric, pulling the dress in. So Vionnet's seams are the ornament, and the ornament is actually the structuring device. Frequently she would emphasize the ornamental aspect of her pattern pieces with something called faggoting, where she could underscore the actual orientation of the grain through a decorative element.

My other favorite, Balenciaga, was Spanish, from San Sebastián, and worked in Paris after the war. He was a master tailor in the most

traditional sense. Balenciaga looked at traditional tailoring and structuring devices and evolved the shaped pattern piece. Unless you shape a pattern piece, you don't get fit; every dart and every seam are the opportunity to pull the fabric to the body. That's why tailoring has all of those seams; otherwise cloth would remain two-dimensional, flat. But every single intrusion to make that piece of cloth fit is a kind of scar, and Balenciaga kept excising and reducing until at the end, if the fabric were wide enough, a dress might have just one seam, one scar. Yet it had all of this shape. Sometimes Balenciaga would carve up the front hemline of a gown so as you stepped forward, it would aspirate, and then at rest it would collapse. Everyone acknowledged that he was a genius. Even Dior said of him, "I have a house of 1,000: Balenciaga has only 500, but his is the greater house."

We have many things that have been given to us by the designers themselves. This is important, because since the 1970s there has been an increasing break between what is seen on the runways and what is worn by the women who can still afford to have couture clothing made for them. What has happened is that the couture has become more exaggerated in its effort to garner press.

Also, it has always been the case that the couture client could modify the designs, but there is a certain point at which a design begins to deviate simply because of the size and proportion of the client. For example, a narrow-shouldered jacket is no longer faithful to the designer's original intentions if it has been modified for someone who has broad shoulders. Even its size ends up transforming the aesthetic of the designer. Because the Costume Institute is about artistic expression, we pursue material directly from the designer, where the design is purely the expression of its creator and is not modified by a buyer, like Bergdorf Goodman or Barney's, who might say, "It's pretty in brown, but we can only sell it in black." Also, it's only on

the runway that you see the uncompromised vision of what the garment is supposed to be.

One of our most extraordinary pieces is a very space-agey Jean Paul Gaultier from the 2003–2004 collection. He has done a catsuit in pale pink wool gabardine with what appears to be a short jacket, but there is no front, there is no back, and the jacket blurs into the trousers. It is as if different parts of the garment have melted together. We have extraordinary examples of Ralph Lauren, in particular a midnight blue evening dress that takes African textile patterns and uses them as a sophisticated beading pattern; it's thirties Hollywood meets equatorial Africa.

Geoffrey Beene, who died in 2004, was like Vionnet in that he invented an approach to dressmaking that didn't exist before him. My favorite piece of his is a black dress with an odd pairing of black leather and black jersey. It has an asymmetrical holsterlike halter neckline that holds it all up, morphing over the body with a surgical precision that is beautiful to see. The dress is executed with a finesse that is not typical of American design. I couldn't understand how he could finish it without some tension at the seams, and I asked him how he did it, but he wouldn't tell me. He just laughed. He got pleasure from the fact that I understood that it was a major technical accomplishment, but he wasn't going to give anything away. It was like a magician's sleight of hand.

We have everything in our galleries. We have Pucci. There was a certain moment in the sixties when everybody had Pucci, but I prefer the Pucci of the fifties. They are wonderful manifestations of Italian design, when Emilio Pucci did extraordinary après ski clothes and palazzo pajamas. There's also Missoni, a woman's hooded sweater, long-sleeved with a hood, that has been knitted in an astonishing origami pattern, all in one piece. Not one component, hood, sleeves,

bodice, is a separate pattern piece. It cannot be replicated today because the complexity of this thing would price it out of the market. It would cost something like six thousand dollars for a one-piece hoodie.

The only problem is that we don't have enough space to show everything. Philippe has suggested we consider inserting costumes in some of the period rooms, but that really makes me nervous because we have all seen those exhibitions where a woman in homespun is stirring a pot over a fake fireplace and a sad-looking child is collapsed in the corner. It could be monstrous.

Henry R. Kravis

"And then we started buying Picassos . . ."

We meet in the library at his office in Manhattan. The picture window gives an unforgettable view of Central Park. Not just a part of Central Park, but all of Central Park and farther north, until one can see, or imagine one is seeing, Canada.

I really didn't grow up with art; my parents had a couple of second-tier eighteenth- or nineteenth-century paintings and a picture of some symphony orchestra by an unknown artist over the fireplace, but there wasn't anything very important.

As a kid I collected baseball cards and first-day-issue stamps; my favorite was the Eisenhower inauguration stamp because he was such a war hero. But my baseball collection meant everything. I had Lou Gehrig, Mickey Mantle, and Roger Maris, which was the greatest one to have. But I'll never forget one day. . . . I came back from school to our home in Tulsa, and I was looking for my baseball card collection. I couldn't find it, and finally I went to my mother, who informed me that she'd thrown it out.

"What do you mean, you threw it out?"

"I threw it out," she said, "because they were just cluttering up the place, and they aren't important."

Not important! Not important? I spent the last years of my childhood collecting those things, and in one fell swoop they were all thrown away. I was very upset about it, and I don't even want to think what they might be worth today.

Actually, that episode taught me I am a true collector because I realized how passionate I was about those cards. Even today when I buy something, it's because I feel passionate about it, unlike some people who just buy names to hang on the wall. It's like "Hey, look at me, I'm rich, so I can afford this. . . ." There's a big difference between a real collector and somebody who buys art because he wants to put something up to impress his friends, and if someone comes along and offers a 20 percent higher price, it'll be gone that day.

When I came out of college, I started collecting what I could afford, which was lithographs and some lesser-known contemporary artists where I could buy original work. As I made more money, I would buy a little better contemporary. My first wife didn't really care about art, so I just went out and bought what I wanted.

Eventually, I gave most of that collection away; I believe you have to give back to society. I wasn't a bit sad to get rid of it because it wasn't a great collection; it wasn't that important.

There was also another reason: I had got married again, and my second wife, Carolyne, was not really interested in contemporary art; she was much more interested in nineteenth-century European painting, and John Singer Sargent in particular. So I started thinking about that, and I said, "Fine, I agree, let's collect him." Some Sargents came up, and I bought four good Sargents, and then I moved into buying Impressionist pictures.

I will never forget one particular Sotheby's auction when I was bidding for a Renoir and a Monet, all in the same evening. I had somebody representing me at the sale because I was in Chicago, negotiating to buy a company called Beatrice Foods.

When I got a message that we had been successful and had acquired both paintings, I was ecstatic. Well, one side of me was, the other side was scared to death; it was the most I had ever paid for art. I really stretched to buy those pictures, and it wasn't as though I had a lot of money at that time. I was worried whether I could ever get my money out if I needed to for some reason.

But I had to have them. The Renoir was a picture called *Reflections*, a small picture of a young woman with her hands on her cheek, and the Monet was a poppy field picture. They just spoke to me, particularly the Renoir. I thought, "My God, isn't that face beautiful?" I can get very emotional about art; I have always had an emotional response to what I am looking at. In the Prado, in Spain, there is a Goya picture of an execution. The prisoners are lined up in front of a firing squad, and every time I see it, it just hits me in the gut.

Later I got divorced and married Marie-Josée, who truly understands art. She loves it, and is passionate about it, and we talk about it all the time. She kept saying we should move more toward modern pictures and then eventually contemporary pictures. The more she talked about it, I absolutely began to agree. And so we bought a couple of fantastic twentieth-century paintings.

We don't just collect pictures. We have, I think, a reasonable collection of eighteenth-century French furniture; well, Philippe and the French curator have said so, so I assume that is the case. We also have some eighteenth-century French mounted bronzes, Limoges, German turned ivories from the sixteenth century, and some sculpture.

I remember a wonderful discussion with Henry Wyndham, who is the chairman of Sotheby's Europe. We were having dinner, and I asked him, "So what should I collect?" "Henry," he said, "I'm not going to tell you what to collect, but whatever you collect, collect *the* best piece you can possibly afford. You're going to be much better off buying one good piece as opposed to five mediocre pieces." I've thought about Wyndham's advice a lot, and kept it in the back of my mind.

It helps that dealers will call us to say they have something we must come see. Every single piece in our collection today Marie-Josée and I found by searching ourselves. We constantly go to museums and galleries; in my view, the only way you can be a good collector is to look at a lot of things. It doesn't happen by osmosis. You can read about the artist, and that's important, but you have to look, and you have to compare the artist's output to train your eye. There are many Picassos, and some of them are not great, but all of a sudden there comes a day when you realize your eye is good enough to see, "Hey, *this* is a really good Picasso," or a great Matisse, or whatever.

We love being able to find the different pictures and put them together. In our apartment in New York we have all eighteenth-century furniture, but we have modern and contemporary art; we go from Manet to a 2001 Chuck Close.

Seeing them in my homes gives me real excitement. If I am in a so-so mood when I get back from the office or a business trip, I will sit in front of a picture, and it makes me feel better. We have a wonderful Giacometti dog sculpture in the entrance; it's such a skinny little dog, and when I look at it, I just smile.

The difference between having something in my bedroom, or living room, and looking at it in a museum is that I can see it any time of day or night. If I want to get up in the middle of the night and go

look at it, I can go look at it. I can't go to the Met at midnight. Also, I don't have to say "excuse me" because there are five people in front of the object or painting.

I'm very lucky. I have the most wonderful life: a beautiful, fantastic, brilliant wife; I love what I do from a business perspective, and my partners and I have built a wonderful firm together, which affords me the opportunity to do the not-for-profit things I really enjoy.

I have been a trustee at the Met for close to twenty years. It was a great honor to be asked. I have not been as involved in the Museum as I would like, but that's only because of time. I have so much on my plate, and I travel so much; I am in Europe every month and now Asia several times a year. But I'm happy to be able to help the Met where I can. In fact one of the happiest days of my life was the day in the early 1980s I agreed to give the Met ten million dollars to do the Kravis Wing. My wife at that time, Carolyne, came home and asked, "What are you so happy about?" I told her that I had just agreed to do this and that I was ecstatic. She didn't understand. "But *why* are you so happy giving that amount of money away?" And I said, "Because it's going to help other people have a place to see what we should all see, which is beautiful art, and in this way I can give back." She finally understood.

It's very important that I can give back. I love doing so. Believe me, I am not a bleeding heart liberal; in fact, if anything, I am reasonably right of center in most things. But I am really proud of how the Kravis Wing looks. It is fantastic. I just think, "This is a great addition to the museum," and to be able to have it in such a wonderful place is really important to me.

Walter Liedtke

"Very arty beret, slashed sleeves, with a big, pleasant smile . . ."

Walter bristles at a mention early on in our conversation of Tracy Chevalier's Girl with a Pearl Earring, *which suggests he might be a stuffy academic. But he can quote lyrics from* The Doors, *and he drives a big pickup truck, so go figure. There are five Vermeers at the Met, extraordinarily beautiful ones, as it happens, and I think he is a little in love with each of them.*

I am just a kid from New Jersey who fell in love with art history. My father was a painting contractor; he employed maybe fifteen people, and in my teens I started helping out in the family business. I didn't learn much, just basics, how you thin paints and how you can create different colors, which is complicated, but not nearly as much as it was in the seventeenth century, when the pigments were ground by hand in the studio.

I didn't really know what I wanted to do with my life. I went to Rutgers because that's the state university, and it's a good school and less expensive than Ivy League schools. Because my father was in business, I became an economics major, but in those days you had to have a humanities elective of some kind, so I took the art history survey, and I loved it. The year 1967 was high hippiedom, even at Rutgers,

and I think that gave me the confidence to get out of the rather un-cool field of economics and into something artsy. I realized that an undergraduate degree in art history is not worth much unless your father owns a major art gallery, so I committed to a serious graduate education at that point and went off to Brown for two years and to the Courtald Institute in London for four.

I remember very well driving into Providence, then up the hill to Brown University. That was the year the first album of The Doors came out, and "Light My Fire" played in the streets all the time: "Girl, we couldn't get much higher . . ." There were a lot of very pretty undergraduate girls, and I had a new Austin Healey in British racing green, so that was a nice time. Rutgers was a good experience, but Brown had a more distinctive character, and because that's where I first concentrated on this field that I still love, I have alma mater–ish feelings for Brown.

The first Vermeer I saw was in this Museum, and it is the Vermeer I am probably still fondest of, *Young Woman with a Water Pitcher*, which actually was the first Vermeer in America.

Young Woman with a Water Pitcher represents a sophisticated Dutchman's view of an ideal young woman, possibly a wife, in an ideal home, a kind of synthesis of *Vogue* and *Architectural Digest*. Think of the photos you see in those magazines. The houses look real, the women are real, and yet in real life you rarely walk into such rooms or see women dressed in that manner. The young girl's head and shoulders are covered with a brilliant white kerchief, which is a metaphor for spiritual purity; the intense sunlight falling through the window is filtered through the white headdress, so it tends to schematize her features a bit. Her right arm is raised to the edge of the open window, which is leaded clear glass, a brilliant passage of painting, and the other hand is reaching back to the table and grabbing a silver gilt

pitcher and basin—very high-class stuff, it's obviously a patrician home—and seems to be still moving slightly because the handle and her thumb are blurred. The basin and the pitcher, which were literally for doing your morning ablutions, the sophisticated viewer at that time would recognize as symbols of the purity of the Virgin Mary. Deliberately difficult problems of representation are set up in this picture. There are a lot of reflections of light, and the Turkish table carpet is reflected in the basin.

If the subject were just an attractive woman in a modern interior, it would perhaps have taken three weeks of painting. What you are looking at here is three months of work. Vermeer's paintings were valued at five or six hundred gilders, which was the average annual middle-class income, so the person buying such a picture, Pieter van Ruijven, a minor nobleman who inherited a lot of property in Delft, obviously had a simple discretionary income, and he was buying two Vermeers a year, so he was Vermeer's best audience.

We have four more Vermeers here. All five of them have women in them. That was partly their selling point at the time, but also Vermeer's world was very female-dominated: he lived with a wife and a mother-in-law, and of his thirteen children, ten were girls.

A Maid Asleep (which was painted around 1657) is our earliest example of Vermeer's work. This picture represents a maid, not asleep, but apparently daydreaming, because she has this smile on her face. She is seated at a table, and her elbow is propped up on the table, and her head is resting in her hand. We know from X-rays that originally Vermeer had painted a man leaving the house, and also a dog in the open doorway next to the maid, looking backward toward the man. But Vermeer revised the painting in a way that made it subtler. Because half of his paintings were sold to a particular collector, he

could afford to be a bit less obvious in meaning than if his pictures were going out into the open marketplace.

A Maid Asleep has also got brilliant flashes of painting—the contrast of light and shadow, like the streaks of daylight on the doorjamb, and the woman's face—although at this point in his career Vermeer hasn't perfected the use of perspective, and he has trouble getting beyond the surface. In this, as in his next four or five pictures, he sets up barriers, like a tabletop or a passage of drapery, to establish the picture plane, and he then puts the main focus of the composition—in this case the maid—behind the tilted-up tabletop. All of his early paintings have objects cramming the foreground, the purpose of which is to create a believable space, but only a year later he is beyond all that.

Woman with a Lute is much more obvious in its meaning. You immediately understand that it's a scene of courtship. A woman is seated behind a table, strumming a lute. One hand is on a tuning peg, which for the literate person of the time is a familiar sign of temperance: as you tune an instrument, you tune or temper your own emotions or sensibilities. She is looking out of the window toward the street with a clear smile on her face. It's hard to see, because the picture, especially at the bottom, has been roughed up by cleaning in the past and also has darkened chemically with age, but if you look for it, there is a big viola da gamba resting on the floor underneath the table. Also, it was very common to perform a duet with a viola and a lute. She is expecting a man to come and play beautiful music with her.

Portrait of a Young Woman is our version of the *Girl with the Pearl Earring*. This young woman is possibly one of Vermeer's daughters. She has a very reserved smile, only just acknowledging the viewer,

and she's wearing a satin costume with a silk scarf wrapped around her head, and this colossal pearl earring. In conventional terms, this girl is not a beauty—she has a blunt forehead, and her nose is kind of short—and yet there is something hauntingly attractive about the face. It is so open, youthful, and friendly that it just pulls you in.

Our final painting by Vermeer is the very unusual *Allegory of the Faith*, meaning the Catholic faith, which was painted in the early 1670s, late in Vermeer's career. It's a very symbolic picture and was probably painted for a wealthy Catholic patron. The state did not allow any outward sign of Catholic worship, but Catholic churches existed within private houses, and everybody knew where they were. The figure is conventionalized as a French or Italian saint might be, and she is seated in what seems to be a Dutch interior, but it is dressed up like a kind of chapel, with a tapestry thrown on the floor, a big painting of a crucifixion behind her, some gilt leather on the wall, a marble black-and-white floor, which was not seen in any but a princely house at that time, although Vermeer used it frequently, part of this *Architectural Digest* scenario of idealizing interiors. She has one foot resting on a Dutch globe, which suggests that the Catholic faith rules the world, and she is looking up theatrically at a clear glass sphere hanging from the ceiling, which was a decorative object of the day but here stands for heaven. Various attributes of the Eucharist are on the table: cross, crown of thorns, chalice, Bible. On the floor a bitten apple has seemingly rolled away from her, but in the immediate foreground is a sign of original sin, a big block of stone crushing a snake, which stands for the devil or evil.

The power of Vermeer, I would say, is that he makes the conventional unconventional; he takes the current realistic style of painting

modern life and then raises that to a higher power on the basis of what clearly was a personal fascination with the way things really look in the environment, particularly the behavior of light. Vermeer adopted popular themes, taking stylistic conventions of the day, but arranged compositions and put a spin on them which make them much more evocative and subtle than they generally were. It's like going to see a Hollywood movie about modern life and then watching an independent film on the same subject, which has more layers of meaning than you would ever have expected.

If you want to know what Vermeer looked like, there are two pictures which include self-portraits. One is *Allegory of Painting* in Vienna's Kunsthistorisches Museum, where we see the artist from the rear, so that is not too helpful. The other is the dashing figure on the left in *The Procuress*, the big canvas of 1656, when he is quite young, which can be found at the Staatliche Kunstsammlungen in Dresden. There he is, painted in rather broad and bold colors: a young man in a very arty beret and slashed sleeves, with a big pleasant smile, grinning at the viewer. He's attractive but not strikingly handsome, an average guy really.

Allegory of Painting is a complicated and sophisticated picture about the profession of painting. Vermeer is seen from the back, just beginning to paint a coyly smiling female model who is dressed up as Clio, the muse of history, and there are examples of art forms—drawings, sculpture, tapestry—that are illusionistically described in a virtuoso fashion. The scene as a whole is an idealized image of Vermeer's studio, and it was kept in his actual studio for visiting connoisseurs to see; they would surely have been struck by the difference between what they saw in reality and Vermeer's imagined world.

My job in this Museum certainly takes up all of my professional

life, and I work at home a lot too. But I am not like some curators
where it is their entire life. I have had a very happy marriage for
twenty-seven years, no kids, but two horses, a dog, a cat, and chick-
ens at home, and I am down every morning at six o'clock cleaning
the stalls and feeding them all. I also have a big truck, my wife and I
each have chain saws, so we do a lot of work in the yard, which we
love. . . . I would say that I am a very contented man.

Christopher S. Lightfoot

"The trouble is, he's lost the top of his head . . ."

*Talking about his subject brought out Christopher's humor and op-
timism, and I left feeling certain that this passion for his work, and
obvious love of life, will see him through.*

I was brought up in Birmingham, England, which in those days,
the late sixties and early seventies, was not a great cultural center.
In fact people looked upon you as being some kind of cultural ig-
noramus if you came from Birmingham.

But there was a very strong classics tradition at my school, and at
age eleven, I started learning Latin and opted to do Greek too, and I
then developed a real interest in the ancient world and began read-
ing Livy and Herodotus. I found these stories of actual events
twenty-five hundred years ago fascinating. Also, I was a slightly soli-
tary child, and it seemed a good way of escaping from the modern
world, and I wanted to escape. I found the modern world a little too
complicated and fast, and I am now the Roman specialist in the
Greek and Roman department.

Our most famous bronze is the so-called *Baker Dancer*, which is a
Hellenistic figure of a veiled and heavily draped lady with a swirling
dress around her, probably late fourth century B.C. I'm not all that

enamored of it. Yes, the figure is artistically fine, it's beautifully made and has movement, but it doesn't say anything to me about the culture that produced it. I am fascinated by objects if they tell me a story about who made them, why they were made, what they symbolized, what they meant to people. So I get much more excited over, say, the diploma we have in our collection. That is the little bronze plaque issued to a Roman soldier after he'd served twenty-five years, a discharge notice, which proved he had served his time in the army and was now a Roman citizen and had certain privileges.

This particular fragment is fascinating because it was issued by Emperor Trajan to sailors from the imperial navy, and the date is such that it probably means the owner of this plaque served on one of the flotilla or possibly even the actual ship that Trajan sailed on from Rome to embark on the Parthian war of A.D. 114. So you see, that object has something of a history to it. It's not a great work of art, as *The Baker Dancer* is, but to me personally, I find it much more fascinating, because *The Baker Dancer* is a beautiful object, end of story.

There is no point in having the art on display if it doesn't provide connections for people or encourage them to learn more about what they are looking at. Otherwise it's just eye candy, isn't it?

I must put in a word for my favorite, *Trebonianus Gallus*. He's this huge over-life-size bronze we have in the collection here. He's the only full-length statue of a Roman emperor we've got, and he's known by everyone as Pin Head because proportionately his body's much larger than his head. He's nude, aside from just a little drapery over his shoulder, and even though I've immersed myself in the ancient world for nearly forty years, I still can't understand how a world leader could want to present himself with no clothes to the general public. He has suffered over time. He was badly crushed, and he's been reconstituted and has got patches on him. Also, we had to open

him up to look inside, so he has a plate in his back between his shoulders where we inserted laser-type wires. I feel rather sorry for him.

I find the whole presentation of the imperial image interesting. Trebonianus was just one of a quick succession of military emperors in the third century A.D., a time when there were political, economic, and military crises all mixed up together. These military emperors were not sophisticated philosophers immersed in the classical world, like Marcus Aurelius; they were hardbitten soldiers from the frontiers who probably couldn't even write their own names.

Our most famous Roman portrait is of Caracalla. He was an early-third-century emperor, the son of Septimius Severus, who died while campaigning at York. Caracalla had been there with him, but he then abandoned the campaign and went straight back to Rome, where he murdered his brother, so that he wouldn't have any problems with succession. It's a very powerful portrait of him looking extremely grim and dour, and he has a very short beard, a tradition begun by Hadrian, and from Hadrian onward, Roman emperors had rather curly, extravagant beards. We have quite an interesting marble bust of Hadrian—the trouble is, he's lost the top of his head.

We don't have the same system here as in the British Museum, where visitors can come in with objects more or less every afternoon of the week. That's because the British Museum is a public museum, therefore the curators are civil servants, so they have to provide a public service of identification or authentication. Having people walk in off the street with objects is sort of discouraged here, but I think it's useful and interesting to see the things they bring, so long as it doesn't take up too much time.

I acquired a ring in that way for the department a couple of years ago. A lady rang up; she had a ring she wanted to show to somebody. She was very keen to get the Museum to acquire it, not because she

wanted to make a profit out of it but because she thought it was an interesting ring and the sort of thing this Museum should have.

When she brought it in, I knew immediately what it was—it was a triple finger ring—as I had published an article on double finger rings, and I remember saying, "The only known example of a triple finger ring is in the Benaki Museum in Athens." This was the second, so it was an incredible find. And it's a lovely and unusual thing. It has three hoops soldered together with little gold studs, so that it forms something like a knuckle-duster for three fingers together. Over the central hoop it has a replacement green bead, which obviously is modern, and between the three hoops there are two pearls, and then the outer two hoops above those are little bezels with green glass settings in them.

There are some very interesting things in the storeroom. We have a large and very impressive collection of glazed Roman pottery, which John Pierpont Morgan had acquired, and we have quite a large collection of fragments which no one has ever studied. I recently found a glass vessel, a nice bowl with cut decoration on it, that had been neglected on an upper shelf since it came into the museum in 1917.

Over the last twelve years I've invested a lot of time and effort in an excavation in Amorium, which is in central Anatolia, southwest of Ankara. Amorium was a site that was found by British travelers in 1836, but no one took any particular interest in excavating there until 1987, when Professor Martin Harrison from Oxford University decided to work there and managed to get a permit from the Turks. In 1991 he invited me to join his team. I told Martin at the time, "Look, I'm not a Byzantinist, I'm not an expert on central Anatolian archaeology," but he was desperate for someone who spoke Turkish, as I do. And so I joined his team, but unfortunately he died in 1992,

and no one wanted to take over the excavation, so for better or worse I did, and I've been doing it ever since.

I could go for hours and hours about my excavation, it means so much to me. Every summer I go back, I spend my annual leave at the excavation, and all the rest of my free time, working all day, weekends and evenings. My wife is getting rather annoyed about it. She thinks we should have a proper holiday, that we shouldn't spend every summer at this godforsaken hole in the center of Turkey.

My first marriage collapsed because there was just too much stress involved with having a home life and running this excavation, and I don't want to lose my second wife.

But I can't give up this excavation.

When I first came here, the director found it all rather curious. He said to me one day, "Why are you excavating that Byzantine site when you are our curator of Roman art?" Fortunately, he has come around to it now, and the Met even provides funds for the excavation, and conservation and preservation as well, which is very nice.

I'm sorry . . . I get very emotional because I've made a lot of sacrifices for that place. But my work definitely comes first. I mean, that's quite normal, isn't it? Particularly with men, they get wrapped up in their work.

It's not just the time that's a burden; it's also the fact that when Martin died, the British wanted to close down the excavation, and I resisted. I was then branded a Judas by the British archaeological community, basically because they didn't want the financial responsibility of a long-term research excavation in Turkey. But partly for Martin's sake, and partly because I had only just started at Amorium and wanted to learn more about it, I continued. I genuinely felt more needed to be done at the site to understand it. I didn't do it for career purposes; I didn't see Amorium as providing me with a good

stepping-stone in my career. I mean, I got the job at the Met despite Amorium, not because of Amorium.

However, at some point I will have to give it up; the personal strain is too much.

So thank goodness I have the job here. I feel incredibly privileged to be able to do something I really enjoy, even though it comes at a cost—well, there has always got to be a cost somewhere, doesn't there?

Hilde Limondjian

"The Museum is central to my life . . ."

Hilde doesn't hide the love she feels for the Met. Her job, which unites her interests in art and music, is to create and administer more than two hundred concerts and lectures every season.

In 1912 the Museum decided to present Sunday afternoon concerts. A few hundred people came to the first event, but soon thousands of New Yorkers were attending. The audience overflowed from the Great Hall into the neighboring galleries. In 1954, to celebrate the opening of the Grace Rainey Rogers concert hall, the Museum inaugurated a formal series of sixteen concerts. Three of the greatest musicians of the time—Artur Rubinstein, Isaac Stern, and Marion Anderson—participated. Then, in 1956, the lecture program was initiated and attracted a large and interested audience.

The walls of the concert hall are lined with Korina wood from Africa, and musicians have told me that the wood has aged like a Stradivarius violin. I remember coming to a concert before I joined the Met and thinking that the acoustics were dry compared with other concert venues. But they have become so very beautiful over the years; the resonance is just glorious. We also have the unique

opportunity of presenting concerts in the Museum's galleries—for example, utilizing the Velez Blanco Patio for a program of Spanish music, presenting choral and instrumental music of the time in the Medieval Hall, or offering vocal recitals at The Temple of Dendur, which has extraordinary acoustics.

I feel as though I was almost destined for this job. As a young piano student I went to concerts throughout New York City and I was deeply inspired by musicians like Claudio Arrau, Clifford Curzon, and Dame Myra Hess.

I was a teenager when I saw a photograph of Myra Hess in *The New York Times*. It inspired me to make a pilgrimage to Carnegie Hall to buy a balcony seat for her concert. I still remember the program, which was sonatas by Schubert, Beethoven, and Brahms. I didn't know the Brahms at all, so I went to the library and borrowed a recording which I studied before the concert. When I heard her performance, I could really appreciate how beautifully she played. When it was over, I didn't want to leave Fifty-seventh Street; I couldn't bear for the feelings she had evoked to fade away. There was an Automat just down the street, so I went and sat there with a cup of tea for a couple of hours. I felt transported. And it is this kind of experience that I want to bring to our audiences here at the Museum.

When I think back to the music that has taken place in the Museum's galleries and concert hall over the years, I am overwhelmed by the sheer number of extraordinary experiences which I have witnessed. There were only two instances throughout his life that Artur Rubinstein participated in a chamber music program; one was in Paris, the other was at the Metropolitan Museum. He played the Faure Piano Quartet with the Guarneri. There was the night when the legendary Rudolf Serkin played the Beethoven Third Concerto with the St. Luke's Orchestra. The conductor was James Levine and

it was a reunion for them. Levine, while still in his teens, had coached with Serkin at the Marlboro Music Festival in Vermont. The audience on that occasion included many musicians. Also, I will always remember Bach's orchestral and choral music resounding throughout the Medieval Hall in our first concert in that space. *The Times* in its review asked why music had not been offered there before. It is an ideal space for music and has been compared in its acoustics to the Thomaskirche in Leipzig, which was the church for which Bach wrote his cantatas.

In addition to my piano studies, I was an art history major at Barnard, where my mentor was the great Rubens scholar Julius Held. His lecturing style, which was both scholarly and engaging, has served as a model for me as I've developed the Museum's lecture series over the years.

I usually stand at the back of the hall as audiences leave so that I can have a sense of their reaction to the performance or lecture. It's always so gratifying when words like *stupendous* and *marvelous* reach my ears. Another obvious mark of success is when the hall is sold out, and the audience gives a standing ovation.

The great majority of our concerts feature world-famous musicians. But I have also made it my mission to discover and showcase new talent. It doesn't matter if these artists attract only a small audience at first, because I know that ultimately their names will be familiar to music lovers everywhere. Would it surprise you to know that Marta Argerich, Emmanuel Ax, Daniel Barenboim, Glenn Gould, Richard Goode, Yo-Yo Ma, Murray Perahia, and Pincus Zukerman are just a few the artists we discovered and presented very early in their careers?

The Museum is central to my life. Like all of us in Concerts & Lectures, I spend a great deal of time in this remarkable building.

But truly, wherever I am, the series is always on my mind. An evening at the movies will inspire an idea for a new film program; a recording or concert will create in my imagination a new way to structure a concert series; a book or an article will suggest yet another way of looking at art through a unique lecture series.

Our most recent innovation in the lecture program is an ambitious two-year project which will focus in turn on each of the Museum's eighteen curatorial departments. It will allow our public to become familiar with the history and some of the most significant holdings of these departments. And, most significantly, it will showcase the Museum's distinguished roster of curators. This is something which truly excites and inspires me.

Eric Longo

"Americans don't know about chilling red wine . . ."

Like a lot of people who work in this Museum, Eric is deeply political; indeed the main reason he took full American citizenship was so that he could vote. But the inner Frenchman loves his food and wine, and Eric is appalled by the unsophistication of the American palate.

Antenna Audio grew out of an experimental theater group in the San Francisco Bay area. Our first audio tour was actually at Alcatraz in 1984, and now we really are the market leader throughout the world. We do business with tons of places and abroad too. In London we have the British Museum and the Tower of London, we have the Rijksmuseum in Amsterdam, the Vatican, the Louvre—the list goes on and on.

When we started expanding into the museum world, the Met had been with Acoustiguide, our main competitor, for the longest time. It had founded the concept of audio guides in museums back in 1957, with those big, round cassette things that weighed a ton. But of course, if you stay in the marketplace without any competition, you kind of rest on your laurels, and all of a sudden this young company comes along, and to make a long story short, in 1998 the

Met decided to take a chance on us and literally kicked out Acousti-guide, and we have been here ever since.

My responsibility is to run the business side of things. It's a very large operation. The Met puts out approximately thirty special exhibitions a year, and out of those we pick eight to be accompanied by an audio guide; plus, we have developed a family tour which is specifically written and designed for children. We have themed tours; there is an "Architecture of the Met" tour, and of course straight commentaries on specific pieces of art. We have approximately twelve hundred audio messages on the permanent collection, which is obviously a needle in a haystack compared with the vastness of the holdings of this place, but we keep adding more each year.

There are five managers on-site here and two creative managers who work with the curators to develop the audio tours. We also have two techs because we manufacture our own proprietary piece of equipment, called the X-plorer +, which is an MP3 player that weighs about five ounces and can hold over sixty hours of continuous programming.

Originally I went to law school; but I always had an interest in art and design and frequented exhibitions and art galleries, so I am very happy I came to work for a company that put me into the Met.

I have lived in the United States for fourteen years, but I am originally French. I became American last year. At first I applied for permanent residence, but I decided to take it a step further and apply for citizenship. My petition for citizenship was finally approved, and I was then asked to report in front of a supreme court judge. On the appointed day, with three hundred other people, all foreigners, I went to a room at a federal court in downtown Manhattan. We were then given our Certificates of Naturalization, which is like a high school diploma, and our pictures were taken. Then the judge

came in, and we took the oath of allegiance, which everybody read out loud, and that's it; at that moment you become a fully fledged citizen of the United States. We all sat down, and the judge said, "Welcome to the United States. I have good news for you: now you can go fight in Iraq," which a lot of people didn't find very amusing, of course.

It has been an awkward moment to become American. A lot of people, even Americans, have asked me, "Why did you become American? What's the big deal?" But it's so I can vote. I want to have my say in electing the most important person in the world into his office. I am in total disagreement with the Bush administration; I think it has done a lot of damage to the image of America in the world.

Do I now feel American? No, because my education was in France, and I think you culturally belong to the place where you grew up. If I talk to a born-and-raised American, he may talk about high school or TV shows he watched as a kid, and I'll have no idea what he's talking about. Also, when I travel outside New York, I just don't feel any connection culturally to the people I meet. My attachment is to New York. One of the things that I really enjoy about this city is the cultural diversity and the fact that you come across people from very different backgrounds, all mingling together, not asking questions about your customs, your religions, your political views, your sexual orientation. Nobody cares; it's a nonissue.

When I go back to Paris, I love going to cafés, and I'll have some typical French food and a glass of chilled red wine, like a Gamay, which you will not get here, because Americans don't know about chilling red wine; they think that's just for white wine. Like . . . hello?

The way the art is presented and installed at the Met, well, it's impeccable. I see the work that goes on here, and it's perfection from A to Z, and it's a stark difference compared with the rest of the world.

I was at the Louvre in November, because we do the program guide there. Of course I have been to the Louvre many times because I am from Paris, but this time I went with a very different set of eyes, and I came back with a whole different perspective. I looked at everything—from the lighting to the art presentation, the floor plans, the cleanliness of the bathrooms, the friendliness of the staff and the guards—and I honestly found that the Met surpasses the Louvre in every single one of these categories. Obviously the Louvre itself is a piece of art. It's a simply gorgeous building; some of the rooms you walk into are amazing. But the installations, the lighting, even the labels are not great; the bathrooms are disgusting; the art was not well displayed; and the guards are horrendously rude—well, they *are* French, for crying out loud. I asked one of the female guards in English where the toilet was, and in French she says, "Can't you see I am having a break?" And I was thinking, "Girl, you would be sacked in a second if you were at the Met."

Jessie McNab

"There are cooks, and men-at-arms, and people who feed the horses and make the armor . . ."

She doesn't look like a septuagenarian, particularly when she swings both legs up on the desk in front of her in teenage posture while we talk. After half a lifetime, not even a hint of an American accent affects her perfect Oxford pronunciation.

It was a sort of "rescue Jessie effort" on the part of American friends. I had been engaged to somebody from the army who didn't come back from Malaya, and I couldn't get over it. One of my friends saw me in London, and said, "Come and spend the summer in New York with us, and you'll cheer up." So I came over and had an interview at the Met, and the head of this department walked me round the gallery, and by the time I got home, he had called, saying, "Can you come in on Monday?"

I didn't have a conventional curatorial education. I went to St. Andrew's University in Scotland, which is now very trendy, but Art History didn't exist as a subject then, although it does now—Prince William studied it there.

My grandmother used to let me play with her porcelain and lace, and she had a button box with enchanting little Victorian buttons. But she also had a lot of silver, and I was always interested in silver.

In Victorian times everything was silver, your tea set, your supper dish, your knives and forks, toast rack, letter opener, and flower vases, and there was plenty of bullion coming from all over the world. That's no longer true, and only special things, like cigarette boxes and photograph frames, are used today; plus, silver needs to be taken care of, and in today's polluted air it gets tarnished much more quickly than it did in the eighteenth century. Taking care of silver doesn't go with the modern way of life.

English silver has always been a little different from European silver. It tends to be plainer, often with beautiful, simple forms unobscured by decoration. I particularly like Thomas Hemming, who worked for Queen Charlotte, George III's wife. He was a very fine silversmith, and his forms are rather unexpected. We have got a wonderful pair of gondola-shaped fruit dishes here, with wide flutes, which, as they curl over, have three-dimensional sculptural leaves fitted onto the ends.

My interest has always been the mystery of art rather than the academic accounting of objects. Unfortunately we have come into a time when art is studied almost in a scientific way. Art historians are diagnosticians, they look for *this* influence and *that* influence, and that does not account for creativity. But this is a museum of art, so I think the duty of this Museum is to keep the window open to that ineffable experience you have when you look at art. It's nice to have a label, and every exhibit now has a label, but very often the labels distract you from truly seeing something. To draw an analogy, you could sit at home and read a book about Beethoven's life, or you could go to a concert and actually be moved by the music itself.

We spend ages writing labels for the exhibits. Unfortunately, then the edit department will take a long label and rewrite it according to the Chicago Rules, which are something to do with a certain way

of writing English that fits into some theoretical way of how English should be written! We all hate it, because when our work has been translated into the "Chicago Rules" style, they read like something written by a robot.

Work has changed a lot. When I first came here, one could spend any number of afternoons pursuing one piece of research. But nobody has time to do that now, unless it's connected with an accession or exhibition or a book or an article, and it's unbelievable how the paperwork has mounted up. We are drowning in paperwork.

Well, I keep thinking I should retire, because it's mean to the young ones, but on the other hand, when I retire, they might get somebody who only wants to be a star, and all the humble stuff won't get done. Besides, I would like to finish correcting the silver cataloging, and I am only about a third of the way through.

Do you realize I am seventy-five? I can't account for the state of my health, but my physical capacities are about twenty-five years younger than my actual numerical age. I have never been ill. Well, I had pneumonia, and I nearly died, but I don't count that because that's an affliction, and I had amoebic dysentery once when we were in the jungle, which was quite unavoidable, but otherwise I just haven't been ill.

Actually, I hadn't thought about how old I am until a few weeks ago. It was something my granddaughter said; she wanted to know if I remembered Queen Victoria. So then I realized I must seem very old to her, but I took her slowly through the chronology.

People ask if I miss England. Well, I think what people who are living somewhere else miss most is not so much a place as a time. I remember the war and oh, how happy we all were in the war; they were difficult times, but everybody was pulling together. I don't

think I could be an American, which is dreadful, isn't it? I should be
ashamed of myself, having lived here all these years. The trouble is,
when you take the Oath of Citizenship, you voluntarily declare on
oath, "I absolutely and entirely renounce and abjure all allegiance
and fidelity to the foreign state or sovereignty of which I have been
a subject. . . ."

I don't think that I would be honest if I swore I would abjure all
the loyalties, because in the crunch I can't promise that I would. I
am a faithful New Yorker and a faithful Villager—Greenwich Vil-
lage, where I live—and a very faithful servant of the Museum. I sus-
pect a lot of people don't take the oath seriously. They may come to
America seeking a better life, which for me was not a better life; it
was rather an impoverished life. Financially, there is a certain sacrifi-
cial aspect about working for a museum. But I did cheer up!

I often think of the Museum as a medieval castle with all ranks
of people busy doing whatever the castle needs. There are so many
different people who seem to know that this is where they are sup-
posed to be, and you feel an interest and dedication when you walk
about the Museum. So there are cooks, and men-at-arms, and peo-
ple who feed the horses and make the armor, and carry the sculp-
tures, and welcome in the public at the door, and people who clean
the place—this Museum is beautifully cared for; as soon as the pub-
lic leaves, the cleaners start, so it's immaculate every day. Then there
are the people who have all the worries. The Metropolitan is still
run by its trustees, the same way it was 130 years ago. The trustees
take ultimate responsibility, and the trustees are very serious about
their mission. And they have to protect the people inside and de-
fend us from attacks from outside and keep up our hearts and all of
that. Of course, Philippe would be the seigneur, and a very good
seigneur he is too. One doesn't come in much contact with Philippe,

unless one has got something absolutely superb to show him that we hope he will be interested enough in to decide we should buy. You hope Philippe will agree, but then you're conscious that you are laying yet another burden on him if it's very expensive. But you know he will make the right decision, which is why he is the seigneur after all.

Philippe de Montebello

"I am the Met . . ."

Everyone at the Met loves Philippe—the curators, conservators, trustees—despite the fact that he doesn't court adulation and cuts an intimidating figure. He is formal in his dress and manner of conversation; on top of that, he is tall, holds an erect posture, and has looks that are saturnine, almost Mephistophelean.

I grew up in Grasse in southern France with my parents and grandparents. It was a beautiful property, a villa with cloisters, built at the turn of the century, which had a kind of Orientalist feeling about it. The gardens were like the Generalife in the Alhambra, with fountains and cypresses and olive trees, with a beautiful view of the Mediterranean on one side and the mountains to the rear.

This was wartime, but to me, as a child, it was a good life. German officers were billeted in the villa for a period of time. I don't know exactly where they were living; it was a huge house, they could perfectly well have taken three or four rooms, and nobody would have been displaced. I was told never to accept candy from them, that it would be poisoned.

Then, when I was six, we moved to different parts of France because my father was head of the French Resistance in the southern

sector, and I became aware of the war. I remember one trip where we passed by burning tanks and seeing the bombardments in Lyon. The reason I particularly remember that is because my brother Georges and I were sitting on a promontory overlooking the city when my father turned and slapped us both in the face. We were utterly stunned; we hadn't done anything. "I did that," he said, "which you will think is terribly unjust, but this way you will always remember what you are seeing. . . ."

Later on I was sent to school in Paris. The beautiful family things were in Paris. My half-aunt, Marie-Laure de Noailles, had fabulous pictures, one of the best collections in France: Rubens, Delacroix, Goya, etc. She also had modern art, Picasso, Ernst, Gonzales, and so forth, many at her property on the Riveria in Hyères. This is where I met Picasso for the first and last time; I was thirteen or fourteen. We all went to a bullfight in Nîmes, I think.

My father lost a great deal during the war, so we were struggling. He was, among other things, an inventor and needed financial backing, which you couldn't get in France during the reconstruction years, so my father went to New York. But because there was a quota for immigrants in those years, we were not allowed to come to the United States with him. My mother and we four boys went to Canada and spent two years in Montreal, waiting for permission to enter U.S. soil.

The whole experience of my exile was not a happy one. I missed everything about France. I spoke very little English and seemed to have a lot of trouble understanding French Canadian. My mother, who grew up surrounded by servants, became a saleslady in a department store, which she must have found very hard to take. But she didn't complain, and we coalesced together as a unit: us against

everything around us. Big brother Georges was the spirit raiser. Georges was always our leader, he was *in loco paterfamilias* since my father was absent in New York. He loved the role and played it very well. I was always a little bit in the shadow of my older brother. He was quicker and brighter, while I'm slow; I need reflection for things. But he was a wonderful brother, and he was very watchful over me.

My parents made a very serious psychological mistake, which was to keep telling us everything would be so much better in Montreal than in France. I never found anything better, and the more they said things were better, the more I resisted, of course. I became much more ingrained in all of my Frenchness, and very resistant to everything Anglo-Saxon. We French are very conscious and proud of being French. I mean, you start school, being given a clear place in history, with *nos ancêtres les Gaulois*, and there is a direct progression from the Gauls to the Capetian kings through to Louis XIV and Napoleon. The Frenchness of France was always something which has made us French very secure—if not sometimes arrogant—but it was very coherent and reassuring and has always been for me.

Finally, in 1951, we got permission to come to New York. I loved it straightaway: the skyscrapers, the look, the feeling, the noise. It reminded me of Paris, not visually but in the sense that it was a burgeoning, active, and interesting place. It was also *the* destination; we always felt we were in a holding pen in Canada, so there was no motivation to adapt.

After the Lycée Français, I attended Harvard, which I absolutely loved. Then, afterward, I had to do military service and I enlisted at Fort Dix, New Jersey. I was not very aware of the world then and got a quick education, discovering for myself that there was such a thing as illiteracy, people who couldn't even read my name tag. I

also learned that Harvard wasn't the end-all for everyone: when people discovered I was a Harvard boy, they threw my footlocker out of the window.

I was lucky. I missed both Korea and Vietnam, but in the peacetime army you went on long marches, which were too boring for words. I remember learning the entire *Ballad of Reading Gaol* by Oscar Wilde and would recite it for my sanity. Then I learned *The Bronze Horseman* by Pushkin—in Russian, because I'd studied Russian at Harvard—and I can still recite a hundred verses of it.

When we moved to New York, I loved going to museums. I used to go to the Metropolitan Museum all the time and by the time I reached college age, I knew I wanted to work in a museum. For a time before that I had wanted to be an artist, but I was simply mediocre, derivative, making paintings that were quasi-cubist, quasi-surrealist. I was never a very good draftsman either, and when I now look at the paintings I did, I'm very glad I went into art history. I went to graduate school at the Institute of Fine Arts, and took the Museum Training course, as it was then called, and studied French and Netherlandish painting of the fifteenth and sixteenth centuries. This turned out to be propitious.

Ted Rousseau, the curator of European paintings at the time, called me into his office and said, "I need a curator for early French and Netherlandish paintings. I gather this is what you do. Would you consider coming to the Met even before completing your Ph.D.?"

"Well, Mr. Rousseau," I said, "I'm studying in order someday to come to the Met. Of course I would come to the Met."

We walked together in the galleries, and he asked me to comment about paintings. "*This* is a picture of great quality," I said about one.

"What is quality?" he asked me.

I remember feeling totally stumped; it had never occurred to me

to define quality. I was surprised after what were probably inanities I had uttered in front of the pictures that he hired me, but he did, and I started right away. I became a curatorial assistant, which is the lowest in the academic progression.

After a few years I was asked by the director, Tom Hoving, to be his special assistant and work on setting up the acquisitions gallery for him. And that broadened my acquaintances within the Museum, and I made a lot of friends. I made it a point to be friendly.

Then Hoving arranged for Houston to hire me away, although I didn't realize that at the time. I received a letter saying, "Would you consider being director of the Museum of Fine Arts, Houston?" I tried to figure out why anyone would want me to go to Houston: I'd never done a budget before, never organized an exhibition; I was unqualified for the job. But I needed the money; with the salary from the Met I couldn't pay my grocery bills, and my wife, Edith, worked in a school, which didn't pay very much, and we had two children. Things were tough financially. At the same time, none of it struck me as terribly difficult, and I was confident I could pull it off.

Having a whole museum to myself appealed to me. The place had never really been run professionally, and so I was practically building something from zero. It had a general collection with everything from Renaissance bronzes to primitive art, a few Old Masters, and a lot of Modern Art, but it was clearly a museum that was totally inadequate relative to the size and ambitions of the city. However, it had just phenomenal potential, I mean, tons of money in town, so it was a matter of harvesting that and establishing a good rapport with the people who would support the museum, the trustees, and others.

By the third year I'd basically done everything I could do. I'd made a success of things, and I was ready to move to a larger place,

anywhere but where I was, where steady negative press gradually got to me. I ran into Hoving at some conference, who said, "Ted Rousseau is ill. I think you ought to come back and take his place as chief curator."

"Yes, of course," I said.

I had by then been in Houston four and a half years. Although I never took to the place, and vice versa, I must concede that I'd probably still be associate curator of European paintings if I hadn't taken the Houston job. I learned so much there and I am looking forward to returning soon to lecture. The museum has come a long way under its current director, Peter Marzio.

I loved working with Tom. He was a tall, handsome man, exhilarating and brilliant a lot of the time. I admired that part of him and deplored the other 50 percent, the narcissistic and megalomaniacal side. But frankly, it was irrelevant what I felt about him. Even if I'd hated him, I would have taken the job of chief curator of the Metropolitan Museum of Art, but furthermore he had intimated that he was grooming me to be his successor.

My job as chief curator was made easier by the fact that the curators tended to trust me. I deferred to their scholarship and they sensed that I valued, liked, and appreciated them and I made an effort to deal with them on a one-to-one basis. It helped that I also had a good relationship with the trustees.

Before I was officially hired, Douglas Dillon, Chairman of the Board, asked to meet me. Dillon was a wonderful man, big in every conceivable way, grand, generous, sharp, intelligent, totally dedicated to the Met. He just had all the right instincts, high ethics, probity, and a great passion for art.

He asked me to come and spend a weekend in Bar Harbor, Maine, where he had a house. I knew it was not to see what I was like as

chief curator, but potentially as director, to find out whether a day and a half spent in the presence of Mr. de Montebello yielded gems in the conversation, a glimpse of knowledge. There was lots of chitchat about the museum world, works of art, philosophy, politics, and he obviously must have been content, although there was an awkward moment when he asked if I played bridge. "I play only once a year, in the summer," I told him. "That's good enough," he declared, and invited friends over for a game. Of course I was not up to their bridge and cost my partners every single hand, and I thought: "I'm blowing my entire career on this stupid game of bridge. . . ."

There was nothing monumental about what happened next. The last year Hoving was director, he wasn't really here—he was clearly disengaging—and then I had been acting director for over a year. I don't want to sound arrogant, but the whole transition had such a logic and inevitability to it that the thought that I might not be made director did not really occur to me.

Part of the reason I seem to have been right for this job, and done it decently, is a certain catholic taste. I have a great interest in all areas. I love objects. I love Egyptian art and classical art, Islamic art, and I'm very happy going from one subject to another. You become miscellaneous after thirty years in this job. I suspect the breadth of my interests meant I was a less scholarly director than others who have a strong art historical specialty, but this appeals to curators who know I'll be open and sympathetic to their particular areas—this is critical to one's success as director of a big, encyclopedic museum.

I've given so many years to this place; this job really does consume me totally. I spend more time with my staff than with my family. I'm here almost twelve hours a day. I work many hours preparing speeches and going to meetings; there are weekend events

and events in the evening, so it's a good thing one loves the place and the people. The Museum becomes your extended family.

I like the fact that this building is huge and grand. I love the majesty of it, the imposing steps one climbs every morning. Occasionally I sit at a meeting with thirty curators, and I think, "These are the great experts in their field. I know they know more than I do, but I'm the one in charge, and getting them to speak, and bringing out the best in them."

One of the wonderful things about this job is that you can make far-reaching decisions, implement them, and get them done. What the director wants to do, he gets to do, and there's something very exciting about that. Someone walks into a gallery and thinks there should be a bench there, what is he going to do about it? Write twenty letters to his congressman? I want a bench in a gallery, I get a bench. I want to change the color of a room, I change the color of a room. I want to put eighteenth-century art here and nineteenth-century art there, I discuss the issue with the curators and generally can get it done. But if curators have solid arguments, they win the day, as well they should.

I love my job. This is my life. I breathe and dream the Metropolitan Museum of Art. I think when I leave it will be very difficult and wrenching. But who knows? It may turn out to be extremely easy, and I may just love my total freedom. I have no idea.

I recently turned seventy. Customarily one retires at seventy or even earlier, and there's a period of time beyond which no creative leader of any institution should remain at its helm, but it's far too late for me to say that now because that time was probably ten years ago. I'm the institution to a level I'm not sure is healthy: the institution and I have totally merged. I am the Met, the Met is me. That's just the way it's turned out to be. But I don't think I've caused sclerosis

of creativity; this is an institution that, in a French expression, *est bien dans sa peau*. But this identification of director and institution will make it more difficult for my successor. I guess the greatest favor I could do my successor is to arrange for a few little disasters to occur in my last year, whenever that is, so he looks good coming in.

Nothing lasts forever. One day I'll have to say good-bye to the Met, to have one last walk. I'll be egotistical about it. Probably I'll go at midday when the sun is highest because most of the day-lit galleries benefit from maximum zenithal light. Also, I prefer to walk in museums when there are people around. For my last walk, I wouldn't want to be alone, in fact I think it is dismal to go to some museums where the guard greets you personally at the door because you're the first person he's seen in fifteen minutes. You see great works of art, you walk through those galleries, but there's no one else admiring them. There are times when you are looking at something so splendid, your wish is to turn and say to someone, "Share with me the beauty of this."

I don't have a favorite work, but there are works of art that can elicit the strong sense that *this* just has to be the finest work in the Museum. And then you take twenty steps, and another work of art dictates the same reaction, and you go to another department, and that happens again. Of course reactions vary according to mood. A work of art can move one strongly one day and leave one utterly cold the next.

I don't know what my path will be, but part of the mystery and beauty of my last walk in the Met is that it will not be planned. I'll bifurcate when I choose to. I will not be needing a schedule because of a meeting or an exhibition preparation later. I will have all the time in

the world. And I will not know the route in advance; the element of improvisation will be an important part of it. I will become a pure flaneur, and, reflecting on what Valéry said about *le vagabondage de l'oeil*, my eye would become a vagabond in the galleries. A huge number of emotions will be awakened. I cry easily, so I might weep.

J. Kenneth Moore

"A boomy bass, a moderate middle section, and a kind of tinkly top section . . ."

The Musical Instruments Department is tiny; it colonizes only a few galleries at the Met. But it is wonderful to find that it exists, and Ken is very happy to talk about the weird and wonderful instruments that reside there.

I grew up on a tobacco farm in Maryland, about thirty-five miles south of Washington, D.C. I really loved living on the farm because we had dogs and cats, ducks and horses, and the next farm over belonged to my great-uncle, so there was a sense of family and tradition. But I absolutely hated anything to do with tobacco. It's a dirty, ugly crop, it's not good for the soil, and it smells. I mean, all the way around it's an awful plant.

The Maryland way of handling tobacco is a little different. In the South they leave the stalks in the field and pick the leaves individually, but we start off in the spring, planting the seedlings, which you nurture until they are about five or so inches tall, and then you plant them in a larger field where, if it's a good year, they might grow to four or five feet. In midsummer they get hung from rafters in tobacco barns and air-cured until winter, when the tobacco turns a

dark brown color. Then you take everything down and go into what are called stripping rooms and strip off the individual leaves and put them into grades, and the following spring, they are packed in large hogsheads and taken to Baltimore to sell at auction. Because Maryland tobaccos are strong, they blend well with Turkish tobaccos and usually end up in export.

I came to New York after getting a BS in Music Education. I had thought about leaving the country because the Vietnam War was going on, and I didn't believe in the war, and wouldn't have been a good soldier, but in the end I waited to see whether I would get drafted or not. I worked at a music publishing company as a score librarian until I found out that I wasn't going to be drafted, and at that point I decided to go to graduate school.

But I needed a job to pay for it, and a friend of mine said he knew somebody who worked as a night watchman at the Metropolitan Museum of Art. The next day I walked in and said to the personnel department that I wanted to be a night watchman. "Talk to the head of security," they said, which I did, and got the job.

I remember only one dicey moment. There's a painting by Rembrandt called *Woman with a Pink*, which is a very nice painting, and this woman came in—she looked very unassuming in fact—went up to the painting and suddenly started screaming at it in an incredibly frightening way, "You've broken up my marriage, you're a whore," just going on and on. The guards started circling in, but before they could get to her, she spat on the painting, and then all the whistles blew—all the guards were issued whistles then—and they grabbed her and dragged her out. Any public institution is going to have that sort of behavior from time to time. I guess we are lucky we don't have more.

Being a night watchman was absolutely wonderful. It was a

revelation seeing the original art; the difference between a reproduc-
tion and the original was amazing. Another enjoyment was that there
was one small bookstore in the Museum, and I used to go in and
find a book at the start of my shift and sit on the post and read it and
then put it back at the end of the night.

During the shift you did four rounds of the building, including
the roof, the catwalks above the galleries, and the tunnel underneath
the Museum. You had a partner, and when he came back from his
round, you went off and did yours.

I was a night watchman for about five years, and at the same time
I was working on my master's, I was the house manager for a chil-
dren's theater, and I would often usher at off-Broadway theaters.
When I look back on it, I wonder how on earth I did all that.

I also took a part-time job in the slide library, coordinating the
photography for the Museum, which turned into full time, so I gave
up the night watchman job, and then a position opened up in this
department for a curatorial assistant. They wanted somebody who
knew about non-Western instruments. It was supposed to be a three-
year job, but they either forgot about me or liked what I was doing,
and they allowed me to stay longer. And then eventually I became
head of the department.

What I've wanted to do here is set up the galleries so they are
more contextual. I mean, let's face it, hanging musical instruments on
the wall is like hanging a deer head or a trophy of some sort, and a
short label doesn't provide nearly enough information. How do you
interpret these instruments and explain their significance? Some of
them are works of art, but many of them have a meaning that sur-
passes their sound—for instance, national instruments, like the harp for
Ireland, the hardinger fiddle for Norway, or the duduk for Armenia.
They all raise interesting questions. Who plays them? Are they for a

low-caste or high-caste person? What do they sound like? We have got plans for the future which will include lots of audiovisuals.

Do you know we have the oldest piano in existence here? It's a really sweet, wonderful little instrument, about three hundred years old, made by a fellow with the name of Bartolomeo Cristofori, who was keeper of the instruments at the Medici court in Florence. It still sounds pretty good, actually. It has a uniquely mellow kind of sound, but it also has all the characteristics of the modern piano, which is a boomy bass, a moderate middle section, and a kind of tinkly top section.

We also have the Todini harpsichord, which is the largest piece of Roman baroque furniture in the Museum, and it's huge; it takes up the entire end of our gallery. It's an enormous construction, all painted gold, with the harpsichord in the middle, decorated with a frieze along the side depicting the Triumph of Galatea, and underneath are tritons and mermaids holding up the harpsichord. At either end of the harpsichord are two freestanding figures, one of whom is Galatea herself, with her hands in a position that suggests she was probably playing a lute at some point, and on the other side is Polyphemus, who is playing a little bagpipe. He's not such an ogre as in the legend; in fact he is actually a pretty good-looking guy.

It's difficult to say which is my favorite instrument. One which I dearly love is a Ming dynasty instrument called the pi-pa, a four-string pear-shaped lute. It is just a gorgeous, beautiful, wonderful object. This particular one has 110 ivory plaques on the back, the part that the audience would not see, and each of these plaques has Buddhist, Daoist, and Confucian emblems arranged geometrically. I love the idea that the most beautiful part of the instrument cannot be seen by the audience; there is something a little selfish about that, but very poetic. I must also mention our weirdest instrument, which

is something we call a nasalophone, a name we just made up. You blow air into it through your nose, and the pressure of the air will give you whatever tune you get.

We once had a policy that we wouldn't get an instrument which was mass-produced, but everything now is mass-produced, even a Steinway piano, so our criteria have changed for the twentieth and twenty-first centuries. The history of musical instruments now is very much about technology. There are absolutely wonderful designs for the MIDI, which means musical instrument digital interface that you plug into a synthesizer and with which you can make any kind of instrument sound. So modern and ancient now blend very happily in this department, and the history of musical instruments is bang up-to-date.

James Moran

"Goodness will always triumph . . ."

Officer Moran buzzes around outside in a sort of superannuated golf cart; after all, the Central Park Precinct where he is stationed is only a few minutes away. As it turns out, he has a degree in history. No, wait, he has two degrees, thus neatly overturning my preconceptions about policemen.

I first worked as a patrol officer in Washington Heights, which borders Harlem. That was stressful. There was cocaine, crack, and heroin flying around, and with drugs come guns, so there was a lot of mayhem, a lot of gun battles and killings; we led Manhattan in homicides.

We would see the drug dealers standing on a corner, and we knew what they were doing, but the Fourth Amendment prevents us from searching people, so all we could do was discourage them by just being there, and they would see us and move on. We felt happy because we were actually doing good just being on the street.

The job was not all fighting crime actually; the majority of it was little things: helping people find their lost dogs, giving first aid; I found contentment helping people with the small things. I delivered a baby, and the child is doing well—it's a girl—I've watched people

die and held their hands during their last breaths. I felt we were making a difference to the people there, which made it worthwhile, as corny as that sounds.

Then the Central Park Precinct needed cops, so ten of us were transferred here. It sure was different from Washington Heights. I couldn't believe how slow it was. I was restless and kind of angry too; I'd been happy near Harlem. There was one cop assigned to the Met, and I thought, "That sounds like a good job"—as a kid I lived in the Museum of Natural History. So when he came up to his retirement, he put a word in with the Commanding Officer that I would like the job, and I was given it.

Because it's such a massive place and receives so many visitors, there is a constant flow of traffic in front, and you have got to move cars, buses, and taxis along. Just being out on the street, I get a thousand and one questions every day: "Where's the nearest subway?" "Do you know a good restaurant?" It's constant, but I don't mind. I'm helping out.

Also, because it's a city-owned building, we are responsible for any crimes that are committed inside the Museum. The gift shops are constantly getting shoplifted. The Museum has its own plainclothes security guards who observe the shoppers, and once they determine someone stole something, I go in and make the arrest and take the property.

Then there are people who want to deface things. A former employee stuck stickers on just about the most famous painting in the Museum, *Washington Crossing the Delaware*, and I arrested him. He was fixated on that painting, and clearly out of his mind, rambling on about different theories. He's in a mental institution now, but I hope he'll be back to normal soon. I pray for him.

Since the attack on New York City, part of my job is keeping an

eye out for possible terrorists, which is very possible when you get so many visitors to one place.

It's a good job being a cop. You work for twenty years, and then you can be fully retired with all your medical benefits and go on to do whatever you want after that. I was a teacher originally; I started out teaching first to fourth grade in Jersey City, and then taught in a few Catholic private schools, so maybe I'll go back to teaching.

Actually, I'm a historian; that's my background. I dual majored in History and Classics with an English minor. I studied early Christianity in North Africa in the Roman Empire of the fourth and fifth centuries. That's what I wrote my paper on, the Coptic Church and the Donatists, because I was interested in the schisms of the early church. Also, I have a graduate degree from the University of Leicester in England. I went there because the exchange rate was favorable, so it was cheaper for me to go to the UK to get a degree. Leicester is a kind of small town compared to what I was used to, but England was just tremendous. It's unusual among police to have academic credentials, and they kind of kid me about it. "You have a graduate degree, what are you doing as a cop?" But this is what I choose to do; it makes me a content person.

My Catholic faith is important to me, more so now after 9/11. I was there when it happened. I live downtown, and I was on my way into work on my motorcycle, and I was stopped at a red light on the corner of Bleecker and MacDougal, when I saw an aircraft just above to my left. I immediately thought: "That's not right; he's not supposed to be that low over Manhattan." And I looked back again and saw the first plane hit the North Tower, fly right into it. It was intentional, I could tell; that was no accident. I felt the concussion; I was quite stunned. And then I saw the second plane hit the South Tower. Thinking like a cop, I made a time check and took a note. Then I

headed full speed up Sixth Avenue fast as I could, through red lights, to get to Central Park Precinct. As soon as I got there, they said, "Get to the Met Museum, that could be the next target"; after all, it's the biggest tourist attraction in New York.

That day was chaotic. We cleared the building, and I stood on guard the whole day with another cop from the station, Rick Tombari, and we listened to the police radio downtown, so we heard everything that was going on, which was horrendous. I hold no hatred for the people who did it because they are all dead. It was their choice, and it was wrong.

I know hating would just tear me apart, so I try to find a positive in everything. I believed in God all along, but after we were attacked, I could see a goodness throughout the world, and I knew that goodness will always triumph.

It feels right that I should be at the Museum. I appreciate being there, and I feel protective of it. If I can help it in any way, I'll do so.

Herbert M. Moskowitz

"Egypt is a challenge . . ."

He still hasn't lost his New England accent, despite spending his entire adult life in New York, nor has he lost his wonder that a boy from Fall River, Massachusetts, has ended up at the Metropolitan Museum of Art.

Next month I will have been here thirty-three years. When I applied, I really didn't know what I wanted to do, but the reason this museum job was attractive was that it listed a month of vacation, and my wife had just started teaching in the public school system.

I had no art at all in my background. I come from Fall River, which is about sixty miles southeast of Boston, which was a nice place to grow up, although there were no museums or anything like that. But for whatever reason, I clicked with the guy who interviewed me, and I was hired to work in the registrar department. Once I got started, suddenly these valuable masterpieces were right in front of me. The first time I saw a Van Gogh it just kind of blew me away, but I was also opening up Monets and Tiffany windows, so I saw the best of everything. It was all beautiful, and it opened up my eyes to a completely new world.

Another thing: I had never been out of the country, and I went to China and Russia; I actually went to the Soviet Union ten

times. These exhibitions were practically the first exchanges any-
body had ever done with Russia, and we sent masterpieces from
our European and American paintings, I mean, the top of the line,
and for each of those I went out to supervise the unpacking and
handling.

I found that I enjoyed the travel and was suited to it. When I first
started going, Russia was like a new frontier. You would go into
these massive restaurants, with lots of waiters sitting along one wall
and nobody else there. They would bring you over a menu with ten
pages, but there'd be nothing to eat. In the end we found that we
would actually have to go to the stores and buy food to make sure we
had enough to eat.

A short time after I started here, we were involved with an An-
drew Wyeth exhibition, and coming in touch with a living artist was
an incredible experience. Wyeth had a studio in Chadds Ford, Penn-
sylvania, and I had to make numerous trips down there to work with
him. One day he asked me, "Would you like to see where I painted
some of my paintings?" And he drove me around in a weird Italian
version of a Thunderbird, and I had a personal tour of the area and
ended up having a wonderful relationship with him from that date
to this.

For over a decade there was an arrangement between Ambassador
Annenberg and the Museum: we had his paintings here for six
months out of the year, and for six months they went back to his
home in the California desert. I was responsible for moving that col-
lection back and forth, and that was really one of the highlights of my
career, first, because it is such a fabulous collection, and second, I loved
working there. The house is on about three hundred acres, and the
vistas are just beautiful; it's in the desert, but you have the mountains
to one side; he also created an eighteen-hole golf course. He picked

the perfect spot, I think. At one point there was consideration of making it into a kind of western White House, but that never materialized. Sadly, Mr. Annenberg died recently, so the paintings are now here at the Met, and they won't move anymore.

Any art that comes in or out of the building goes first to my registrar's department. I have five guys who do all the unpacking of the art, and when we unpack it, we check it for condition and then ensure that it gets to the proper departments. We also pack everything that leaves the Museum and coordinate the shipping for wherever it's going.

These days it's very rare that anything gets damaged in transit, but our philosophy is to assume that when something leaves here, somewhere along the way it is going to be exposed to some sort of mishandling which it needs to be protected against—not only vibration or shock but changes in humidity and climate. We start with a wooden crate; we use MDO plywood and use a lot of foam so that in the event that it is dropped or mishandled, the vibration and shock will be spread out along the width and length of the painting.

We send a courier with anything of high value or importance to it. Any full-time curatorial, registrarial, or conservational department person is qualified to be a courier, but we also use a customs broker who specializes in Fine Arts as well. The courier will go out to the airport and see the object removed from the truck, taken into the cargo terminal, and put onto a pallet or a container and strapped in. Then the courier will go to the passenger terminal, while the customs broker will stay with the crate and follow it down to the tarmac, watch it go into the plane, and then get word to the courier that the shipment is on board. We have an agent in the other country doing the exact same thing when it arrives.

Fortunately, I learned a long time ago that I can't go home and worry about the Rembrandt on Lufthansa flight 211 or the John Singer Sargent on KLM. I mean, by then it's out of my control anyway. So I don't stay up at night wondering whether the shipment's going to arrive safely.

A passenger plane can handle crates up to only about 63 inches in height, which is really not too much, so for anything larger we use 747 cargo planes, which are enormous. You can get a crate with a height of about 125 inches into them.

I have been doing this job for a long time, but something new always comes up; there is always a different wrinkle, which is actually one of the nice things about it—it's not a routine job. Some jobs are more difficult than others. Anything involving Egypt is a challenge. For instance, we borrowed forty icons from the Greek monastery of St. Catherine's in the Sinai for the Byzantium exhibition. Understandably, the monastery is very protective of its things, and this was the first time anything had left the monastery in over nine hundred years. But because the monastery is on Egyptian soil, the Egyptians look on it as a loan from Egypt.

We built crates, and we sent our people over to pack the objects, and I went there to supervise the shipment, as required by our insurers.

We had to sign an agreement with the Supreme Council of Antiquities in order to get approval to have these things leave Egypt. But then, on top of that, they insisted that the American ambassador to Egypt send a letter to the Egyptian minister of culture, saying he was aware of the importance of this exhibition. In the past the United States government would write a letter saying it guaranteed the objects would be returned at the close of the show, but for whatever

reason, the U.S. government had decided that the word *guarantee* could no longer be put into this letter. That was unacceptable to the Egyptians, so for two weeks we were there trying to come up with language that would satisfy both the American and Egyptian sides. Finally, it was the night before the day we were supposed to sign the contract, and now the American ambassador wouldn't do anything without the State Department in Washington saying OK. So *we* began talking to the State Department and got the language changed and finally got it signed, but it was right up to the last hour.

This had a happy ending, but getting things out of Egypt has always been tough. The first time we were there, I stayed for three weeks, and when we left, we still hadn't gotten it done.

Sharon, my wife, just turned fifty-five, which qualifies her to retire in June, so I went with her last week to a retirement seminar. During the discussion they wanted to know how long I was going to work. I'll be sixty-three in September, but I think I'll probably be here until I'm sixty-five. I still have plenty of energy, and it's still exciting enough that I don't see any reason to leave any earlier than that.

John P. O'Neill

"Ask me my favorite Mozart opera . . ."

At first this tall man was very formal and reserved, almost reluctant to get involved in conversation, I would say . . . until we start discussing Horace, Virgil, Dante, and Rossini, when his eyes began to glisten.

I was brought up in a little town called Enid, Oklahoma, which, if you work crossword puzzles, is always the clue, "a town in Oklahoma with four letters." It was named after a character in Tennyson's *Idylls of the King*. It's hicksville. When I was growing up, there was no museum in the town, and I doubt if there is now, although I haven't been back since my parents died.

I have seven brothers and sisters; my parents emphasized a good education for all of us, so we had lots of books in our house, and education was considered of great value. All of us have university educations, and several have Ph.D.s and so forth.

I am in charge of publications here. We do between thirty and forty publications every year; some of them are very large and complicated exhibition catalogs, others are collection catalogs. In addition, we publish four issues of the *Bulletin* every year, which has a circulation of around 120,000 and goes to all our members. We also edit all the labels for the exhibits, which is a huge amount of work,

and we publish one volume of the *Journal* every year, which is a compendium of scholarly publications written by our curators and outside scholars to do with the Museum's collections.

We also do trade books, such as the book about St. Catherine's Monastery in the Sinai, which was timed to coincide with the Byzantium exhibition. I had 117 authors for that book. It's 680 pages long with more than 800 illustrations, most of them in color, and just crammed with type and pictures. The cost of putting that book together was around $1.5 million. If we hadn't worked on a design that was compact, the book would have been a thousand pages, and I wouldn't have been able to bind it, or probably sell it—although a few years ago we published an eight-hundred-page book on Leonardo da Vinci's drawings, and I had to reprint it twice. Actually, we have now recovered all of the outlay of the Byzantium book and made some money by selling all our copies.

My biggest problem with books and catalogs is that I never get all the text and illustrations at the same time, the main culprits being the curators, and it's very hard to plan a publication that way. In trade publishing, you receive the manuscript and the illustrations, and then you start out, and if you don't have them, publication is postponed. But here we don't postpone or delay any exhibition catalog because we must have it to open the exhibition with. That's a strict rule of our director. But amazingly, we do always get the book out on time, so perhaps the way we work is the way we will always have to work.

We have lots of support and resources from Philippe to make each book as good as we can. For example, our books have very good indexes; some publishers don't do that because they don't have the time or can't afford to. Most important, our books have very solidly researched bibliographies, which can be extremely expensive to compile, and I have two or three proofreaders for everything. Through

the years, the director has enabled me to build up my department; I now have about thirty permanent staff and a freelance cast of seventy to eighty people.

Art is something I need in my life, but even more important to me are literature and music. I love to read, and I love to listen to music, and these are the great sustainers, through thick and thin, through whatever madness or rashness or whatever befalls you.

I am a great fan of Horace's odes; I love Virgil with a passion. Coming forward, I adore Proust, and I have read all of Henry James from cover to cover, and boy, that's a lot. I am also a great admirer of *The Divine Comedy,* and I have made a translation of it, which has never been published, so no one has ever read it except me; it's less than professional but better than amateur, I would say. I just did it for myself, to help me with my Italian.

I absolutely adore opera. My mother and I used to listen to the Metropolitan Opera broadcasts when they began in 1941, so all my life I have had a great love of classical music. Ask me my favorite Mozart opera. . . . It's the one I saw most recently. I was at the opera last night. The Met Opera opened a fabulous new production of Richard Strauss's *Salome* with Karita Mattila in the title role, who was fantastic and did a fabulous Dance of the Seven Veils. See that photograph? It's a Nadar portrait of Rossini, who is my favorite composer. I love Rossini; he is marvelous. He wrote so magnificently for the voice. People who aren't specialists think he wrote a couple of comic operas, and that's it, but his *opéra séria* are totally beautiful, and *William Tell* is a fabulous work. Oh, I adore it.

Every week I have a meeting with Philippe where I tell him about everything that is going on in my department and what my concerns are, and I seek advice from him. He is extremely interested, and he looks at all the designs, and we talk about titles and jackets. Naturally,

after so many years working together, I generally know what he wants, and when I don't, I ask him.

I love working here; it's a job in which I have been extremely happy because I have had wonderful support, and I am treated with great respect. They even pay me well. I have learned so much, and I am still learning and still engaged; you are never too old to learn if you want to.

But I am seventy-four years old, and I have made up my mind that I will leave when Philippe leaves. I am going to retire then. Plus, I have another job. I don't know if you are familiar with an American painter named Barnett Newman? He was an abstract Impressionist and a friend of Pollock and Clifford Styll; there was recently a retrospective of his work at the Tate. There is a small foundation to do with Barnett Newman's work of which I am the director, and I want to spend more time on that.

We have three paintings and maybe five drawings of Newman's here. *Concord* is one of the earlier works; it's mostly green with a faintly yellow and green stripe down the middle, which is very beautiful. But most of all I love *Shimmer Bright*, which is a very late and difficult painting. It's all white with two blue stripes. People say, "Oh, I can do that in a minute," or "My child could do that." Try it. It's not some silly, trashy thing. That painting does everything for me. Everything. It's radiant. It lights up my life. Just go take a look at it.

Sally Pearson

"Every child is beautiful in this retail world . . ."

This woman is a firecracker, and it's not just because she has flaming red hair. There's an excitement and fizzing energy she transmits when she talks about merchandising in her office half a block away from the Museum.

I come from the outside world. I had always worked for big retail companies, billion-dollar businesses, like Saks Fifth Avenue, where I ran their apparel divisions, and I was president of Liz Claiborne retail, where I operated 120 retail stores.

But I had just gotten married and was on a sabbatical, doing the wifely things, and someone asked me, "How would you like to run product and retail organization for the Met?"

"That's an intriguing concept," I said. Who doesn't want to work for the Met? Right?

Six months later I was here, as head of retail and merchandising. My mission is to make as much money as possible, in the most creative and tasteful way, to help fund the education programs and to pay the operational costs of the Museum. All the proceeds, every dime, go back to help the Museum's expenses and educational programs.

When I got here, I realized there was a much more serious situation than I had anticipated. Nearly a quarter of our inventory was in old, aging product, and that is unacceptable in any business. You cannot just create new product, you have to clear out old inventory.

This was an organization that hadn't reduced stock before, so it was traumatic; you know, change is not easy. But they all came to the party. I sat down with the product developers, and we laid out every single product, best sellers, medium sellers, poor sellers, and I said, "If we are going to bring in a hundred new styles, we have to get rid of most of this." Even if somebody said, "Oh, that's my personal favorite"—every child is beautiful in this retail world—we would have to say, "No, the customers have voted, and they don't like it."

So we took the old inventory—twelve million dollars' worth of goods—marked it down, and started selling it out through our stores and satellites, and within nine months it was gone, which was thrilling, because that gave us the chance to introduce new product. When you have a high rate of repeat customers, like we do, the most important thing is to show them something new every season; new product is what drives your business. We began introducing 10 to 15 percent new product every year, and we are now up to 40 percent.

We never want to appear too commercial or do things that are inappropriate for this Museum. For example, there is a lot of product out there that we would not reproduce, even if it made money, things like cutting boards with a Monet painting on the surface or making umbrella designs out of a painting.

Direct mail is big business now. We mail about ten million catalogs a year, which give us the chance to reach a customer who doesn't get

to the Met all the time, and it drives membership sales too, because we offer a discount on product to members. We also have a great Web site, which is doing extremely well; we had a 40 percent increase in sales this year.

The best-selling products in the Museum are books. Books are phenomenal; we are one of the great arts and art history bookstores in America, and we want to be known for that. Our 3-D products—reproductions of original sculpture—sell well, Christmas ornaments that are reproductions of our objects go like hotcakes, stationery products are excellent, and posters are a big part of the Museum's business. Our quality of reproductions is like no place else in the world. I really believe that. It looks authentic because the curators get involved and make the final decisions on how the product looks. Nobody likes anything more than a gift from the Met, and we have all kinds of housewarming or hostess gifts. We now have great baby gifts, and educational children's books are very popular.

Before the Mughal exhibition, Philippe said to me, "I think you should do some special, high-end jewelry for this exhibition." I was concerned, because we had never gone after high-end jewelry; $3,000 to $5,000 was the top dollar we carried. But Mahrukh Tarapor knew a Munnu Kasilwal of Gem Palace in India who does fabulous jewelry for the maharajas, the royal family, and celebrities and we produced about $3,000,000 worth of jewelry, with some items up to $100,000, and we sold $1,200,000 million in just weeks. That was a great lesson for my organization because it taught us not to be afraid of price. In fact just this Saturday a man came in with his girlfriend and bought a piece for $36,000, and we regularly have people who buy $33,000 bracelets from our Web site, sight unseen, which I find incredible.

There are seventeen desks or shops within the Museum. Our

most valuable desk, which we call the nineteenth-century desk, is near the Impressionist area next to the elevators, and it does about $1,600,000 a year, which is terrific. But the permanent shops do millions; I mean, they are gold mines. The big shop next to the bookshop does $8,000,000 a year, and the little shop behind the audio guide desk pulls in $3,500,000, so that whole little complex outside the Great Hall does close to $15,000,000—they are just little gems.

We also have twenty-one satellite shops scattered across the country, from New York to Los Angeles; the airport shops have been particularly strong because people always want to take home a gift from the Met, and through a licensing partner, we have twelve international shops, which are important because they extend the brand.

This job has changed me. I've become softer. In the outside world, when someone said, "Sally, I need five million dollars in expense cuts, by tomorrow," you'd do whatever you had to do to get to that number, and it was usually people, because payroll is the biggest part of any business. But at the Met we do everything we can *not* to make layoffs, because the people we deal with here are ladies and gentlemen.

My personality is not going to change. I am still a fighter; I want to get every bit of business I can. But now I am interested in helping my fellow competitor. Other museums will come to us for advice, and we help and encourage them. When I was at Saks, I wouldn't have helped Neiman's—except over my dead body. I don't see myself going to that outside world again. I like it here; this is home.

One little PS: My husband, Stephen, is the one who really turned me on to museums. Way before I worked here, he was always a big museumgoer. In fact our third date was at the Met. We saw a big

Mantegna exhibition, and I was very impressed that he was so knowledgeable about art, as he works in the financial markets. He was incredibly jealous when I got this job. "That's the job I should have," he said. He insists we come here on weekends, so now I work here Monday to Friday, and on Saturday or Sunday we are over here too, but that's OK; it's always a thrill to be at the Met.

Amelia Peck

"Apparently the boredom of being on a whaling ship was extreme . . ."

As you might expect from a woman who deals primarily with women's art, which is a unique role within the Museum, this is a bold, forthright, outspoken woman. She is also thoughtful and challenging, quirky and humorous.

I've been here a long time. God, it's got to be almost twenty-five years. I came as a summer intern at twenty-four years old, and I spent a lot of time just trying to figure out how to fit into the world here, which seemed very foreign to me. I come from a Jewish family where everyone tended to be very outspoken, and arguments were the way of relating, and the Met then was very much a WASP bastion, the culture was much less verbal and emotional, and I learned to sit back and become more restrained. It was a great place to grow up.

The world here has changed. There are more women, more religious diversity.

I am the curator of American textiles, from the seventeenth century through to the early twentieth century. I'm one of the few people in this building who actually deal primarily with women's art,

and it's all amateur art, which somewhat puts me at odds with the mission of the Museum, because this is an institution of professional art.

The thing I like about American textiles is that this is as close as many women get to being recognized as artists, even though it is practical work. We have got a really good collection of bed coverings, quilts, coverlets, and embroidered pieces, plus a very nice collection of schoolgirl needlework, which are samplers and embroideries. There's something called the Phoebe Warner coverlet, which is a very beautiful appliqué coverlet. It is astonishingly well worked, and it's incredibly engaging visually. There's this profusion of flowers and these birds cut out of chintz, sitting on the branches, staring down at the people who are half the size of the birds. It is close to a folk painting, but a painting in textile, and was made by an aunt for her young niece in 1802.

Quilts come from all over the world, but they're very much part of the American frontier myth, those thrifty, industrious, American women making a home in the Wild West, sewing together different scraps of cloth until suddenly they had these wonderful objects. Actually, most quilts were made of specially bought fabrics; for example, the Phoebe Warner quilt was made by a well-to-do woman who chose those fabrics in New York City and had a sophisticated visual vocabulary.

There's a huge following for quilts and samplers among the public; I got something like forty thousand visitors for a little quilt show I did recently, which had only nine quilts.

It's very hard to say specifically what makes one quilt better than another; it's a combination of really good workmanship and how the colors work together, plus a visual image that is arresting and beautiful stitching. Your run-of-the-mill blue and white quilt with the

repeating pattern, it's like, who cares? It's a quilt that could have been on any hundreds of people's beds.

The other great collection we have here is by a woman textile designer named Candace Wheeler, who was working from the 1870s into the 1890s. She was the first woman interior and textile designer in New York, and she started her own firm, hired only women, and worked with the early silk mills in Connecticut to produce her designs. We have a large archive of her material.

My favorite Wheeler textile is a large, unfinished panel, probably meant to be incorporated into a wall hanging. It has a gold metallic cloth ground that has been appliquéd with full-blown pink silk tulips. The tulips are placed on the background in a pattern of swirling circular forms. Instead of depicting the tulips at the perfection of their bloom, as would be usual for most designers, Wheeler has shown them past their prime, the petals blowsy and widespread, about to fall off. It reveals Wheeler's eye, which found beauty in out-of-the-ordinary places. My other favorite design is of water lilies printed on silk. It is an iridescent fabric because of the fact that the warp and weft threads are different colors. She had the pattern of water lily blossoms and leaves printed on the warp (vertical threads) before the solid-colored weft (horizontal threads) were added. When the warp and weft were woven together, the pattern softened and fell slightly out of alignment, creating a shifting and shimmering quality, like real water lilies floating on water.

I also curate something called miscellaneous natural substances, which are all the things no one else wants to deal with in the decorative arts and have been dumped on me. There are strange bits of things on ivory, weird pieces of folk sculpture, fire buckets made out of leather, plates made out of trees. We have a horrible little profile portrait of Ben Franklin in wax, now half melted, and odd bits and

pieces, like scrimshaw, whale teeth that have been carved on by sailors. Apparently the boredom of being on a whaling ship was extreme, and the sailors would make decorative objects out of these things to bring home to their wives and families.

The Museum is a big part of my life, but I have many other things in my life. I have a husband, who is the director of an outpatient treatment center for the mentally ill and is involved with a lot of life-and-death kind of stuff, people who are decompensating, throwing chairs in the middle of the program, or who may have to be hospitalized today. I am a little angry at my husband because I have written several books, and he doesn't read them. OK, he doesn't have to read the whole book, but I think he should read some of it. He *will* come to the opening if I have a big exhibit, however. We were actually at the Museum last weekend, although we saw nothing of the American Wing. His real passion is abstract expressionism, so we were over in the Modern Art Department, looking at all those post–World War II men painters.

I've got two children, and the twelve-year-old is disabled. The Museum is wonderful about letting me have time off if she is unwell. But in some ways the Museum is where I come to relax. I find a great deal of pleasure being here and doing the work. For me, work is pleasure. I also think my colleagues are a gift, they have become such good friends. I can't believe sometimes that they pay me to come here.

Stuart W. Pyhrr

"I can't remember a time when I wasn't interested in knights in armor . . ."

For a man who presides over the Arms & Armor Department, galleries festooned with halberds, pikes, swords, muskets, crossbows, and numerous other weapons of mass destruction, Stuart looks remarkably unbellicose. Furthermore, he is reassuringly gentle and thoughtful in his speech.

Most specialists in the arms and armor field started as children, playing with swords and guns, imagining themselves as King Arthur or some warrior hero. I grew up in Chicago, where there was very little arms and armor, but that didn't stop me from becoming fascinated with it through books and films. I can remember watching Errol Flynn in the fighting scenes in *Robin Hood,* and avidly reading *Prince Valiant,* which was a comic strip about a knight in the court of King Arthur.

But medieval knights were always my primary interest. I can't remember a time when I wasn't interested in knights in armor and all the accoutrements, and I embarked on a quest for books and toys which related to them. I collected an array of swords, first in plastic, then in metal, and finally antiques, and I became a serious collector.

My greatest treasure, which I collected at a very young age, was a French mid-eighteenth-century small sword, the kind of sidearm that would be worn by a well-dressed gentleman civilian, with very finely chiseled steel and bearing small figures of soldiers in contemporaneous costume. A real work of art and one that I thought terribly expensive at five hundred dollars, but whose full value I only came to realize later on, as I studied more and more swords of that period.

I had very indulgent parents who understood my maturing interest, and when I was sixteen, they took me around Europe to visit armories, and I was allowed to choose my itinerary. So we went to the Royal Armory in Madrid, the Imperial Armory in Vienna, the Tower of London, of course, and the Musée de l'Armée in Paris.

I visited curators and talked to them about careers in the field. I saw how museum professionals could study and handle the objects, and that became my goal. One of my mentors was Helmut Nickel at the Metropolitan, and every year I would visit him to study the collections. I can remember him opening drawers of swords in rows of ten, and showing me the riches that exist in a museum storeroom, and it all comes alive when they're in your hands. I was very fortunate. Helmut had been searching for a young curator to study the field, so he was very pleased to find me.

The collection here is about fourteen thousand objects. It's one of the largest and most encyclopedic collections of arms and armor in the world in its range of dates and cultural spread. As a museum of art we don't have the space or the mandate to present a didactic display of the history of warfare; we are more interested in armors and weapons as decorative art rather than as weapons. About half the collection is European. A good portion of the non-European are Japanese objects, and about two thousand are from the Islamic world and Indian subcontinent, plus a small group of American arms.

Around 1500 a gentleman wore a sword as part of his daily civilian dress, the way you and I would put on a coat and tie in the morning. You would choose your sword according to your economic situation. So a very wealthy nobleman would have a sword decorated to match the quality and ornateness of his costume, although at the same time it would provide him defense if he were attacked in the street or had to fight a duel. In fact a wealthy person might have a dozen swords of various styles for different periods of his life. For example, he might have a blackened sword which would be appropriately unostentatious during a mourning period. And if he were dressing for a ball and wearing very ornate silks and satins, he would have a sword with a golden hilt or even one studded with diamonds. If you look at male portraits of the time, the men quite often held their swords up so that you could see the hilts.

The popular image is that armor was exceedingly heavy, and when a warrior fell off his horse, he couldn't get up without help; in Laurence Olivier's film *Henry V*, they actually had a crane lifting the king up on his horse. That is completely inaccurate. Battlefield armors had to be light because you often lost your horse on the field and had to be able to put your foot in the stirrup and get back on again.

Unfortunately, very few medieval arms and armor survive because they were made of iron and steel, which rust and disintegrate much more readily than, say, classical Greek armor, which is bronze. In fact there are fewer than a dozen homogeneous armors anywhere in the world dating before 1500.

For complete armors we jump to the sixteenth century. Our great strengths here include a very important group of English armors made in the royal workshops at Greenwich. We have the armors that belonged to the Elizabethan courtiers the earls of Cumberland and Pembroke. A very distinctive English style of armor was created

there, extremely well constructed, with numerous safety features, extra reinforcements and hooks, steel hinges rather than leather straps to ensure that the parts intended to stay closed did just that. There was a great emphasis on safety that you don't find on the Continent because these were armors for both sport, meaning the tournament, and warfare.

We also have wonderful German and Italian armors and a very important group of French court armors, which were made in the second half of the sixteenth century, when goldsmiths worked on armors for the French court. The armorers would fashion the steel plates, which the goldsmiths would then emboss into relief sculpture, like a jeweler's work.

One of the best known of our armors belonged to Henry II of France. It is covered from head to toe in low relief with hundreds of figures over the entire surface, with spiraling leafy tendrils inhabited by human figures, grotesques, and chimerical creatures that take their inspiration from ancient Roman painted wall decorations, and the surfaces were then heat blued, gilt, and damascened—that is, overlaid with gold and silver. The complexity and originality of design, and the richness of materials, distinguish this armor as one of the most important examples of French Renaissance metalwork. Henry would have worn it in a parade situation, whether appearing before troops or riding through the streets of Paris, and it was meant to show off his status as a king who could afford an armor that took many months to make and employed the leading goldsmiths of the time.

The Negroli helmet, a helmet whose owner has not yet been identified, but which is signed by Filippo Negroli, the master metalworker of Milan in the second quarter of the sixteenth century, is perhaps the finest piece of Renaissance metalwork in this Museum. Negroli had

such self-confidence as a designer and craftsman that he signed his name, in full, in gold, across the brow of the helmet, which was unique at the period. We live in an age when logos and designers' names are displayed prominently on our clothes, but in the sixteenth century most works were anonymous, and were certainly not signed ostentatiously. But Negroli knew his status, and his patrons accepted it.

The helmet is a single piece of steel, worked in high relief, with huge complexity and imagination of design, and it all fits and works and flows together. And it's so beautifully worked with the extraordinary craftsmanship and artistry that no matter how long you look at it, you keep discovering more, and as long as I've known it, and as familiar as it is to me, it never ceases to amaze.

Chronologically, our latest armor dates from 1712. By that time armor was symbolic rather than practical; the battlefield was now occupied by soldiers wearing only the occasional piece of armor, such as a breastplate. This was made for the future king of Spain when he was about five years old, and it's charming because of its diminutive size. Its primary decoration is heraldic, with hundreds of small rivet heads that take the shape of the coat of arms of Spain.

We have quite a wide range of firearms, dating from the sixteenth to eighteenth century. Perhaps the best-known is a pistol with two barrels and two locks—in other words, affording two shots—made about 1540 for Emperor Charles V by a very famous gunmaker and clockmaker in Munich. It's interesting that at this early period gunmakers had training as clockmakers, largely because of the very complex mechanisms involved with the ignition systems, in this case the wheel locks. It merits attention because of its early date—few wheel lock firearms date before this time—and its restrained but fine decoration—the barrels and lock are etched and gilt with Renaissance

ornament, and the wood stock is inlaid with engraved white bone with a hunter, dogs, and a stag—and finally, its prestigious owner, Charles V, holy Roman emperor and king of Spain.

Our collection also includes six delicately decorated firearms from the personal collection of Louis XIII of France, best known for being in the *Three Musketeers* saga. From his youth he was fascinated by gun-making and collected hundreds of firearms of all kinds.

We have Colt revolvers which were made in the 1850s by Samuel Colt, the time when they were new on the market and making inroads into the international firearms scene. The selling point of the Colt was that its multishot mechanism was reliable; it had five or six shots which could be easily loaded and it had interchangeable parts. Our finest example is very luxuriously decorated in gold with American patriotic emblems. It had been presented to the sultan of Turkey in the hope of landing a large order from the Turkish army, while its mate was given at the same time to the czar of Russia, also with the hope of landing a large commission. Of course Russia and Turkey were at war in the Crimea at the time, so like so many arms dealers, Colt was playing both sides of the field.

It's very difficult to turn off my interest in arms and armor. Most of my vacation time is spent in Europe pursuing my own research. My last holiday, in Florence, was spent doing archival work on the Medici and della Rovere collections, and of course, whenever I have a chance, I go to other museums' collections and search through their storerooms, looking for parallels to our collections or material that will help inform me better about what we have. The only time I actually stay away from museums completely is when I go to France for two weeks every spring. I drive through the countryside and look at houses, landscapes, and seashores. It's an enforced holiday from my first love but a very pleasant change.

I don't collect any longer. My tastes have become those of the Metropolitan Museum, so they are unaffordable on a curator's salary. My indulgences now are books about arms and armor for my library. I will occasionally buy an ornamental print, but that feeds my interest in design for the period, which in turn relates to the design of arms and armor of that period.

There's a patrician element to the wealthy industrialists and entrepreneurs who support this institution and become very close to it. We certainly have a great number here who do it without asking for anything in return; noblesse oblige is the best way I can explain it. It's not always that way with the younger generation coming up, who've made their money quickly and who are orientated differently, more self-centered perhaps, and want something for everything they give.

Arthur Ochs Sulzberger, the chairman emeritus of the *New York Times,* is the principal benefactor of the department of Arms & Armor, and he does it because he lived across the street as a child and visited the Museum and enjoyed arms and armor. He is not a collector, yet he's endowed the chair, he's given us acquisition funds, and his name is attached to many objects. He's given to the Museum both his time—he was chairman of the Board of Trustees—and his money, and he adopted our department and has been our major patron for the past twenty-five years and is one of the great gentlemen of his age, the kind that are quickly disappearing. . . . We owe him so much.

Annette de la Renta

"Punch Sulzberger and I had a bet..."

The de la Renta apartment seems to be overrun with dogs of dubious pedigree, one of which, a stray, was found on a beach and given to Annette by the dancer Mikhail Baryshnikov. There are extraordinary paintings and tapestries on the walls, and a large table, formally set, dominates the sitting room. Sparkling, fun, mischievous, she positively bubbles with delight at life and laughs constantly— about the Met, life, and herself. She is a delight to be around, the reason why I thought up spurious excuses to visit her in this wonderful apartment she shares with her husband, designer Oscar de la Renta.

I was brought up in Far Hills, New Jersey, the eldest of five sisters. Our father was a successful international businessman, and the family traveled widely, but our home was always New Jersey, and we all began our schooling at Far Hills Country Day School.

We received our art education at home, where we were fortunate enough to be surrounded with Impressionist paintings: Manet's exquisite children descending a staircase, a very beautiful, enormous *Water Lilies* by Monet, van Gogh's *Water Mill*, which was in the dining room, and a wonderful, huge, romantic, very early pink Picasso depicting the mountains of the Pyrenees, which the art historian John Richardson tells me he painted when he was very in love. So some

truly extraordinary things. In the midst of all that dazzling beauty, you look at those masterpieces day after day—even as children—and gradually your eye tells you what you like best.

Luckily for me, I don't have to have them; I am happy to see them in museums where masses of people can enjoy them. Over the years I've bought a few things. I have always had a soft spot for Rothko—not the suicidal, purple things he did at the end—I bought a beautiful red and yellow, bold and happy Rothko; it's just a joyful thing. I also bought a beautiful silver Stella, and a lovely Morris Louis. I am no expert in abstract expressionism, I just liked them, and I had the space for them in those days.

I can't remember a time when I wasn't involved with some aspect of the Met. I came on to the Board after my mother resigned following my father's death, and have been active ever since.

Today I serve as chairman of the Acquisitions Committee, which meets in the Douglas Dillon boardroom four times a year. Our mission is simple but crucial: to build the collection. I am the guardian of the chair, but like all my predecessors in the position, I turn the meeting over to the director, and then Philippe runs it brilliantly.

To my mind, it's by far the best committee to be on if you like art. I don't specialize in numbers, and I'm sure the people on the Board's Finance Committee think that theirs is fantastic too. But at Acquisitions you get to meet and hear the Met's curators, young and old, veterans and newcomers, as they passionately describe the works of art they hope the Museum will acquire. They are passionate in their earnestness and dazzling in their scholarship—genuinely inspiring. Somehow, at each and every meeting, we run the gamut from ancient to contemporary art in just a couple of hours, and manage to add to the collection, filling gaps at what Philippe calls the highest level of artistic accomplishment. Nothing less will do.

From time to time we have fun while we're being serious. We once had an acquisitions meeting at which we were asked to consider a pastel of a little cupid with flowers in its hair—a curious picture, but in the most wonderful, beautiful eighteenth-century frame. Curator Keith Christiansen got up and made such a fantastic presentation that the entire room voted to purchase it. Only Keith could arouse such excitement: everyone loves him and respects his judgment and taste enormously.

My beloved fellow trustee Punch Sulzberger and I had a bet: I said it was a boy, because I had read my briefing papers carefully, and he said that's not a boy, it's a girl. He ended up having to pay me a dollar because I was right. His generosity didn't end there. Punch is an incredible gentleman. On the afternoon of September 11, 2001, he strolled down Fifth Avenue and presented Philippe with a two-million-dollar check. "I thought you could use this," he said, as he guessed audience figures would slow down for a while.

When all of the curatorial presentations are finished, Philippe goes through the list with the trustees, object by object, painting by painting. Most of the time, because of careful advance budgeting, there are enough funds in each curatorial department to buy the works they've presented. Every so often, a trustee will step up and offer to personally fund a purchase that is costly, but particularly important to the director or one of our curators.

I go to the Museum all the time to see the new acquisitions hanging in the galleries, grateful to watch the public getting the opportunity to see the newest additions to the collection. And, of course, I go to see the new shows, Max Ernst, Fra Angelico, Americans in Paris, Vollard, or the deeply moving Diane Arbus that so many young people flocked to a couple of years ago.

I love the Met and am very proud of my family's association with

it. The Engelhard Court at the Met was given by my mother in my father's memory; it's in the American Wing because he always felt deeply patriotic, and he liked the idea of a space where you could sit and look at the greenery after spending a morning or afternoon walking through the galleries. Now the courtyard is going to be completely rehabilitated and reinstalled—with a new mezzanine gallery upstairs and, I personally hope, with more Saint-Gaudens sculpture in the courtyard than ever. He is my hero as an American sculptor. He and the Met belong together.

Sabine Rewald

"Yesterday was a very fine moon . . ."

She speaks English with a light German accent and is quite endearingly eccentric—and completely charming.

I grew up in Berlin in the 1950s and '60s; it was a strange city, way beyond normality. I came to America when I married my husband, and did all my studies at the Institute of Fine Arts. My dissertation was on Balthus, and the Institute made an exception for me to do it, because one was not usually allowed to do a Ph.D. on a living artist. What drew me to him were his strange images and interiors full of foreboding; there was something slightly sinister in these pictures that reminded me of interiors in Germany. They struck a chord and made me think about my room at home as a young girl, where I hung very depressing images of Utrillo squares around Montmartre, with sad, rather isolated figures, which is the Germanness in me probably. I am not a gloomy person, I am just attracted to it.

Generally, I don't have favorite artists, I have favorite pictures. Picasso, for instance. We have a wonderful collection of Picassos, but our crown jewel is the portrait that Picasso did in 1906 of Gertrude Stein, which she left to us in her will in 1946, when we didn't even have a Modern Art Department.

It's a very tough, wonderful picture, largely in browns and blacks. Stein was a heavyset, corpulent woman, a mixture between a sort of Buddha and a savant, and in this picture she wears a very drapery dress. Picasso needed ninety-nine sittings to get her head right, and in despair one day, while she wasn't there, he painted her face with a mask like an ogre. "I don't look like that . . ." she said, to which he replied, "You will, you will." And she did.

I love Vuillard's small interiors, he is so very poetic. He lived with his sisters and mother in modest apartments from which his mother operated her corset-making business, and he focused on the world that surrounded him. He would make beautiful interiors of women sewing and create these kaleidoscopes of patterns: the patterns of the wallpaper, patterns of the women's dresses, patterns of the bolts of fabrics they used—delicious pictures, little masterpieces. He never married. I think he was totally devoted to his art, but he was apparently a very fine friend and had a sense of humor, although you would never know it to look at him; he always looks very melancholy in his photographs.

You would be shocked coming to my house, because all the pictures there are from around 1800, little German landscapes and portraits by unknown artists. Odd, isn't it? There is no Modern Art in my house and no modern furniture either; you would never think I am a curator of Modern Art. I am a total anachronism. I have a fridge, a CD player, and a radio, and that's about it for modern appliances. I don't have a television: I recoil from it. American television is grotesque; there is this hectic stupidity that I find completely overwhelming.

People who become curators are idealists, because it is very difficult to feed a family on the salary of a curator; you really need money of your own, as did former generations, when they put the

paycheck in the drawer. This job is really for people who are passionate about pictures, about wanting to make exhibitions and write about art. I do it because it is my vocation, and I hope I contribute something. I would have liked to have been a writer, but I lost my German, and I don't think my English is good enough, but I get great satisfaction writing on art, and I think I have a very fine eye for quality, so when I combine the two, it's a perfect match. Does that sound conceited? I hope not.

The thing I have written that I am most proud of is a tiny little catalog for an exhibition I did with Gary Tinterow called Moonwatchers, in which I assembled a small group of pictures to do with the moon, which was a labor of love because I love the moon, you see. It was inspired by a famous picture by Caspar David Friedrich—well, there is another gloomy artist—called *Two Men Contemplating the Moon*. It shows Caspar David Friedrich on his habitual evening walk in a landscape outside Dresden with a young painter friend. They walk up a mountain path, and the picture has what I must admit are somewhat theatrical props. There is a gnarled old oak tree, and beside it is a pine tree where they rest just to admire the waning moon in front of them. In fact, Caspar David Friedrich was known to take walks only early in the morning or before sunset because he did not like the strong sunlight.

Another favorite was a small, delicious little picture by Johan Christian Dahl, called *A Cloud and Landscape Study by Moonlight*. I like it because it's so spontaneous. He did it looking out of his window, and he had to be very fast as he had to catch the clouds moving over the moon at terrific speed. It's a very dexterous, beautiful depiction.

The show opened on September 11, 2001, strangely enough. The public didn't come, because we closed the galleries half an hour after the Museum opened on that extraordinary day. But this exhibition,

with these very moving, meditative pictures, became a favorite with the public, because the public was in need of consolation, and people streamed to it and felt solace.

I am a sort of moon specialist myself. The sun is so indiscreet and pervasive, and you can't look at it, because it is too strong. But the moon is not such an invasive force; it has this melancholy distance. I find it extremely poetical. I can see the moon from my apartment when it rises over the East River. Yesterday was a full moon, and it was a very fine moon, bright and delicious.

Jeff L. Rosenheim

"She told me about growing up in
a nudist colony . . ."

He has something of the politician about him, urbane, diplomatic, articulate.

In 1839 Samuel F. B. Morse, the inventor of Morse code, was in France, trying to sell the patent rights to his electromagnetic telegraph. The reported story is that he went to the Academy of Sciences, and the director said, "Well, Monsieur Morse, we have an inventor in our country who like you has made an invention he claims will change the world. Perhaps you two should meet." And he introduced Morse to Daguerre. Completely blown away by Daguerre's invention, Morse then wrote to his brother, who was a newspaper publisher, saying he had seen this amazing invention, the daguerreotype, and when the technical information was published in New York, people started making cameras and trying out these experiments.

Photography took hold in America. People in an immigrant culture wanted photographs of themselves to send back to the old country, and pretty soon there were more photographers and

studios in New York City than there were in Paris and London combined.

In the first ten or so years photography was primarily a portrait medium: the farrier and his tools, the seamstress, the blind man with his reader, who is reading him the newspaper. Mathew Brady was certainly the most famous studio photographer in New York in the 1850s. After he opened a second studio in Washington, D.C., he photographed so many politicians that the question everyone asked was: "Have you been Bradyed yet?"

There was this great documentation of American Indians with all their regalia. We have a wonderful picture of Kno-Shr, a Kansa chief who is sitting bare-chested with a bear claw necklace and a tignon, a wrapped headdress with feathers in it. His ears are pierced, and he has got dangling gold nuggets hanging down, and is staring at the camera with undeniable grace and power. It has been hand colored red because that was the color of power. When this picture was made, he was probably on his way to Washington to seek a treaty with the U.S. government—which, no doubt, we would renege on shortly thereafter. It's one of the greatest pictures of a Native American that exists.

By 1857 or 1858 the Daguerreotype era is on its way out, and in comes photography on glass plate negatives, which greatly expanded the medium. The Civil War began in 1861, and the camera at war became a very big part of American photography. We have an enormous collection of Civil War photographs at the Met, over five hundred pictures. After Bull Run, the first battle of the Civil War, Mathew Brady put his cameras in a wagon and began making an extended documentation of the war. He and his corps of field photographers followed the Union armies to photograph the preparation

and aftermath of battles; plus, he did portraits of individual soldiers, generals, and the wounded.

Alexander Gardner's picture of the dead at Gettysburg is an unforgettably brutal picture of bodies, and he recorded other scenes, like *The Sharpshooter's Last Rest*, which shocked America.

Cameras then started going along with engineers to document where the railroads would go, so they were part of the migration west, and the camera climbs mountains and crosses creeks and goes to the corners of America. We begin to see extraordinarily beautiful landscapes; A. J. Russell, William Henry Jackson, and especially Carleton E. Watkins, made great Western views, in which America has a kind of pure, Edenic quality, showing these monumental mountains in Yosemite and the Sierra Nevada, with magnificent valleys and waterfalls coming out of rockfaces. Congress was so inspired that when its members saw these great Western photographs, they said, "We must set this land aside so that no mining would be allowed." This became the beginning of the National Park system.

By the late 1870s and early 1880s, as the price of camera equipment went down, it became possible for individuals, who had leisure time and a little bit of money, to use their own equipment instead of hiring a professional, and you had a springing up everywhere of little amateur clubs.

Then, in the late 1880s, George Eastman invented the little Kodak, the first camera that was truly affordable. This camera didn't require a tripod; it had a spring-based metal shutter that went across the lens and made a loud return sound as it did so, sounding something like *k-dak*—hence Kodak. It was a little rectangular box, not unlike a shoebox, and you could hold it horizontally or vertically—it didn't matter because the image was round. You

bought the camera at the drugstore, and it came with the film already loaded with a hundred pictures in a roll, and when you were finished, you took your camera to the store and it gave you another one.

Soon everyone had this device, so we began to see vernacular photography. We have these great pictures of billowing sheets or children with their lunch pails going to school; people were even photographing drying laundry in the backyard, what you could consider the banality of life or, depending on your point of view, the richness of life.

The turn of the century saw the development of a fine art photography tradition. These photographers were not war photographers or portraitists; they were artists. Alfred Stieglitz recognized that the medium of photography had its place in the art world, and he opened the first photography gallery in America, in which he incorporated photography, painting, sculpture, and drawing in one gallery.

Stieglitz himself was a master photographer. In fact the very first photographs that the Met acquired as art, in 1928, were his photographs of Georgia O'Keeffe, who was one of the great artists of her day. They're very intimate pictures of this very young woman, who was much younger than he—in fact she lived until the 1980s, and he died in 1946. They are nudes, primarily, which were quite radical for the time. It's fair to say these studies are some of the most progressive and avant-garde studies of a woman in photography. Georgia O'Keeffe has a very strong face; there is strength of character in her jaw, the intensity of the stare of her eyes. She also has a beautifully proportioned body, beautiful breasts, and a long, elegant neck. She was just a great model.

Steichen's photograph of the Flatiron Building is the signature

image of that time, the first years of the twentieth century. The build-
ing is down on Madison Square, where Broadway and Fifth Avenue
meet, which creates a very acute-angled corner—someone described
it as "the prow of a ship parting the centuries." Many people consid-
ered this building to be the first great modern building in the city, and
so Steichen's photographs of it were timely: this was modernism. We
have three versions of the same negative with different chromatic val-
ues; one of them is quite cool and blue, one is more blue-green, and
the other is quite brown. They are tone poems, basically, taken right
out of those tonalist and luminist qualities that you find in Whistler.
And they are absolutely stunning.

Walker Evans wanted to be a writer, and he was very talented, but
unsuccessful, and in 1928 he picked up a camera and decided he was
going to be a photographer. Within a year the stock market crashed;
it was the beginning of the Depression, and things were very tough.
He was hired by the U.S. government to photograph in the rural
South, and he photographed struggling farmers, both white and
black, and the important and sometimes quite tragic elements of the
Depression.

Probably the most interesting photographs are the pictures of the
Burroughs family, cotton tenant farmers in Alabama. There is a
wonderful picture of Allie Mae Burroughs standing in front of the
simple clapboard wall of the farmhouse in which she lived. Her lips
are pursed and make this very straight, flat line, as planed as the clap-
boards behind her. She is a young woman, about twenty-six years
old, although she looks twice that age. But she has her dignity; she
doesn't look defeated by the experience, she looks like a participant
in the endeavor, and she is unafraid of staring right back at the cam-
era. You could look at that picture forever.

After the horrors of World War II, we leave behind the view camera and focus on the 35-millimeter camera, and we begin to see a movement where feelings are more important than facts.

This is a whole new era of photographers who believed that their personal experiences could be recorded, and there is a fascinating intersection between European and American tradition, where we see the influence of Henri Cartier-Bresson and Robert Frank, who was Swiss, and William Klein, who was photographing everything, from someone putting up the new title on the marquee to his picture of men queuing up to use the urinal, where there is this white porcelain and interior with bright, glowing lights and dark shadows.

Also in our collection is an interior of a café by Frank. A television set in the corner shows a television preacher like Oral Roberts, but the café is empty, so the television is broadcasting to an empty room. Your feelings are loneliness, a little bit of anxiety, but a lyrical feeling of the presence of the artist as the vehicle through which we see the world.

We have a very good collection of Diane Arbus's work. One of her most famous pictures, made on the eve of the Vietnam War in 1963, is *Child with Toy Hand Grenade in Central Park*, a picture made just outside these Museum doors. There is this pastoral view of a verdant Central Park behind the boy. He is scowling at the camera and clawing one hand and holding the grenade in the other. We also have the famous picture of the two identical twins, and I have met the twins and had a wonderful conversation with them.

Similarly, there is a famous picture of a young waitress, probably no more than fifteen years old, at a nudist camp; she has her waitress doily on, with a notepad tucked into it, and she is nude from the

waist up. She called me from Florida one day just before our show on Diane Arbus and introduced herself. We had a fantastic conversation, and she told me about growing up in a nudist colony while going through puberty and never feeling comfortable.

Those were amazing interactions. For a curator of photography that was huge. It would be like a subject of Rembrandt's arriving at the Metropolitan Museum and talking about what it meant to pose and work with the artist.

E. John Rosenwald, Jr.

"Dan, we are very hopeful you will give us five million dollars . . ."

The enthusiasm, energy, and philanthropic motivation of this man are awesome.

I f I can be honest, I am known as a very big fund-raiser in the city, and there should be no doubt that my connection to the Met came about as a fund-raiser as opposed to my being a major collector or a patron of the arts.

Punch Sulzberger asked me to come to lunch with him, and I went up to the Metropolitan, and we schmoozed about what I do, and he said they would like me to come on the Board. That was a deep, wonderful honor. Sure, there are the boards of MoMA and the Whitney, but the Met's Board is just a singular honor to be invited to join. Certainly, in the cultural world it's considered the most important board in New York.

It was 1994, and they wanted me to chair the first campaign the Met had ever had, to celebrate its 125th birthday. We simply called it The Fund for the Met, and we planned to raise $300,000,000.

Two years later that goal was raised to $400,000,000, and some years after that it was raised to $650,000,000. A couple of weeks ago

we were on the front page of the *New York Times*, announcing we were raising the $650,000,000 goal to $900,000,000. And we shall hit the $900,000,000; we're at $700,000,000 at the moment.

When I am asked to chair a campaign, the first thing I do—after saying yes—is make my own gift. I have to be personally committed to the institution in which I am asking people to invest. Also, it's critically important that I make an important gift myself before I ask anybody else to make a gift. Then I can look anyone in the eye and say, "*I* have done it: *you* have got to do it." The professional development staff at the Met are the best in the world. They are outstanding, but, as outstanding as they are, here's what they cannot do: they cannot sit down with a prospect and say, "I have given a million dollars, so you have to give a million dollars." A staff member cannot do that. If one has never written a check to a charity for a million dollars, one just doesn't know the dynamics of the exercise. And if you don't know the dynamics of the exercise, you are not going to be an effective salesman.

To be a good salesman, you have to do your homework. I'm a great believer in research. If I have asked you to have breakfast or lunch with me to solicit you for the Met, I want to know everything there is to know about you, your level of giving to other philanthropies, your interests—I want to know which hand you use to brush your teeth. I am serious. I plan these solicitations in the same way the invasion of Normandy was planned. There's an awful lot of information in public databases. There are services that keep track of stockholdings, and you'd be amazed how much the databases provide about people: *He* just sold his home in Nantucket for five million dollars, or *he* just gave ten million dollars to Harvard.

I shall then endeavor to find out in which of the missions of the Metropolitan Museum of Art you are most interested. It might be

Arms and Armor or Greek and Roman, or it might be Education, or Information Technology or giving money to strengthen the security system. I want to know what your passions are, because that is what I will ask you for. I put it right on the table: I tell people when the date is made what the purpose of the lunch is. I say something like, "Dan, we are very hopeful you will give us five million dollars. Whatever you give us, we are going to be grateful, but that's the figure we are hoping for. . . ." And I *am* hopeful. You might respond, "John, I have just given all my money to the Whitney, so I am not interested," but if someone has accepted my invitation, the chances of his turning me down are very small.

I enjoy doing that, because I am a salesman. I want to make the sale. I have a book my father gave me which was written by Elmer Letterman, one of the greatest life insurance salesmen that ever lived. The name of the book is *The Sale Begins When the Customer Says No.* That means, if the customer is all ready to buy, then you are an order taker. But if the customer says no, it is then that you become a salesman.

And then it's a chase, a challenge, a sport. A few years ago, the person I was soliciting happened to be a very prominent real estate developer in the city. At that particular moment, the real estate business was terrible. He looked at me and said, "I would be ashamed to make the commitment to you that I can financially make today, so I'd rather say nothing."

"I accept that," I said, "but would you make us a partner in your recovery?"

He agreed. "That's fair," he said.

I was patient, and we ended up eventually with a seven-digit gift from that person.

You have to listen to what someone is saying. If he says, "I have just

made a major gift to Yale, and I am uncomfortable with making any additional commitments now. Can we speak in a year?" I'll say yes.

And I will call him in exactly one year. "Here I am, you told me it was OK to call you."

"Boy, oh, boy, you have an efficient system," he always says. "I would be happy to sit down with you now."

In my world of philanthropy we have an expression: Money isn't everything—health is 1 percent. But I love it when someone says he will give us their collection when he dies. Of course, it has to be a collection the institution wants; you may have a collection you are passionate about, but it might be less than significant for the Museum. If you have an incredible collection, of whatever it is, and you are deciding what to do with that collection when you are finished with it, where better could you put it than the Met? I suggest that you might want it to be at the Metropolitan Museum of Art because more eyeballs will be blessed by those pictures than any other place in the world, just because of the number of visitors who pass through and the quality of the collection of which your pictures will become part.

Let me tell you something: I was the only member of my class at business school who went into the securities business. It was not a profession anybody chose then. In fact there was a joke that went around: "Don't tell my mother I work in the securities business; she thinks I play the piano in a whorehouse." But I decided the opportunity was gigantic, and I was right; the guess absolutely played out. When I was thirty-one years old, I was made a partner of Bear Stearns and began to make some money. When we went public at Bear Stearns thirty years later, you know what I did? I took all the money I received out of the public offering and gave it to charity.

My partners at Bear Stearns created a culture of philanthropy; we put in a policy where all senior management people in the company

had 4 percent of their income withheld and six months to give the funds to a charity—or *we* would give it away. We made that compulsory, yes, sir. I don't believe that people are born philanthropic, any more than they are born knowing in which hand to use their fork. By forcing people to give away a percentage of their money every year, they quickly learn they can give a hell of a lot more away than they thought they could and still be able to afford to go bowling on Saturday night.

There is a remarkable range of attitudes about philanthropy. I have found that it is easier to raise money from people who have made it themselves than from people who have inherited it, and I think the reason for that is people who made it for themselves can remember what it was like not to have anything. Bill Gates would be a perfect example.

My money goes to the Education Mission at the Metropolitan. I love going there early in the morning and seeing the school buses emptying out, and the kids come in and sit on the floor and start learning about art. I call that a human dividend check. I make the investment, and instead of a check, my dividend is watching those kids. Every year we have 250,000 schoolchildren who get the beginnings of art education at the Metropolitan, and I don't just mean my grandchild going with me by the hand. I am talking about entire classes of schools being brought to the Met, where they are lectured to by docents.

I also give a scholarship to a university every year, and the only condition on my gift is that the student who receives the money write me a letter once a year and tell me what he did, which is a huge dividend check. If I endow a doctor at my medical center, we'll have dinner every year, and he'll tell me about the research he is doing to find a cure for cancer. That too is a huge dividend check.

I don't know how much I have given in my life. Pound for pound of what I am worth, I have given away as much money as anybody I know. So I know the pleasure and satisfaction from giving.

My own enthusiasm as a salesperson, as a solicitor, is driven by these human dividends I get, and I think I am doing *you* a favor getting you to make a gift.

Raymond Smith

"Maybe I am not Matisse . . ."

I first came across Raymond spread out in one of the European galleries, with paintbrushes, easel, canvas—of no more than thirty centimeters, as the Met insists—taking up most of the spare room. He looked completely absorbed in his work, so I didn't talk to him. But when I saw him a second and third time, I pounced and invited him to chat. His long hair and laconic way of speaking brand him a child of the seventies.

My name is Raymond Smith. I am fifty years old, and I've been an artist as long as I can remember—primarily self-taught, except for a class here and there.

Originally I come from the Midwest—Hammond, Indiana. We had an excellent library in Hammond, and I started ditching school to go there; they had a smoking room, and I would sit there and smoke and read art books, and that was where I became aware of Picasso and Dalí and all those guys.

Even as a boy I wanted to be an artist, I wanted to be the guy art teachers would teach people about. But my father was not there at all for me; he didn't encourage my art one bit—in fact he tried to discourage it. My mother was totally supportive, but unfortunately she wasn't too aware of how she could navigate me into art school,

and my high school guidance counselor meant well, but she was some little old lady ready to retire and didn't know how to pull that off for me either.

Eventually I got a job in a factory with the idea that I'd save money and put myself in an art school, but having an apartment and a girlfriend was just so much fun I spent all my paycheck on that. I started at the beginning of the summer with all the college kids, and then come September the college kids went off back to school, and when they came back a year later, I thought, "Hmm, *you* went off and had a year at college, and I have been here the whole time and haven't really been saving money or furthering myself." So I left that job and got a window displaying job, and I felt closer to the art world then, hanging out with all those arty types.

I wanted to launch myself as an artist, but I wasn't really ready in terms of confidence, so I got a job in a design studio in Chicago and began taking these night classes, which is how I got into graphic design.

I was doing a cover for some low-end roofing magazine when *Fortune* called and wanted me to do a cover in this airbrush art deco style I had developed. I was just totally overwhelmed and intimidated to be doing a *Fortune* magazine cover, and I didn't do it in my air-brush style—I thought it wouldn't be good enough—so I sent off a watercolor painting. They were furious. I can't believe I did that— this was my first big assignment, and I blew it. I was too embarrassed to ask for another chance, and I didn't work for them again, although I did have a few nice assignments.

Meeting my wife was a bit like that *Fortune* cover. When I saw Mary in a life drawing class, I immediately thought: "OK, she won't talk to me." Subconsciously I was thinking I wasn't good enough to talk to her. But as soon as I thought that, I resolved to talk to her.

The class was in a library in Jersey City, which had a pretty nice prints and drawings exhibit. After class they said, "You guys can go in there and look at it by yourselves." Let me tell you what happened. One minute Mary was behind me, and then suddenly she walked right past me and got on the elevator, but I stepped it up and managed to get on with her. So now it's just the two of us, and I have two floors in which to make my move. "That was a nice exhibit, wasn't it?" I went. "Let me know which one you want, and I will get it for you. Oh, by the way, would you like some coffee?"

"Sure," she said.

And we went down the street and had some coffee. I got her phone number, and two kids later here I am.

It's been a great marriage, and my confidence level has risen; I have always told her that. And my kids make me feel incredible; they are both great-looking and well behaved—sometimes it's hard for me to look at them and imagine I helped to make them.

Fatherhood is a great responsibility, but I think I have lived up to it. The only part I wish I could improve is the financial part; I wish I could be the daddy with the big paycheck. But to tell you the truth, you couldn't want a better father than me. I make all the time to be with my kids. In fact my daughter's school is visiting the Met next Wednesday, so I changed my schedule just so I could be there when they visit, and share my copying experience with them.

I go to the Met because I want to learn what those guys seem to know that I don't know, and I have found that if I expose myself to a painting, it becomes like my skin after a while.

The first thing I ever copied was *The Weeders*, by Jules Breton. It's of these peasant women pulling weeds in a field in the late afternoon or evening; the sun is setting, the sky's kind of greenish. When I first walked into the gallery and looked at that painting, it just

struck me, and the woman standing on the left really broke my heart. I felt, *that*'s it; that's my painting.

I did van Gogh's *Irises* for my wife's Christmas present, and I did a Fragonard for my daughter, *The Love Letter*, which I think is eighteenth century—I can never remember those century things. It's of a pretty girl with poufy hair, and she has got a little dog; my wife says it's like a real expensive dog for royalty. The girl looks like you just walked in on her, and she's pleasantly surprised, and she's holding a bouquet of flowers and holding a note toward the viewer. In the painting, the inscription on the note says, "To My Cavalier." I changed that. I made it, "To My Superb, Beautiful Daughter, Love Daddy," which is the only time I've ever changed something in a painting.

As soon as I start copying in the Museum, people come over and ask annoying questions. I will tell you a little secret: I've started marking the back of my canvases with how many times I get asked, "Do you have permission to do this?" or some variation of that. I look at them, and I think, "Are you *that* stupid?" I have got all this apparatus, paints and brushes and a big easel; it's not like I walked in with a tiny sketchbook. How do they think I got past the guards? Then the next question is: "How long does it take you to do that?," which is a more reasonable question, although I was keeping a score on that for a while too.

But I try to involve people, particularly kids. I can pick up on the kid who is really intrigued by art; he is always more quiet, and watching intently. I will then ask the parent or teacher, "Do you mind if he has a go at it?" And I will take his hand, because when you are making your first marks, it's good to have somebody say, "Hold the brush this way," or, "Don't push on the brush like that." Of course I will choose an area where if he screws it up, I can wipe it off.

Copying is mentally very tiring. But if I've had a good session, it's like getting a brain massage. I feel sort of buzzed from that concentration.

There's a Latour painting I am responding to now, and the next painting I want to do is by a French guy called Greuze; his application of paint and the softness of the edge sure are amazing. His palettes are like Norman Rockwell, these little morality paintings. He did a painting called *The Broken Glass*, which shows this middle-class family with a broken pot on the floor, and they are each reacting to it in different ways.

I feel privileged to be a part of the Met. I remember my first day here, and how proud I was setting up in front of *The Weeders*. I wrote a letter to Philippe de Montebello last Christmas. I just wanted to tell him what a privilege it is to be here and that I try not to take it for granted.

Also, I feel I am sharing in a tradition. You know, every serious artist used to copy; it was part of what they did. Matisse used to go to the Louvre and copy Chardin flower paintings. Maybe I am not Matisse, and I don't have his following or gallery, but, you know, he also chose to copy a painting and learn from it, so I am definitely doing something he would have done.

Right now I am still an illustrator, but I am trying to sell my work to galleries, still trying to figure out a way to actually earn a living doing art. I just figure it's never going to be easy, but I am sure I can do it.

Kenneth Soehner

"It would be horribly bad manners not to . . ."

Ken expresses himself just so, *with participles and qualifying clauses all neatly tucked into fully formed sentences.*

I grew up on Long Island. Like lots of delinquent twelve-year-old boys, I would decide to skip school now and then. But the peculiar thing about my truancy was that I wasn't out fishing or visiting amusement parks. I would go to this very Museum and have a much more enjoyable day than I would have had if I'd sat through the day that had been planned for me at school.

Like most people who come into any job, I got here through chance or good fortune. A position called Bibliographer/Acquisitions Librarian became open here because the person in that position had been made Chief Librarian, and I applied for it. It was a very attractive position, and I suspect many people applied for it, but it was offered to me, nine years ago. I remember the date quite vividly, because I began on my fortieth birthday.

I inherited a great library, meaning that the collections have a breadth, a depth, and a comprehensiveness to them which are quite extraordinary and which still, nearly ten years later, reveal themselves to me and the curatorial staff every day. So it's not an infatuated first

impression, it's a series of revelations. And there is not a week that goes by when someone doesn't stop me, pull on my sleeve, and tell me how extraordinary he or she finds the collection of the library. Even people who have been using it for a generation or two.

Books have to be looked after in the same ways that works of art have to be looked after, because many of the books are works of art, particularly some of the earlier printed books. But what's important to understand about this library is that although there are tens of thousands of rare books, it is not a rare book library. It's a working library; it's a research library and a scholars' library.

The real treasures of a library like this are not necessarily how many editions of Palladian treatises you might have. The real treasures are, for example, extensive periodical runs so we will have that extraordinary periodical *L'Artiste Russe* that was published from 1846 to 1847 in St. Petersburg, in French. It's those rare items, the items that are held in very few other libraries, combined with the mainstream material, which give it its richness.

The sport in my job is when a curator comes back from Helsinki with a skinny little catalog, published in Finnish, on a modest Rembrandt exhibition and says, "Oh, you should really have this catalog." Then I will say, "You're absolutely right, thank you very much for your suggestion . . . and the call number is *this*, and I believe it's downstairs on the shelf." It's not a gotcha game by any means, but so often we'll have what you need in anticipation of your need for it.

The original Museum charter of 1870 says that "A Museum and a Library will be built in the city of New York," which indicates that the idea of building a library was fundamental to the founders of the Museum. And the founders and trustees gave of their resources in the grandest scale to help with the founding of this place. In 1901 Jacob Rogers gave a major bequest of five million dollars to

the Museum for works of art and books for the library. Happily, that momentum has continued, even when there were interruptions, like the Second World War. We now have about six hundred thousand volumes, which make it one of the largest and most comprehensive art libraries in the world.

Trade catalogs are very important to this library, because they very clearly establish a date and attribution for a variety of objects that a particular manufacturer is carrying. They'll cover everything from Sheffield silver at the turn of the eighteenth century to one published in Kansas in 1880 on American furniture, which gives an idea of the kind of furniture that was available to people living in Kansas at that time, which was not necessarily as rustic or primitive as you might think. A recent purchase that brought a certain degree of satisfaction was a book which describes a technique of glass manufacturing which apparently was a very innovative method when it was first developed in the 1820s.

To think I have time to read everything is to misunderstand the nature of my job entirely. I have time to look at something to confirm that we have made a useful purchase, and then my responsibility is to see that it gets cataloged and properly conserved in a nice linen box. But it's a great kick when I find a book which is going to be helpful to the library. I suppose I have been able to understand the nature of my job well enough so that I don't have to focus 101 percent of my day on administrative and managerial tasks, and therefore I can allocate a small part of my day, or at least my week, to traditional librarian roles, like book selection.

People who go into this field are passionate about it and are happy to commit themselves to it. It takes up a good part of my life, so I don't have many hobbies. I enjoy going to the ballet, if that's a hobby, and I like chamber music very much. But I have a four-year-

old daughter, and there are few activities that can compete with spending time with her, so if spending a huge amount of time at the playground in reasonable weather can constitute a hobby, I suppose spending time in a playground is my hobby.

I try to show some discrimination about books that come into my home. But I have far too many art books. It's a bad habit; if it got any worse, it would be a weakness or an affliction, but for now it's a habit, and you can always kick those.

November 1, All Saints Day, is my birthday. Well, I think to have a good party for a fiftieth birthday is the correct thing to do; it would be horribly bad manners not to. So I will have some sort of fête at our apartment, but the interesting thing about this gathering will be the number of people from the Met who will be there, because in my soon-to-be ten years here, my daughter's godfather, the witness at my wedding, and many of my dearest friends are all friends that I have made here.

James Spann

"Muons and gluons and quarks . . ."

He has the actor's desire to hold the spotlight, to milk each story for all it's worth, and he is a wonderful conversationalist. It felt as if I were having a privileged private performance. He has a deep baritone voice that emits a sound that seems to vibrate long after it leaves his larynx. I joined one of his tours for a riotous romp around the museum, which was not as ordered a procession as he might lead you to believe they are in this interview.

I was in the theater for nearly twenty years before this. Life as an actor was exciting, I was young, and I did a couple of Broadway shows, a dozen off-Broadway shows, and four national companies, which meant a great deal of traveling, which was all to the good, as I love traveling. It was a lot of hard work, but there was a little glamour to it also.

The very first thing I did was a Sean O'Casey off-Broadway play called *Red Roses for Me,* which was how I got my Equity card. As I remember it now, the language was beautiful, but it was lugubrious; the entire second act had to do with a death and a funeral. On Saturday we did a seven o'clock and a ten o'clock performance, which was overwhelming, and you only had about half an hour in between, and then you had to plunge right back into it. Much more

congenially, I did *You're a Good Man, Charlie Brown,* and where *Red Roses* left you feeling very down, with Snoopy, who I played, you could not repress your spirits.

My first Broadway role was *Little Me,* with Sid Caesar, and I played his son; I played a lot of sons in those days. I also played the son of the rabbi in *Fiddler on the Roof*, and at the same time understudied Motel, the little tailor, who sings "Miracle of Miracles."

The Met has now become my stage, and this job is an opportunity for the ham in me to come out. You can take the actor off the stage, but you cannot take the stage out of the actor.

The first few minutes are always important in establishing a rapport with your audience, letting them get to know you: I don't bite, I am friendly, this could be fun. I'll start off with something like "My name is Jim Spann; I am going to walk with you through this Museum. It's huge. The *New Yorker* once had a cartoon showing the facade of our building. Two flags are hanging out. One said in bold letters, '**ART**,' and the other said, 'dot dot dot **lots of it**.'" That gets a laugh. And then, when we get started, I'll tell them another funny thing. "When the Museum first moved here, a journalist at the time wrote, 'The Museum is twenty blocks beyond the bounds of polite society.' And that," I say, "is not a bad place for art."

You can't have a set script; you have got to adjust for each group. For instance, I recently had a bunch of blue-collar workers. I couldn't have referred to Edith Wharton and her novel *The Age of Innocence*— that would have meant nothing to them—but I could refer to Michelle Pfeiffer, who did the movie. And you have to be flexible as you walk around, because that favored painting or sculpture you love talking about, well, a group of school kids might have just pulled up their stools in front of it and are going to be there forever, so you have got to find something else to discuss, hopefully in the same area.

You are looking at the audience all the time; you have got to pay attention to them, so you can tell when there is that certain something in their eyes, a response. But you must let the role develop naturally. If you try to think out a role and make it all logical, you remove the heart from it; it becomes too cerebral. The best things happen when you allow your intuition to work.

Do you remember Maggie Smith in the play *Lettice and Lovage*? She is a tour guide in one of the stately homes of England. She starts off with a very factual tour—"This home belongs to so-and-so"— and she talks about the art and the provenances of objects. Then she decides to juice it up a little bit, and of course she goes overboard, oh, it's wonderful, and by the second act it's: "Up these stairs the mad duke killed his young wife and raped his sister. . . ." The audience is aghast, but by God, they are paying attention.

Often a theme develops. Say we are standing in front of the Carpeaux, the statue *Ugolino and His Sons*. Here we are dealing with Dante. In Canto XXXIII of *The Inferno*, Dante meets the count, who was rumored to have eaten his own sons, in the lowest level of hell. (And at this point I mention that as a curatorial joke the Met has it displayed right next to the snack bar in the Petrie Court.) But of course Dante ends with the Paradiso, the Brilliance of Heaven, so we are making a trip from dark to light, and with van Gogh, we see it again. In his painting *Cypresses*, this cypress has roots in the earth, but they aspire to the very heavens. In fact they go right out of the canvas; you don't see the top. And beneath the surface the cypress tree is full of movement and energy, all that buzzing, blooming confusion of atomic and subatomic particles, muons and gluons and quarks, muons and gluons and quarks—as the poem goes.

In the summertime many of the volunteers go on vacation, and sometimes I am the only show in town. I have had as many as a

hundred people on a tour, which is really much too much; with these huge numbers, it takes elevator after elevator just to get them to the second floor. I frequently have two tours a day, and there have been a few occasions where there have been three tours. Well, there are two million square feet to the Museum, and after that I feel like I have paced every single one of them. I am used to a matinee and evening performance, but a third performance in a single day is way too much. These are relaxed performances, but they are still performances, so I really need my Mondays off, when the Museum is dark.

There are certain artists who just really impress me. Vermeer is a favorite of mine, and finally the rest of the world has caught up with me; we have even got the movie now. My favorite Vermeer painting is the *Maid Asleep*, where you have got a figure of a young woman asleep at a table. One observant scholar has said, "That's no maid. Take a look at her costume; it's much too rich for a maid." Another scholar has written, "She is not asleep. Her left hand is clutching the edge of the table; she is in a little half sleep, a reverie." Now it gets interesting. What kind of reverie? What is the nature of this reverie? I could speculate forever.

I sometimes think about a final performance. A very good friend of mine is retiring this year, and my younger sister has been retired for five years. But I have got all my energy. What would I do with that? And I like art. No, as long as the situation is accommodating, I'll be here. We had a lady curator who was ninety-three, and every day she would take the bus from the West Side and come to the Museum. Just this past year she got ill, she went to the hospital, and within a week she had died. And I thought: Are *you* listening? That's the program I would like.

We have a number of paintings in the Museum which express the idea of death. I particularly think of *Thanatopsis*, 1851, by Asher

B. Durand, one of the Hudson River painters, and also the name of a poem by William Cullen Bryant, which had inspired the painting; Bryant was instrumental in founding this Museum. The scene is neither an American landscape nor a European landscape; it's a composite of the two. There is a castle, and a church, and a little winding rivulet that meanders to the great ocean, where there is a sunset. There is a funeral going on in the middle ground, and sometimes I can imagine that it is mine.

William Cullen Bryant, 1794–1878
Thanatopsis (Last verse)

So live, that when thy summons comes to join
The innumerable caravan, that moves
To that mysterious realm, where each shall take
His chamber in the silent halls of death,
Thou go not, like the quarry slave at night,
Scourged to his dungeon, but sustain'd and sooth'd
By an unfaltering trust, approach thy grave,
Like one who wraps the drapery of his couch
About him, and lies down to pleasant dreams.

Ira Spar

"Brava Kabaivanska. Bravo Bergonzi."

He is big, bearded, and bearlike. His desk looked as if a bomb had hit it—at first I thought his office had been the target of a particularly untidy gang of criminals.

I haven't seen Sandy Fisher since the tenth grade, but he wore pennies in his loafers, which were considered to be in at the time, and anything he considered in, I considered out. There were a lot of rich kids in my school who I didn't relate to.

I was very determined to go to college and get away from New Rochelle, which is a terrible place, after receiving my BA in international relations. I heard that the University of Michigan was famous for Near Eastern history, and I always liked to read about the ancient world, so it seemed perfect. I called up and asked for an interview, which was granted, and took a bus to Ann Arbor. There I met a very eminent individual named George Cameron, the chair of the Department of Near Eastern Studies.

"What can I do for you?" Professor Cameron asked.

"Well," I said, "I am looking for something in my life."

We had a very nice chat, and afterward I wrote some BS and sent it in, and a week later I got a letter back, saying, "Congratulations,

you have been awarded the Horace G. Rackham Fellowship for the Study of Ancient Near Eastern History and Language." *And* it was completely free. I thought: "Can't beat this deal."

So I am now an Assyrianologist, although we shouldn't call it that. Assyrian is the British nineteenth-century appellation. We should call it Akkadian. Akkadian has dialects, and I specialize in a dialect called Neo-Babylonian.

I'm working on a collection of cuneiform tablets which have been at the Met since the nineteenth century. There are over six hundred tablets and fragments; some pieces are extremely small, the size of your thumbnail, and other pieces are seven or eight inches. Tablets were made of clay, generally riverbank clay; if it was an important tablet, something that was going to be official, say, the clay would be sifted and the impurities taken out, and if it was very important, it would be baked in an oven instead of letting it dry in the sun.

The cuneiform writing system is pre-alphabetical, so there are no letters. Documents were created by using a stylus to inscribe wedge-shaped signs into the surface of a slightly damp clay tablet. Each sign consisted of combinations of vertical, oblique, or horizontal wedges, and you are never sure what you're looking at because there are literally hundreds of signs which have multiple meanings and can represent either words, syllables, or vowels.

It's a terrible system of writing. Terrible. No wonder it was replaced by the alphabet. But people were so conservative in the Near East—same as they are today—and even after they adopted the alphabet, they continued using cuneiform in their official correspondence. Imagine using that system when they could have been writing in the alphabetic system!

Also, unlike English, which has an enormous vocabulary, Babylonian has a more limited vocabulary in which words have multiple

meanings. For example, the common verb *epeshu* can mean "to act, proceed, permit, happen, do, make, practice, perform, conclude, or copy." When used in phrases with other words, it can mean "to do domestic service, to intercede, to take an oath, to commit a sin or give medical treatment, to make a woman a lawful wife, or to fish," and I could name even more different meanings.

Well, the first thing to do with all these tablets was to catalog them. The Metropolitan's collection of tablets is comprehensive; it contains everything from economic to royal, literary to scientific, as well as religious types of documents. The economic texts are very mundane, everything from how many animals entered into a sheep pen at such and such a time to the distribution of goods from that animal, like hides, wool, and meat. But we also have fascinating texts that give an insight into the reverence, fear, and awe the Babylonians felt for their gods. The universe was ruled by a distant god named Anu. He left his number two person, Enlil, in charge of running the earth, and underneath Enlil was a hierarchy of different deities in charge of all aspects of different forms of nature, from the sun and the moon to vegetation and storms.

The ancient world believed that the gods were inscrutable, and that one could never understand the motivations that were behind their actions with regard to mankind. They gave hints, however; they allowed you to gain insights. For example, if an animal gave birth to a malformed offspring, that was the gods giving you a message. But they never told you everything; they never gave you their unlisted phone numbers. By looking at a series of texts we call Wisdom Literature, which spells out the dos and do nots, we can see what is acceptable behavior and what is not. The do nots are the most easily accessible. Do not kill, don't steal, don't commit adultery, don't sit alone in your house with your neighbor's wife.

Wisdom Literature includes some positive precepts: Justice creates life, a loving heart maintains a family, a hateful heart destroys a family, worship your god every day, marry a wife according to your choice, have children to your heart's content.

I have been working on the Metropolitan's collection of cuneiform for thirty years. Three volumes have now been published; volume one is 400 pages long, volumes two and three are around 540 pages each, and I am working on the fourth, which will be the last volume, and then the entire collection will have been published. I am also professor of ancient studies at Ramapo College of New Jersey, so my life has been very full all these years.

However, you have to keep things in proper perspective: Your job *is* important, but your family is the thing that generates your heart. I love my wife. The greatest moment of my life was meeting my wife, and she brings me joy every day, and my son too, who is wonderful and doing well; we are so proud of him.

The only thing I would rather have done in life is be a bass baritone. I would never consider being a tenor. Never. They're boring, they have no character, they're just useless. Bass baritones have real meat in their roles, and that's where the guts of the opera are, and I visualize myself in certain roles and how I would interpret them. Russian opera is the best. I mean, where can you get an aria like the final death scene in Mussorgsky's *Boris Godunov*, where the czar sings, "Good-bye, my son, I am dying . . ."? *That's* opera. I start shaking when I hear it, I am so overtaken by the emotion of the scene.

But of course this is all fantasy; my voice is terrible. People know when I am singing; they can hear me through the crowd: "That's the one. *Out!*"

It was fun to go to the opera in the old days. That was the era of the diva, and just before a performance the lights would dim, and the

reigning diva, Renata Tebaldi, say, would walk down the aisle, accompanied by Rudolf Bing, the head of the Opera House, resplendent in his tuxedo. Everyone would stand up and begin cheering.

After the performance, performers at the Opera House would pay people to scream "Bravo." These people were called the claque. I remember one performance when I accidentally stood among the claque. The soprano came out for her curtain calls. I can still remember her name, Raina Kabaivanska, from Bulgaria. The people to the left of me started screaming, "*Brava Kabaivanska.*" But then the great tenor Carlo Bergonzi came out for his bow, and the people on the other side of me began shouting, "*Bravo Bergonzi.*" And then these two groups start competing with one another as to who could shout the loudest, which was a show in itself.

That was all so much fun, but it doesn't exist anymore, and I can hardly afford the great prices the Opera House charges now. Sandy Fisher could afford it—he is probably making a million dollars a year on Wall Street. But the advantages of being in my field of work is that I get paid for sitting in this Museum and looking at ancient texts that no one has seen for thousands of years.

Donna Williams Sutton

"I have a mission . . ."

In contrast with the last interviewee, Donna is one of these preternaturally chic and tidy people. She is passionate in her hopes to bring more people of all races into the Museum, as both visitors and employees.

We noticed that you didn't see a lot of diversity in the people who walk into this Museum, and in a city made up of so many different cultures, we felt we should really be getting more people of color. So we started this initiative to increase the awareness of the Museum to traditionally underrepresented communities. Initially, we invited our African American community for lunch, and the question was asked: "Why don't more people of color visit the Museum?" And one of the things they said was they really didn't feel that welcome here. Everyone here was just totally surprised and taken aback by that, but if the perception is out there that we are not accessible, then we have to do something about it. Also, a lot of people thought of us as just a French Impressionistic Museum, and that is so not the case.

So I arranged a highlights tour of the Met for four hundred people, and we had them go through the different wings of the Museum,

and we also had some of our senior staff members at a reception so they had chance to meet and talk to them. That earned an incredible response from the community, saying, "This is great!"

I grew up in Cranford, New Jersey, which was basically a Caucasian town. Most of the African Americans lived together on one side of the railroad tracks, and on the other side, nearer the school, were the Caucasians. It was a mostly white high school, and we integrated a lot, and we had Caucasian friends, but we didn't date each other in high school.

My parents were activists, and we were involved in many kinds of worthwhile causes for our community—getting people registered to vote, for instance—and my father and I went to the March on Washington.

During one summer vacation my parents arranged for us to go down South so we could experience what life was like for our ancestors. We stayed with my uncle's sister, in Chapin, South Carolina, which was very rural: dirt roads, everybody out on the front porch in the evening. There was one big bedroom and a huge kitchen with the best smells, and they made huge breakfasts, which included foods like hominy grits, Southern ham, and johnnycakes.

As soon as the rooster crowed, around 5:00 a.m., we would have to be up and doing our chores. I even tried to pick cotton, which was really hard work. Have you ever tried it? It kills your fingers; my gosh, it has thorns on the bush, and if you don't know what you are doing, your hands are just bloody by the time you are finished. I guess they knew what they were doing in those days.

The one thing that is really important in my life and has made me the person I am today is what a great people we come from. That was instilled in me all my life, and it's stuck with me forever.

There is hardly anything you can do to us that we can't survive; we have survived a lot. And because of what we have had to go through as African Americans, I do have a strength that maybe some other people don't have.

Our histories affect how we interact today. We remember that during slavery days you couldn't acknowledge another person. That's why when you walk down the street and you see another African American, you acknowledge him.

Things aren't as bad as they were, though some things still exist today. I have been stopped at midnight, and the police have pulled me over for nothing, just because *I* am in the car. You might not know what that feels like, Danny. They don't say, "Oh, excuse me, ma'am, you have a broken taillight." They say, "Get out of the car. Now." And I have to get out of the car and show them my license, and I am a woman, so I can only imagine what that would be like if I were a black man.

I am so proud to be part of this Museum. This is not just a job; I feel I have a mission. I can see there has been a change in the people who are interested in becoming involved with the Met. People of color have called and said, "Can we be a part of this?" I can't even explain to you how much things have moved forward. And when you bring more people and more diversity inside, we can only move forward, so I am very excited about what is going on here.

In regards to myself, I want to make sure I am the best person I can be, because it's not only me I'm representing. I am also representing my family and my race. I have to make sure that my family is proud of me every day; it's a part of who I am. So I really think carefully about what I do and what I say, like all the people at the Museum.

There are a lot of people of color who are training in the museum field, but until recently many didn't apply here. I would love to see another black curator here. It is very difficult because this place is very competitive. You come here when you have made it—the Met has the best curators in the world. I think we have got to do something about that, at the least incorporating them within the museums, so they can move up the ladder.

Mahrukh Tarapor

" 'Even for a million, how can I say yes to you . . . ?' "

In her capacious office on the executive fifth floor, there are hundreds of photographs from her dozens of trips around the world.

I was brought up in India. We lived in a hill station in South India, and it was idyllic, I would not change one second of my childhood. Hill stations were an invention of the British. To escape from the heat of the summer, they developed these wonderful resorts, typically seven to ten thousand feet up in the hills. They called ours the Switzerland of India, because nothing was flat, except a beautiful, very exquisite lake, and plums, apples, pears, greengages, gooseberries, and strawberries grew everywhere.

After completing my Ph.D. at Harvard, I began working at the Asia Society in New York; I was quite happy there, I had three months off a year when the society was closed in the summer, so I could travel in India. For me, still, going back to India is necessary; it is my reference point.

In 1982, the Met approached me to work on the major international exhibition "India!" The project interested me, but frankly, the

Met did not; it was just too big and intimidating. And then one day I got a call: "Mr. de Montebello wants to talk to you." He came on the phone, and his first sentence to me was, "This is Philippe de Montebello, and nobody says no to Philippe de Montebello." I have seen the truth of that a hundred times since. Certainly Philippe can be utterly charming. He is a master manipulator, and he uses his wiles to the great good of this institution. I think we have all been victims, although I may have grown out of that a little bit. At least I hope so. Even though I had genuine doubts about the job, his persuasion worked, and eventually I took the job as special assistant to the director for the "India!" exhibition being organized by Stuart Cary Welch, then head of the Museum's Islamic Department.

After the "India!" exhibition closed in 1986, Philippe asked me to oversee the Museum's busy and complicated exhibition program. Since then my job has been to oversee an exhibition from the moment of conception through its final presentation. We have anything from thirty to fifty exhibitions a year, sometimes eight or ten at a time.

People are always amazed how long it takes to mount an exhibition. For the big international loan shows, I would say it takes four years from when it comes to my desk to completion, and before that, who knows how long the idea has gestated and been reshaped and rethought by the curator?

What usually happens is that the curator will come to me and say, "I am thinking of an exhibition along these lines . . ." and bring me a list of the kinds of objects he thinks we're going to need. Sometimes I have to do a reality check: *These* objects are simply not going to travel; you're not going to be able to get them because they are national icons—in the same way we would never

lend *Juan de Pareja* by Velázquez or Rembrandt's *Aristotle with a Bust of Homer.*

It's also my job to suggest that the thesis may be better suited to a book than to an exhibition—if the works essential to its realization are too expensive or even too important to borrow. Sometimes I recommend that the curator might want to rethink the idea. Some never come back; others come back a year later, when I think they've gone away forever, and then I work with them to get the idea into a form that I feel will meet with Philippe's approval. Philippe is the ultimate decision maker in terms of which exhibitions the Met will organize; he decides, yes or no. Mostly he says yes, because he has a hard time saying no to curators. Once he approves a project in principle, then I work with the curators to get his conditional approval translated into definitive approval. Twenty years have taught me that if the vision of the curator matches the will of the director, the exhibition will be a success.

So I'm a mediator between the curator and the director and between the curator and the various administrative and operational departments in the Museum that are responsible for different aspects of an exhibition. I also conduct a lot of the external negotiations, in whatever country the works of art happen to be. For that, I prefer not to go to the top person, because although I might get a minister to give approval for a loan, I have realized that if the man who has the key to the storeroom in some remote village doesn't want to be found, he simply disappears and my trip is wasted.

I'm also a mediator between the curator and the lender. I have to be convinced by the curator for the absolute need to borrow a particular work of art so I can communicate that conviction to the lender. I try to make lenders feel there's something in it for them, that they are not just lending their object to the Met but to a project

that is so important that if they deny their object the privilege of being in this exhibition, they are not doing justice to it. Private collectors are passionate about their objects. This is wonderful, but it can also be a problem, because it makes it that much more difficult to convince them to part with their treasures. But I love and admire such collectors because one can almost feel the dynamic energy between them and their objects.

Sometimes fund-raising happens along the way by chance. I meet people who end up helping underwrite an exhibition. For instance, I was in Athens to get the ministry's approval for our Byzantium exhibition some years ago, and seated next to me at a dinner in a private home was a Greek banker. He asked me about the exhibition. I described the main ideas, he liked the subject, and expressed interest in sponsoring it.

"I don't think you can," I said. "We've already got a bank." I had learned that banks frequently are competitors, and an American bank had committed a few hundred thousand dollars, not the full amount, but a substantial amount.

"Why not?" he asked, obviously very keenly interested, and I could see our neighbors around the dinner table were starting to listen. "I'll up whatever they're giving you by a hundred thousand dollars."

"Sorry," I said, "you could offer us five hundred thousand dollars but we've given our word to this other bank."

"What if you were offered a million?" he said.

And now the whole table was listening, and the curator is looking at me nervously, thinking, "I need this money for my show. How is Mahrukh going to handle it?"

"Even for a million," I said, "how can I say yes to you? We have a sponsor."

Anyway, we left the dinner with me telling him that if he was

serious, he should write me a letter. I say that to most people, and their interest usually just dissipates. I woke up the next morning thinking that was the end of that, and there was a letter under my door that his bank would be willing to consider sponsorship at an extremely high level. In the weeks following, amazingly, everything fell into place. The American bank agreed that he could be the primary sponsor, and they stayed in it themselves, and the exhibition was a huge success.

For that exhibition, "The Glory of Byzantium," the Museum worked with the Monastery of St. Catherine, which is a very desolate place in the Sinai Desert that has existed from Justinian times. We were the first institution ever to borrow from St. Catherine's, in 1997, and the monastery lent us nine icons, and one manuscript. Sixteen to twenty Greek Orthodox monks are guardians of a grand and ancient tradition that is not the main culture of the country in which they live, Egypt. The monastery is a place of extraordinary spirituality, and it is an immense privilege to have access to its great holdings, and to know the holy fathers.

When it was time to ship the monastery's objects to New York the first time, the monks wanted me there in Sinai to make sure that their religious treasures were properly cared for and respected as they were packed and prepared for transport.

It was not easy because the icons from Sinai had never left Egypt. New procedures had to be put into place, in addition to the long-established requirements for Egyptian escorts, conservators, archaeologists, including, of course, Egyptian police and security. But the effort was more than worth it—the icons were a revelation to scholars and the public alike and contributed tremendously to the great success of the exhibition, which, in turn, resulted in the creation of

the Mary and Michael Jaharis Galleries of Byzantine art. I like to think of these beautiful galleries as St. Catherine's enduring gift to the Museum!

Each exhibition has its own identity, characteristics, and set of problems—but each also has its own great rewards.

Thayer Tolles

"There was a big stagecoach in the barn..."

She speaks about American sculpture—particularly works by Augustus Saint-Gaudens—with passion and conviction.

I grew up in the museum world. My father was the director of the Essex Institute in Salem, Massachusetts, which has now merged with the Peabody Museum. Even before that, my great-uncle was the director of the Fogg Art Museum at Harvard, and another great-uncle was the director of the Boston Athenaeum, so it's sort of in the family.

So I grew up in a period home owned by the Essex Institute, a big Federal-style house, which, when it was built in 1818, was the largest house in New England, and when we lived there, it was open to the public on Thursday afternoons.

As you can imagine, growing up in this house I was surrounded everywhere by art, and while my friends were putting up posters of David Bowie, on the walls of my bedroom were portraits of fusty old New Englanders, although they were real people to me.

In fact it was like a magic house to a young kid. There was beautiful Empire-style furniture in the living room, the textile and costume collection for the museum was on the third floor, so I was naughty and dressed up in wonderful old clothes, and there was a big stage-

coach in the barn outside to climb in. Even after ten years, there continued to be exciting new places to discover.

And so when all my friends from college were going off to be investment bankers, there was never any question that I wanted to go into museum work. It just seemed like the natural thing for me to do, although I have a younger brother who took this whole museum experience and turned and ran the other way; while I was a history and art history major, he was a math and computer science major, and is now a financial wizard out in Silicon Valley.

If I see a downside to this profession, it's financial—not that my father discussed that, because he is a New England WASP, you know, buttoned up. We didn't travel to faraway places, so while all my friends would be going off on fun ski trips, we were getting in the car and driving to museums. I mean, I didn't get to Europe until I was twenty-eight.

The Met came into my life when I was brought in to work as a graduate assistant on a ten-week internship. Once that period ended, I was asked to stay on as a research assistant for an exhibition of paintings by William Harnett, and just as that ended, my predecessor in sculpture left to go to another institution, and I was asked if I was interested in that position. Of course I said yes, and I now oversee the world's greatest collection of nineteenth- and early-twentieth-century American sculpture. We have about four hundred pieces in the collection.

It is said that as a sculpture person you favor either marble or bronze, and I prefer bronze. I appreciate marble, but I really warm to the bronzes. The process of casting bronze is very intricate and challenging to carry out, and the fluidity of the surface and the texture of the material are amazing; a great bronze rewards on so many different levels. Also, the bronze-casting tradition didn't start in America until

about 1850, and my interests have always run more toward late-nineteenth-century art.

American sculpture didn't really start up as a fine art until the first quarter of the nineteenth century, and then the bulk of activity took place in Rome and Florence. Americans went there for practical reasons: the marble was in Italy, the trained carvers and craftsmen were in Italy, the lifestyle was much more affordable, and that's not to mention the artistic riches that were on view at every turn.

The American sculptor Henry Kirke Brown went to Italy and studied in Florence and Rome for four years. But unlike many of his colleagues who stayed in Italy, he came back with this mission to create an American school of sculpture and foster an appreciation for sculpture here. He brought two French foundry workers into his studio in Brooklyn and cast small bronzes of remarkably high quality and promoted bronze as a medium that could be entirely produced in this country, which tied in with a larger cultural statement of America's coming of age as a world power. He began pushing American sculpture in a new direction, moving away from neoclassicism to realism, from mythological subjects to subjects that were based in American identity and experience, whether representations of Native Americans, portraits of patriots or presidents, heroes, or martyrs.

That movement reached its apogee in Augustus Saint-Gaudens, the greatest American sculptor of the nineteenth century. I could go on forever about him, because I wrote my dissertation on him. He was born in Dublin in 1848, the son of a French father and an Irish mother; his father was a successful boot- and shoemaker to New York's rich and famous. Aged thirteen, Saint-Gaudens was apprenticed to a French cameo cutter, while at the same time taking draw-

ing classes at the National Academy of Design and the Cooper Union, and then went to study at the École des Beaux-Arts in Paris.

There is a dynamism and excitement in his work that you don't find in the other expatriate Americans' work, and he redirected the course for American public sculpture. The gilded equestrian statue of General Sherman down by the Plaza Hotel in New York is one example. He also created some pretty incredible portrait relief sculptures. What could be considered his greatest achievement is the Shaw Memorial in Boston, across from the State House. It's dedicated to Colonel Robert Gould Shaw, the leader of the Fifty-fourth Massachusetts Regiment, which was an African American regiment of soldiers, many of whom were killed in the Civil War down at Fort Wagner in South Carolina. Saint-Gaudens worked for thirteen years on this sculpture; in fact he obsessed over it. He made individualized portraits for each of the soldiers' faces; he paid African Americans to come off the street into his studio to model. So it's like a history painting; it has that sort of processional quality. It is incredibly innovative compositionally: how he has merged Shaw with the troops is completely unique in American sculpture, this merging of in-the-round and high-relief sculpture, and also there is a meeting of real and ideal, epitomized by this allegorical angel hovering above them, leading them on.

Saint-Gaudens worked part of the year in Cornish, New Hampshire, where he initiated this remarkable art colony, which in its heyday was a locus for artists and musicians and writers. His home in New Hampshire has the largest collection of his work, but the Met has the second-largest collection. We have more than forty sculptures by Saint-Gaudens, some incredibly fine pieces representing all aspects of his career.

I may be a fool for Saint-Gaudens, but I confess that not every day was a good one for him. When his heart wasn't in a commission, it really showed. We have some pieces in our collection which I consider soulless, because either he was not emotionally invested, or they were cast by his wife after he died.

I am going to do an exhibition on Saint-Gaudens and the Met's collection a few years down the road. He is the only American sculptor I can do a show like this on; he is on a par with John Singer Sargent or Louis Comfort Tiffany, which is the company he kept, socially and artistically. He professed to be shy, but in fact he was very adept at infiltrating the genteel society of New York, and he was perfectly comfortable among the rich and famous. For instance, he was great friends with President Theodore Roosevelt and the architect Stanford White.

Roosevelt commissioned Saint-Gaudens to redesign the ten- and twenty-dollar gold coins because he thought American coins to date were pedestrian—he wanted coinage as beautiful as the Greeks'. Saint-Gauden's first version of the twenty-dollar coin was executed in such high relief that it didn't stack properly, which of course didn't fly with officials at the U.S. Mint—Saint-Gaudens was thinking like a sculptor and not a medalist here, but it is considered one of the most beautiful and rare coins ever made.

My favorite sculptures are the ones where the artist kept his hand in from the beginning of the creative process until the end, where you can really see the strength of the modeling and the individuality of the surface chasing and patination. Saint-Gaudens, Frederic Remington, and Paul Manship, who created the Prometheus Fountain at Rockefeller Center, were consummate craftsmen who cared intensely about the quality of the individual cast. Remington in particular pushed the envelope technically, and a superlative Remington is just about as vi-

sually rewarding as you could ask for. We have three in our collection that were all purchased from Remington directly.

Aficionados of Remington get caught up in differences between casts, like whether the rider is wearing woolly chaps or not, how the rifle is positioned, or whether the horse's tail is blowing back or down. For instance, our *Mountain Man,* which is cast number nine in its edition, is the first where the horse's hind leg is tucked in under its rear rather than extended. I particularly like that composition because it captures a moment of high drama—a combination of physical tension and technical bravado—where the horse and rider are making their way down a steep slope, and they have to work together as one unit to navigate the terrain.

Another great sculptor is Frederick William MacMonnies, whose *Bacchante and Infant Faun* in the American Wing's courtyard is an exhilarating, spiraling figure, full of verve and personality. It makes me feel happy whenever I walk past it. If you look closely at the surface, it's not smooth, it's almost fleshlike, and even lumpy in areas, and she's a real size eight or ten woman whom you can relate to.

The thrill of walking up the stairs to the Museum never diminishes. It's a real privilege and an honor to be a curator and look at wonderful sculpture every day. I still can't believe I get paid to do what I do.

Remco van Vliet

"Looks like it comes from outer space . . ."

*I met Remco in his shop in Manhattan's flower district. There is
nothing so plain as bunches of flowers around this showroom; in-
stead there are artful arrangements that use wild flowers and fra-
grant berries. He still has a strong Dutch accent, but his English is
perfect.*

I was born in a city called Den Helder, which is all the way up in
the north of Holland, and I basically grew up in the flower busi-
ness. My grandfather was a florist, and my father is a master florist,
and he taught my brother and me floral design, and we worked on
large events with him for the Dutch royal family and throughout
Europe. My father has a great eye; instead of just a flower arrange-
ment, he uses organic materials in decorative ways, pieces of drift-
wood, for example, half pieces of burnt wood, an eclectic mix of
textures that creates a very nice environment.

Twelve years ago, when I was fifteen, I came to America for the
first time, and walking around the streets, I made the decision I was
going to come here after I finished my education because I had a
feeling this city could give me opportunities. In America there is no
proper education to become a floral designer, but in Holland I was
trained as a master florist, so I had to know every single flower:

where it comes from, what time of the year it grows, and in what type of climate, how long it lasts, plus all the proper techniques to handle it.

For seven years I worked for a flower importing company, making bouquets and flower arrangements, doing displays in stores, and arranging events. And then I had a huge opportunity. Chris Giftos, who had been the special events manager of the Met for thirty-two years, was looking for a protégé because he was about to retire. He asked several of his friends in the flower industry for likely candidates, and my name came up, and he asked me if I would be interested in giving him a hand in the Great Hall.

Some things you never forget. The first arrangement I did with him was a variety of Dutch lilies, flowering branches, some palm leaves, and five or six other varieties. Fairly soon, Chris had taught me all he could teach me, and I couldn't wait until he finally got off the ladder and let me go up and show what I could do myself. Eventually the time came, and of course my first solo arrangement I wanted to put my stamp on it, so I'd been exploring dozens of different color combinations, textures, and flowers, and the arrangement I made was spectacular.

Everybody likes to see something new and different, particularly in this city, and there are so many interesting flowers coming from all over the world. For instance, there's *albiflora*, which looks like it comes from outer space but actually grows in the African desert, or the *bixia,* which is a seedpod from which seeds are used for dyeing cloth Siena red. I love using fruit and berries and flowers that are not yet developed, or flowers that have bloomed out, where you're left with just the center of the flower. And all these different things combine very well with the more classic flowers, like roses. I also like to use green roses, and they have now brought a virus into the

rose that creates a striation, so there are several striped varieties, which are the result of cross-pollination between different varieties, like *hocus pocus, abracadabra, sim salabim*. They come up all the time with new hybrids and varieties; there's really no limit to it.

With so much variety, I always want to create something different. I never do the same flowers two weeks in a row. People look forward to walking into the Great Hall. Many people come just to see the flower arrangements, so I owe it to them to make it interesting.

I have two assistants, Gary and Albert, who come in to the Met at about seven o'clock on Monday, when the Museum is not open to the public. They take out all the old flowers from the previous week, clean out the steel containers, disinfect them, then fill each one up with fresh water, add flower food to it, and by that time it's around eight o'clock, which is when the Great Hall opens for deliveries, and all the flowers I've ordered from the flower markets in the past week are brought in by the different vendors. It takes me on average five hours to do all the flowers in the Great Hall, although the more flower varieties I use, the longer it takes.

I am constantly aware of the Dutch influence in New York, because so many of the place-names are of Dutch origin. Harlem, for example, is named after a city in Holland, Haarlem; Flushing comes from Vlissingen, which is a fishing town; and Brooklyn is Breukelen. So all these names daily remind me of home when I am not at home.

At this point in my life I wouldn't want to be anywhere else than New York City; I feel I'm part of the American dream, and I love the energy of this city. But I miss Holland, particularly after a visit home, when you fly over the tulip fields, and you see all these big color palettes, millions and millions of tulips of all different colors, and hyacinths and daffodils too, and the whole country looks like a

Mondrian painting. It's so impressive. I miss my friends, of course, and wonderful Dutch food, like *kroketten*, which is like ragout rolled in bread crumbs and deep fried, which you eat with mustard. Oh, and raw herring with onions, that's hard to find here, and *frikadellen*, which is basically leftover meat, with plenty of sodium and herbs to make it tasty.

Lulu C. Wang

"Why all this focus on money . . . ?"

We walk into the boardroom of her office. There is nothing on the enormous table other than a packet of Pepperidge Farm cookies. I haven't had lunch, so I hope she doesn't notice how I am tucking in. There is something very endearing in hearing a collector enthuse about her passion.

When my husband and I were first married, we began buying used furniture and prints because we were furnishing a home and we liked the look of old things. But we were students then and limited by budget; it wasn't until much later that we began to collect seriously.

We've always loved the sound, the smell, and the design of old cars, so when we could we began with collecting vintage racing cars, and we collected with great enthusiasm. Cars are much more forgiving than paintings; you can have an "incident," and if the engine and chassis are intact, you won't have fatally damaged the value of the car. Restoration is often part of the history of a race car because most of the great ones have been in crashes and had to be restored, so it isn't critical if the original panels or even the original nose or tail are still there.

We had bought an old Porsche when we got out of law school, but very quickly we realized that our interest was really in the Italian marques. As our fortunes began to improve, we bought our first Ferrari, the 330 GTC, which was a nice road car, and then went on to put together a collection of racing Ferraris.

We're pretty lucky to have some special Ferraris. I particularly love our 250 GTO, which was just made to go fast. It's alloy-bodied, light, and very responsive. Fewer than forty GTOs were made in the 1960s. They raced well, and they've become legendary among Ferrari enthusiasts.

We also have some Alfas, as Alfa and Ferrari are close brothers. Enzio Ferrari raced for Alfa until he began his own Scuderia Ferrari in the 1940s. They made some great cars. I'm fond of our Alfa SZ, which is a prototype, with funky lines, but is also light and pretty fast. My husband is partial to our prewar Alfa Monza, which is amazingly quick for a seventy-year-old car.

We've now gotten to a point where we're running out of space, so we're using this as an opportunity to upgrade and trim back the collection. We've sold off some of the less important cars we'd collected earlier, or where we had duplicates of a particular model.

Our interest in colonial American furniture is how we came to be involved with the Met. When collecting, you need to look at the very best there is in any field, whether it's cars or furniture or paintings, and we often learn by comparison. By looking at a good Queen Anne chair, then looking at a great one, often to be found at the Met, you train your eye. I hope that our collection has benefited from this, but we keep learning. We are fortunate to own an eighteenth-century four-shell Rhode Island kneehole desk that is pretty much as good

as it gets. The desk has a refined but powerful form and the carving is very balanced within the overall design—you don't want to overwhelm an already elegant piece with too much carving. It also has a wonderful original surface.

Searching for these things and then researching them are part of the joy of collecting. Doing the homework for something that is going to be a major investment is important. For example, with the desk we looked at a number of Rhode Island kneeholes and analyzed their strengths and weaknesses. By looking at them comparatively, we were able to see what we thought the ideal form should be and what we were prepared to pay for it. You don't want to be foolish and overpay for something just because you love it, but at the same time you don't want to be dogged by regret, so sometimes you stretch when an object is unique and not likely to be available again.

We bought our kneehole at auction. There are some collectors who raise their own paddle and don't mind the attention, but my husband is incredibly publicity shy. Nowadays the press covers most of the major auctions. In our case, the press surmised that we bought the desk without any kind of corroboration from us. We really didn't enjoy opening the *New York Times* the next day and reading we had just bought a multimillion-dollar desk. We're not being coy; we're just not comfortable with being in the headlines as big spenders, and the price of the desk was not what was important to us.

Why all this focus on the money? Why not write about why this piece is so special, rather than focus on how much it cost? It's such a shame, because we seldom bid for ourselves anymore, especially on an important piece.

We also prefer to be private in our philanthropy, but we agreed to

be identified as the donors of the new campus center at Wellesley, because it was a landmark gift ($25 million) for the school. We had to think long and hard about that. Money is a very powerful tool, but so is "buzz"—if both are used well, it can do a lot of good, as we hope will be the case with our support for the Met's American Wing.

William Westfield

"He was a tough son of a bitch . . ."

Billy is the master of the corny wisecrack, which I sense is a distancing technique. New York City firefighters have had to devise a lot of ways to get through these past few years. He becomes very emotional when he talks about his brother.

W here was I brought up? I was brought up in an elevator. . . . Danny, I gotta remind you, firemen live life on the edge, and we've all got pretty decent senses of humor, not fully understood by everyone else, but any rate, seriously, where was I brought up? In Brooklyn, New York.

When I was a kid, I used to be mesmerized by the flash of the fire trucks going by. They had big brass bells then. This is going back to the sixties now, and there was often a page in the newspaper showing tremendous examples of bravery and courage; sometimes the whole front page would be filled with flames, and I would say to myself, "I'm going to do that someday."

It's nice to get your first fire out of the way, because there's a lot of trepidation in the beginning, but you've got to realize you're in good hands; you're surrounded by the other guys, who guard you, coddle you, maybe give you a push when you need it. It's a close-knit family in the firehouse; the camaraderie is unbelievable.

I've seen my share of fires now, so if I don't see another one, that's OK. But you never forget your first fire. Mine was on Roosevelt Island, which is a big mishmash of crazy up and down apartments, so it's a dangerous place. In this case, somebody was careless with a cigarette, which ignited the sofa, although we didn't know all this before going in, and the room was engulfed; we couldn't see anything, it was all by feel and instinct. I was the first on the line, the nozzle, they call it, and I was hitting the fire where I thought it was, but unbeknownst to me, a lamp had fallen down and energized the water cascading off the couch, and I was getting electric shocks. I said to my officer, "Hey, Loo, I'm getting zapped here," so he told another guy to take my position just to give me a breather.

My worst fire was in the middle of winter: two homeless people, a father and son, living rough in railroad yards, and the makeshift heating or cooking oil spilled and ignited all their belongings. The son got out, but the father didn't wake up in time, and he was burned, he was really badly burned. I saw him, which was very traumatic. I mean, any burn victim who has his skin all peeling off looks pretty awful, but if it's the face, the muscular system more or less contracts, and he looks very distorted; you can barely recognize him as human. . . . It's hard to describe.

I'm sorry, I'm getting a little emotional here, but if I may digress? The New York Firefighters Burn Center was started by a couple of firemen in response to what they felt was discrimination against burn victims, and it's a favorite charity of firemen and has raised all this money for burn victims; the good work these guys have done is awesome.

I do volunteer work for an organization called DART, that's Disaster Assistance Response Team, again, started by a couple of firemen who wanted to help out with disasters around the country. We

don't get into firefighting. It is more shelter operations and mass care, and I went down to Louisiana a week after Katrina stuck, and the Met paid my salary while I did that. They were real gracious about it; they said everything was taken care of.

They staged us to Baton Rouge, and I was delivering supplies: cots, MREs (meals ready to eat), all that good stuff, servicing the outer-lying areas of New Orleans. You could drive for miles and miles and just keep seeing this utter devastation, and there were some places along the coastline which were simply obliterated.

For some reason, one place hit me pretty hard. I went into this town called Slidell, in St. Tammany Parish, where I had to drop off a truckload of stuff. They had taken a pretty good hit, but the first street I pulled into there was a shopping center, which looked OK, just some signs and things falling down. But on closer inspection, the stores which had appeared open were all closed. In reality this was a ghost town. There were no businesses, there were no people. It was a little shocking. Just when you thought: "Oh, here finally is a building that's standing," there was total economic devastation. They couldn't open for business; the water supply was contaminated. . . . I don't know why that so affected me.

Understandably, accommodations were a little sparse as all the hotels had refugees from New Orleans, so we were put up in a church. I was on a cot, which was tough, my frame's too big for that, so two nights I had zero sleep, and the next morning I had to drive for twelve hours—but you do it somehow. Anyway, that night the locals threw a Taste of Louisiana Night. They wanted to show their appreciation for us, and they cooked jambalaya and all the local dishes, and it was just delicious, the best food I ever had.

We've got nine guys here at the Met, all retired New York City firemen, as the terms of employment stipulate. The oldest is sixty,

the youngest is fifty, so you're talking many years' combined experience.

There's always some type of construction phase going on, so we have to be extra attentive to the tradespeople. Nothing against them, but they don't understand what is at stake. There's just countless billions' worth of priceless stuff, so it's got to be really emphasized that no torch work can be done unless they're licensed, and we'll check on them frequently. A couple of years ago, when they were doing the Greek and Roman phase of construction, a spark from one of the construction workers' torches lit some old paper up in a void, and because the roof was open, smoke was actually being downdrafted, which could have been really disastrous.

There are other things to take care of around the Museum; we're not just looking out for fire hazards. Just this morning we had a painter trapped on a hoist, and we extricated him. We respond to stuck elevators, and medical calls happen all the time. Well, we get five million people coming through here every year, plus, there's twenty-five hundred staff, so it's like a small city, and things are bound to happen. We get heart attacks and injuries, and all of us guys are trained in first aid, CPR, defibrillator use, and I do brain surgery too—no, I'm kidding again now.

I know a lot about fire, but I don't know much about art. Sometimes, though, things catch your eye; there's some plates in one section of the Museum that have these really unbelievable colors, and they're hundreds of years old, they're enamels somebody told me, and they're just beautiful.

My favorite thing, however, is the Christmas tree; it was bequeathed to the Museum, which is a nice gesture on the part of whoever did it, and it's put up every year, and decorated with priceless antiques. I love that tree; it really gets me in the Christmas spirit.

If fire were to erupt, God forbid, go ahead and grab the art—but it's at your own peril—we'd concentrate on the fire itself. Our priority is to get to the seat of the fire because you would lose precious time trying to extract art from a gallery, and the fire would gain headway because fire propagates exponentially.

I had nightmares after 9/11. I lost a lot of really good friends then, and my brother almost died. He's a fireman too, and he had gotten down to the towers just as the second tower fell; the antenna was like over his head as he ran for his life.

You know, in the Fire Department, there's firemen, and there's firemen's firemen. They're all good, don't get me wrong, but some guys are just outstanding. My brother wasn't afraid of anything. Maybe I'm bragging a little bit here, but it's justified. He was a tough son of a bitch, twice the size of me, and he'd go anywhere. He made hundreds of rescues—grabs we call them, I was so proud of him. But after 9/11 he just turned into a ball of mush. It really affected him; he lost like seventy-five friends. And he still mourns. I think it's always going to haunt him. You know, 343 New York City firemen died—were murdered, I should say—and they were all good guys too.

Linden Havemeyer Wise

"They only had one Renoir . . ."

Softly spoken, thoughtful, clearly choosing her words carefully, she meets us at her home just a few blocks from the Met. There are few people in this book so related to the Museum by blood ties as she.

A rt and education were as fundamental to me growing up as they are to the mission of the Metropolitan Museum. When I think of the influences in my life that led me here, the obvious ones are on my father's side of the family, but it is my mother's side that placed a real premium on education, even, and especially, for girls.

My mother grew up in Philadelphia, on the edge of the Main Line. Her family was comfortable but not socially prominent. Her father was professor of dental medicine at the University of Pennsylvania, and he and her mother set much store by education, giving the best to their two daughters, Eugenie and Antoinette. It was also the era of *The Philadelphia Story* and following the social convention of the time, both daughters were launched as debutantes. After graduating from Vassar, both met and married men who were wealthy and important in their communities.

My father's family was a prominent New York family, of some

means. My great-great-great-grandfather came over from Germany, from a family of bakers, and started a sugar business in the lower part of Manhattan. His name was Frederick Christian Havemeyer, and his grandson, H. O. Havemeyer, grew the business and became what is referred to in American history as the Sugar King; at one point he controlled some 98 percent of the sugar-refining industry in this country.

He and his wife both collected art before they married each other and had their own tastes. H.O. had started out buying the Old Masters, and his favorite artist was Rembrandt; in fact he had a room in his house in New York City which was called the Rembrandt Room, that had eight Rembrandts in it. My great-grandmother Louisine Havemeyer favored the Impressionists. She'd been introduced to them by her great friend the artist Mary Cassatt, and she bought her first three when she was twenty. She saw them in a shop window, pooled her allowance with her sisters, and managed to acquire a Monet, a Pissarro, and a Degas.

When the two of them came together, the combination was really explosive in terms of collecting, and they assembled an extraordinary collection, and even though H.O. was running this large industry, they spent a considerable amount of time traveling for the purpose of collecting.

In the old-fashioned way, where the woman deferred to the man, H.O. had to approve each one of Louisine's acquisitions. But actually Louisine worked her influence on him. She had certain favorite artists among the Impressionists, principally Degas, Courbet, and Manet. She was very moved by Degas and the effects he could create in the gossamer fabrics he painted and by Courbet's very sensual portraits. They had only one Renoir, which *he* favored—I think she felt that Renoir's subject matter was frivolous and fluffy and light,

and it didn't move her. What she really was moved to buy was what she perceived as art that spoke the truth about something, art that conveyed the very soul and essence of a person in a portrait or the truth and beauty of a landscape.

It was very unusual to have Americans buying these sorts of works at a time when most found them off-putting and ridiculous. But I think of it as extremely lucky that they were open to the new style of the Impressionists and adventurous and courageous enough to embrace it, and of course, because there was so little interest, it was a time of great opportunity in acquisition. And it did this country quite a service, because it's thanks to them that the Met's Impressionist collection is as great and deep as it is.

My great-grandfather died very young, in 1907, and when my great-grandmother died in 1929, she left a bequest to the Metropolitan of some 150 specific works of art, and empowered her executor, who was her son, to increase this. In fact she urged her three children to build a memorial to their father, to be known as the H. O. Havemeyer Collection, and she wanted them to pick out the best of the collection and allow the Met to have it. The way my grandfather chose to carry out his mother's request was that he gave the Met its pick of the collection, and the result was a gift of some two thousand objects and paintings.

So that's a bit of family history, which I hope you didn't find too boring.

As for myself, I was raised in New York City, the eldest of six girls. We had an apartment on Park and Seventy-seventh Street which wasn't grand or anything. It accommodated us all tightly; it had just four master bedrooms and three maids' rooms. We sisters all shared rooms, and when the last girl arrived, I was bumped into the library and made to make that my room. I felt very deprived because it was

a public room, so I wasn't allowed to put up posters or do anything that would detract from its public aura.

I was very close to my grandmother, who lived just around the corner from us at Seventieth and Park. And when I went to her apartment, there were Cézannes and Degas and Manets, probably the most well-known and important one of which was called *Gare Saint-Lazare*. It's a wonderful picture of a woman with a child gazing through the railroad grille at steam coming out of trains. It was a very radical picture for its time; the direct gaze of the woman is so arresting, but even more startling is the fact that, not quite in the center of the frame, is this child with her back to the viewer.

My grandmother also had a Vermeer, which was probably the first picture that really moved me. It is a portrait of a young girl writing, and unlike many Vermeers, her gaze meets the viewer directly, and the directness of her gaze is arresting. At the same time, her affect is so gentle and sweet, compassionate, soothing, and pastoral, which was my grandmother's effect on me as well, that it created quite a profound feeling in me.

So art was a big part of my life growing up. From an early age I came to appreciate the joy and privilege of living in proximity to great art, to experience its effect in a way you only can when you spend a lot of time with a great picture. Grandmother also took me to the Metropolitan Museum a great deal. It wasn't because she appreciated the art necessarily—her interest really was how collections were formed, the people behind them, who gave what and why—but the fact of the matter was that I spent a lot of hours in the Met very comfortably and happily with this relative who made it seem like an exciting place and an extension of our home.

The Met is terribly important to me. Like many people, I think of it as a national treasure, but I also have a very deep emotional tie to it as a family matter, and that fosters pride and allegiance and loyalty, and in my family we tend to feel these institutional allegiances very strongly.

Index